The Nature of Dogs

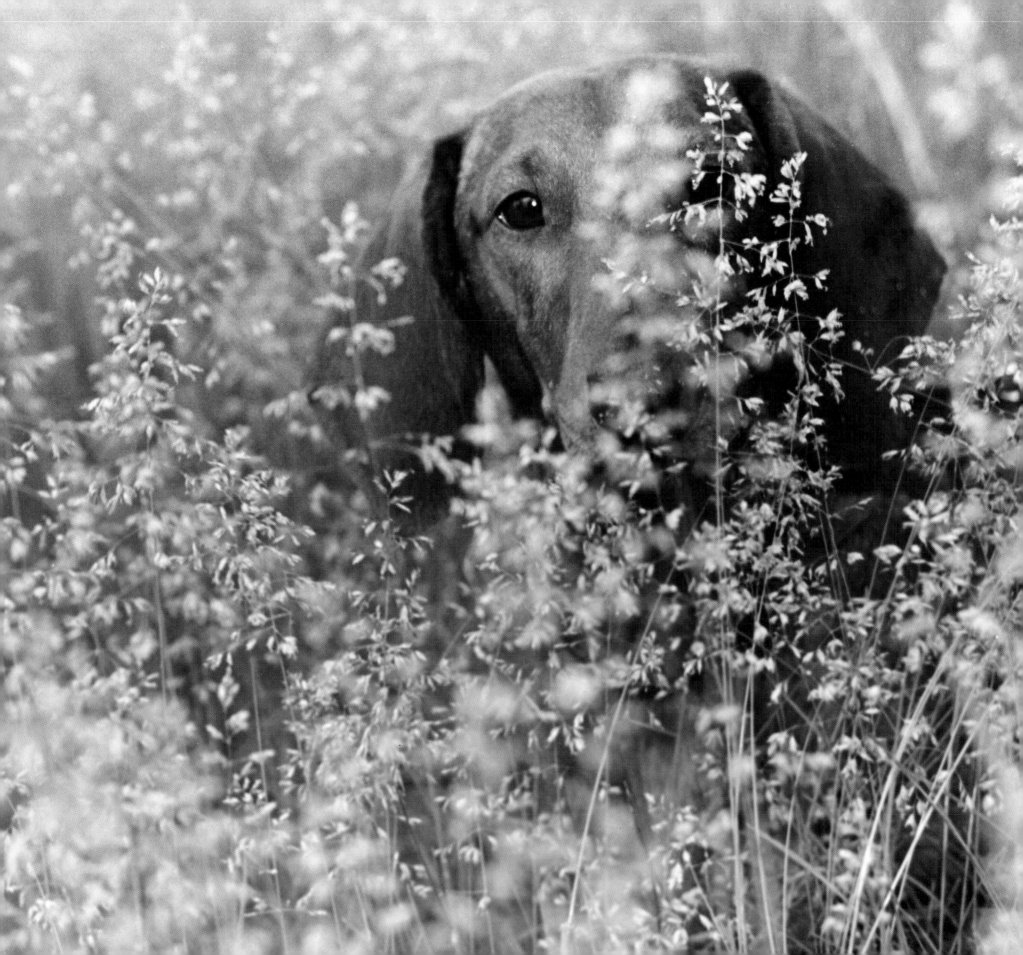

The Nature of Dogs

PHOTOGRAPHS *by* MARY LUDINGTON

FOREWORD *by* PATRICIA HAMPL

SIMON & SCHUSTER

SIMON & SCHUSTER
1230 Avenue of the Americas
New York, NY 10020

Developed and produced by Gary Chassman

EDITIONS

Burlington, Vermont
www.verveeditions.com

First Simon & Schuster hardcover edition October 2007

SIMON & SCHUSTER and colophon are registered trademarks of Simon & Schuster, Inc.

For information about special discounts for bulk purchases, please contact Simon & Schuster Special Sales at 1-800-456-6798 or business@simonandschuster.com.

Book design by Kari Finkler
Copyedited by Elizabeth S. Shanley
Printed in China by Global PSD

10 9 8 7 6 5 4 3 2 1

Library of Congress Cataloging-in-Publication Data
Ludington, Mary, 1956-
 The nature of dogs : photography / by Mary Ludington ; foreword by
Patricia Hampl. -- 1st Simon & Schuster hardcover ed.
 p. cm.
 ISBN-13: 978-1-4165-4287-2
 1. Dogs--Pictorial works. I. Title.
 SF430.L83 2007
 636.7--dc22
 2007017521

ISBN-13: 978-1-4165-4287-2
ISBN-10: 1-4165-4287-6

For Kevin and Charger

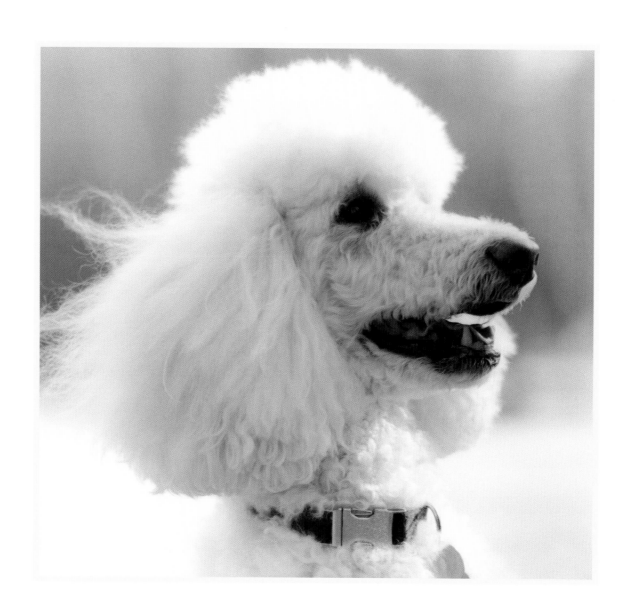

There is really only one dog—mine.

Or, of course, yours.

I T IS POSSIBLE TO BE DRAWN TO A BREED, a type, longhair this, pug-nosed that, to be partial to a look—winsome, fierce, haughty, or a pal. But love is specific. That's the point, isn't it?—to give over to the matchless other, exceptional, distinctive, solo. The beloved. The most surprising thing about loving a dog is how shockingly unique this animal you have taken into your home is. Not a breed, after all. A being.

Therefore: Lily. AKA La Lily, Lilinka, Lilypad, Lilleputian, Lilissima, and officially, on the American Kennel Club Standard Poodle website registration form, Lily of the Mississippi River Valley.

Not that I ever wanted to be a person possessed of a poodle. Would I start voting Republican? Yearn for a high-end Volvo station wagon? Wasn't I a terrier person? Or at least I was my father's daughter, Stan with his doleful English springer spaniel, the aptly named Buddy.

But no, I took into my arms the little white fluff of a poodle, about the size of a cottage loaf of bread, on that Sunday afternoon almost twelve years ago when my husband and I had gone for a drive in the country, the puppy in the newspaper ad just an excuse to roam on a beautiful fall day. The breeder was saying something about bloodlines, pointing out a slight imperfection in the formation of the leg that made the dog not quite show material. I was instantly insulted. Wrote the check, walked out in a daze. The line from the mystical Blake poem kept going through my head— "Little lamb, who made thee?"

And that's how it's been. Enthralled. Occasionally incensed (the billy goat aspect of the little lamb was not immediately evident—I don't want to go into the tennis ball, the entire Irish soda bread. Many bizarre things have gone down that gullet).

But to see her run in a wide green park, the gazelle in her, the fleet Baryshnikov of her flight. Gravity ever so slightly vanquished.

And to sit with her (yes to the question about the furniture, and yes, so you have a problem with that? to the bed question), oh to stroke her, the fine narrow head thrown back in a swoon of pleasure, the black infinity of her eyes filled with gratitude. And to turn over the ridiculous big furry mitten of her ear to the girly pink of the inner ear.

Well, it's been sweet.

So now that the hard part has started, the late night mad dashes to the vet hospital, the leg shaved for the IV, the x-rays, the meds, the plastic slapped down on the counter without a question—chi-ching, chi-ching—we're in for the bitter, in for it all.

The inevitable shines now with primordial acceptance and overlays the infinity I always marveled at in those streaming black eyes. She knows. Not the knowing we have—which is simply a cringing fear of death. Her knowing seems to partake entirely of acquiescence. The eyes are going milky, the visage no longer madcap, but profoundly, tenderly inward. She sleeps more. Does she dream? She makes little moans in her sleep. It isn't pain. It must be some memory, maybe of flying, leaping. Surely it's something free, something filled with delight.

—*PATRICIA HAMPL*

The Latin name for the dog, canis, seems to have a Greek origin. For in Greek it is called cenos, although some think that it is called after the musical sound, canor, of its barking, because when it howls, it is also said to sing, canere. No creature is more intelligent than the dog, for dogs have more understanding than other animals; they alone recognise their names and love their masters. There are many kinds of dogs: some track down the wild beasts of the forests to catch them; others by their vigilance guard flocks of sheep from the attacks of wolves; others as watch-dogs in the home guard the property of their masters lest it be stolen by thieves at night and sacrifice their lives for their master; they willingly go after game with their master; they guard his body even when he is dead and do not leave it. Finally, their nature is that they cannot exist without man.

—THE *ABERDEEN BESTIARY* (12TH CENTURY)

of the nature of dogs

The dogs of my childhood, a beagle and a collie, were family dogs that roamed free, chased bicycles, and ate Gravy Train. They competed for our affections with rabbits, gerbils, birds, turtles, and a pony and were the subjects of my first black-and-white photographs.

While I continued to love all animals, horses became my passion. It was only a decade ago that the unplanned adoption of a shelter dog, a beagle/bulldog mix, brought me back to dogs and to a path that would eventually lead to this book.

I had photographed landscapes for many years, searching out places that evoke solitude—landscapes where the viewer felt both within, yet apart from the natural world. I often worked in the country, where I keep a horse, but resisted photographing any animal within this space, fearing the images might be read too literally. Nonetheless, I was drawn to the horses and challenged myself to reveal them in photographs as I saw the landscapes, as quiet meditations on the ineffable.

Living with a dog again created new photographic challenges. How do I make an image of a dog—an animal with which we share such a strong familiar connection—that conveys something of its mystery? My work became about seeing dogs as separate from our relationship with them.

More dogs joined our family and I began showing them in conformation and field-sport events. I became more intrigued about their form and function; every aspect of a dog has a purpose related to the work for which it was bred and I continue to marvel at their complexity. Shooting in natural environments, with dogs moving freely, I don't direct the dogs but rather observe them with the camera. Then, in the darkroom, with infinite choices about negative selection, exposure, paper tone, and texture, I work to discover and translate the essence of the dog in the photographic print.

Inspired by Audubon and his extraordinary paintings of birds, my collection grew and I resolved to photograph every dog breed. The photographs in this book represent favorite images spanning the past ten years of my work.

I also drew inspiration from medieval bestiaries, which utilized texts and illustrations to chronicle animal behavior as a way to teach us more about ourselves. Examples of bestiaries are found as early as the second century AD. The *Aberdeen Bestiary,* published in the twelfth century, provided a particularly rich example. I think of *The Nature of Dogs* as a personal bestiary.

Still, it is nearly impossible to see dogs outside of our relationships with them; to observe them absent the profound mutual affection humans and dogs share. So I asked some of my favorite writers—Mary Gaitskill and Peter Trachtenberg, Temple Grandin, Patricia Hampl, Kevin Kling, James Hillman, and Winona LaDuke— if they would expound upon the nature of dogs through their own experiences. Their provocative essays speak to the heart, psyche, and history of the human connection with these creatures.

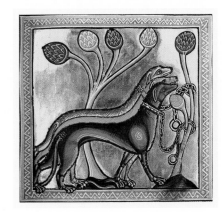

For me, it has been a privilege to photograph so many enchanting dogs and to share what I have found in them: beauty, grace, and purpose.

—MARY LUDINGTON

Detail from the *Aberdeen Bestiary*

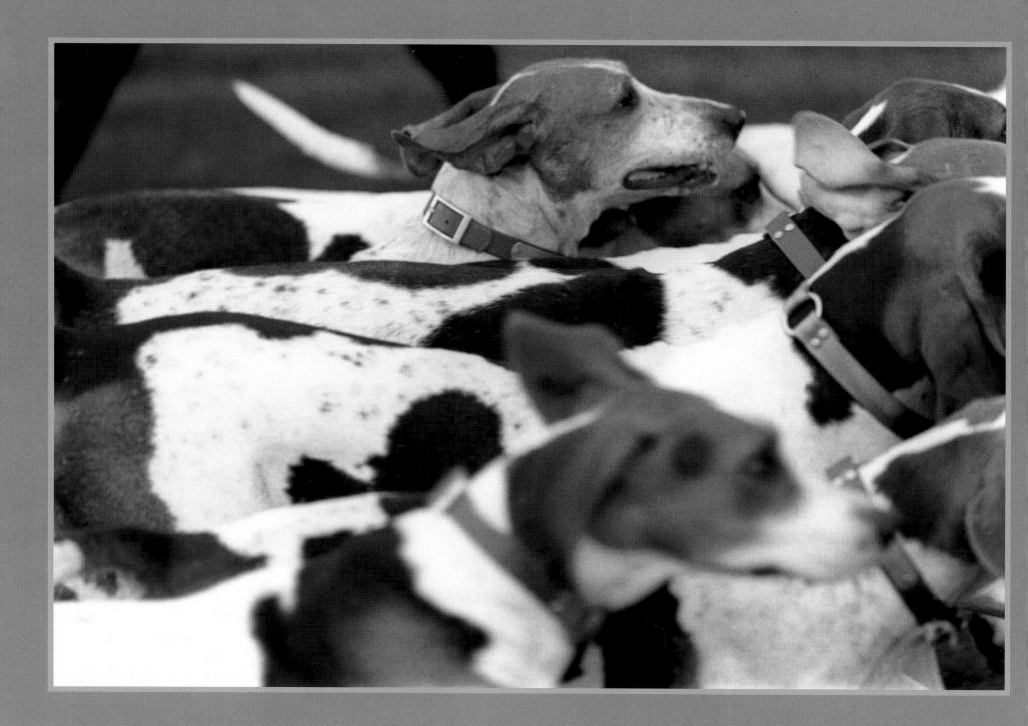

HOUNDS

heart of the hunt

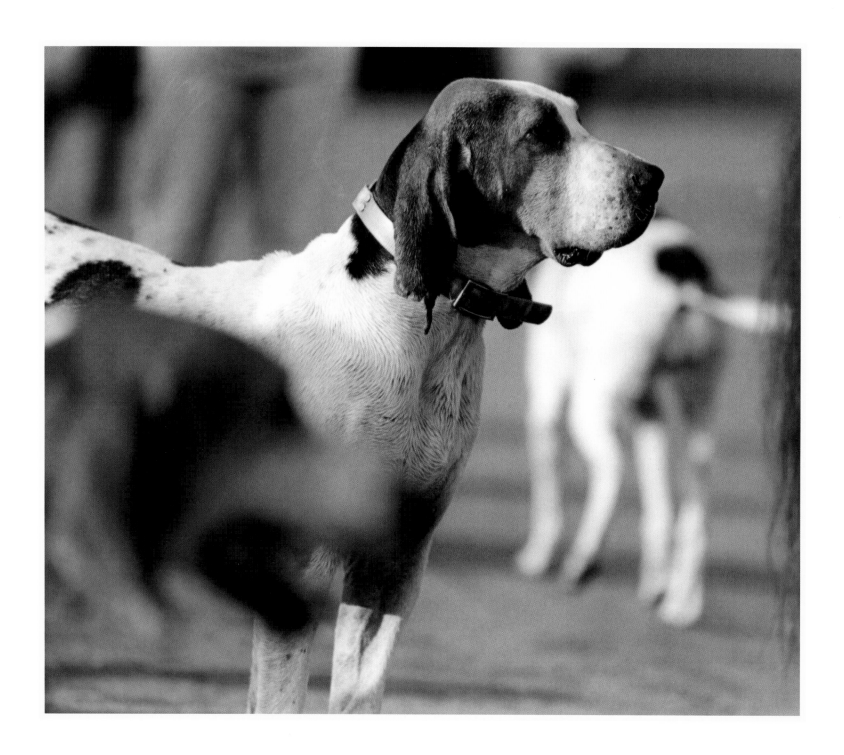

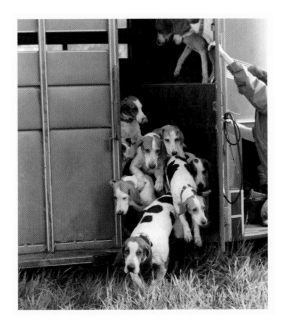 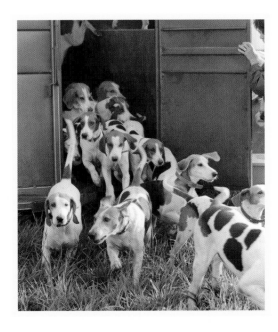 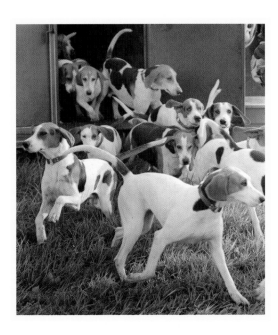

THE NEW WORLD DEMANDED A NEW NOSE and the American Foxhound's longer muzzle made it ideally suited to the drier conditions in America. Descended from the English Foxhound, it was bred to be lighter and taller. Its long, straight-boned legs gave it optimal speed for the longer expanses of the American landscape. An affable breed, its sociability is somewhat overshadowed by its independent nature; once it picks up a quarry's scent, the American Foxhound will disregard any command until its appetite for the chase is sated.

On the straightest of legs and the roundest of feet, With ribs like a frigate his timbers to meet,
With a fashion and fling and a form so complete, That to see him dance over the flags is a treat!
—G. J. WHYTE-MELVILLE, *THE KING OF THE KENNEL* (1800S)

BASSET HOUND

AN INTRIGUING STUDY IN CONTRASTS, the Basset Hound is a heavy dog on dwarf legs; its jaunty personality camouflaged by a woebegone expression. Traits that at first appear caricaturelike, however, are really brilliant adaptations. ☐ Low-slung, ponderous scenthounds like the Basset were greatly valued by hunters without horses. This hound hunts in

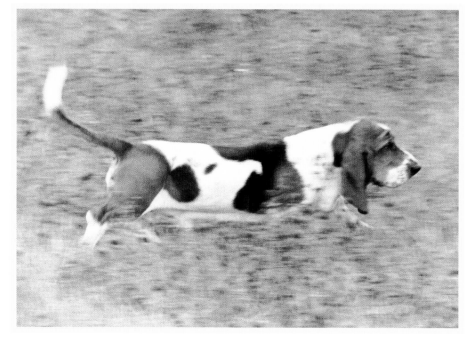

a pack, yet uses its nose independently. Its long ears and skin folds stir up scent particles. Its upright, white-tipped tail can be seen from a distance. Its short legs and deep voice allow hunters on foot to easily follow the pack. Handfuls of loose skin protect the Basset as it drives through dense thorny brush in single-minded pursuit of rabbits and hares. ☐ Like most scenthounds today, the Basset Hound's origins can be traced to medieval France. Early French short-legged hounds were referred to as "bassets" (the French word *bas* means "low") and often named according to region. Today's Bassets most likely descended from the Basset d'Artois, perhaps with a bit of crossbreeding with its larger cousin, the Bloodhound. ☐ Although today the majority of Basset Hounds are kept for companionship, do not be fooled by their floppy appearance; a hunting dog lurks just beneath the surface, patiently waiting for the unattended sandwich or dropped morsel—for these, it has no mercy.

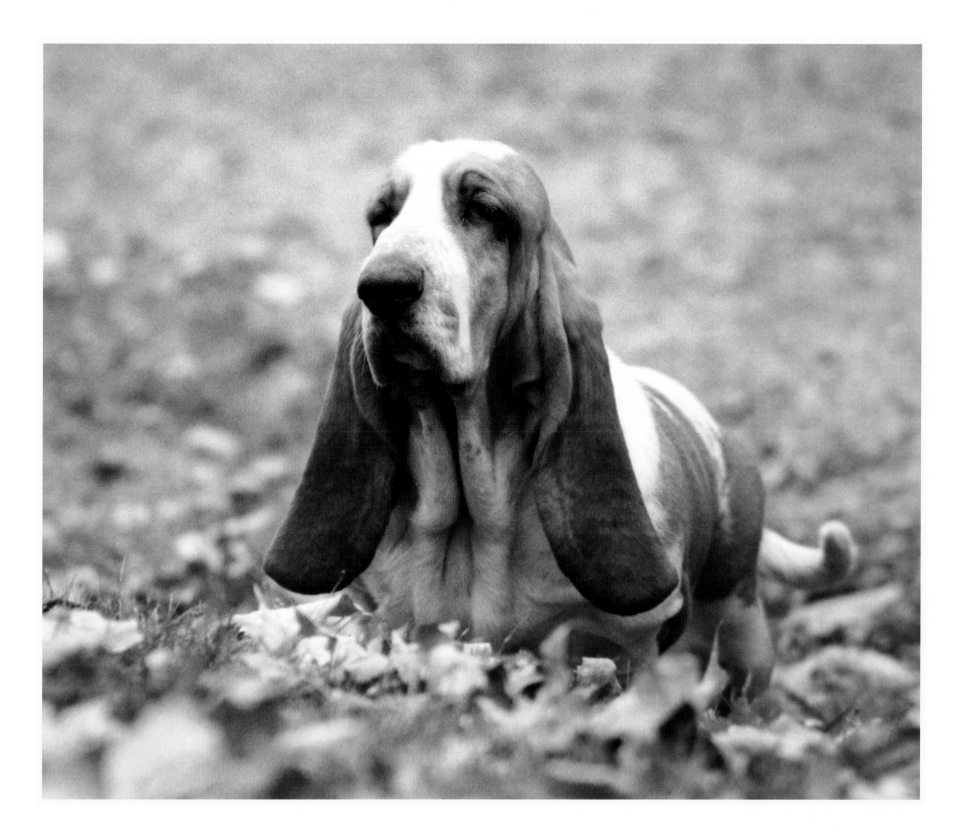

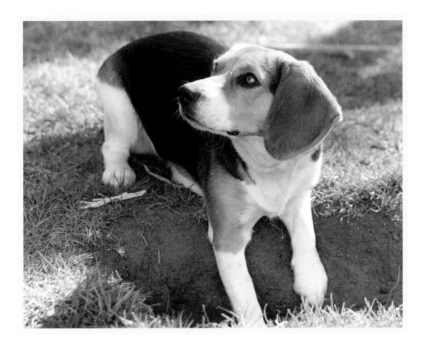

THE BEAGLE'S NAME MOST LIKELY DERIVES FROM THE FRENCH WORD *BEGUELE*, which means "open throat," or, more informally, "loudmouth." Developed in Great Britain, the breed was enhanced by genetic contributions from the hounds of Roman invaders, the European Talbot hounds, and, finally, the Southern hound, from which it received its large ears, deep voice, and slow pace. ☐ Often incorrectly labeled as difficult to train, if this hunting dog detects a curious scent, it will not hesitate to dig, chew, and howl until it solves the olfactory puzzle. The Beagle is so intelligent that it will ingeniously look for different ways to achieve the same solution to avoid routine and boredom, an approach that is sometimes interpreted as misbehavior or stupidity. ☐ But hunters in the early seventeen hundreds clearly admired the breed's artistry, staging retreats to the field to be entertained by a pack of thirty to forty well-bred Beagles in pursuit of rabbits. In full pursuit, the Beagle emanates a bloodcurdling howl, also called *tonguing*. ☐ The Beagle's use declined as fox hunting gained popularity, and the breed was crossed with the buck hound to produce what we now know as the Foxhound. If farmers in southern England had not discovered their use for flushing rabbits, the breed may have become extinct.

BLOODHOUND

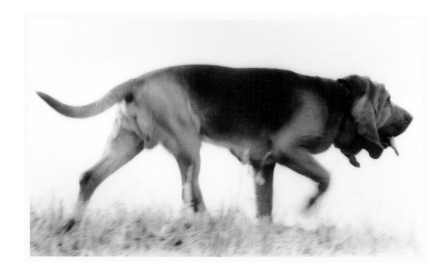

AS IF BY DESIGN, THE BLOODHOUND IS THE ULTIMATE TRACKING MACHINE. Loose, elastic skin that falls in soft, velvety folds allows the hound to bulldoze through the thorniest of thickets without laceration. When the nose is down, skin oozes over the eyes, protecting the hound from injury and eliminating visual distractions. Long, soft low-set ears that extend beyond the nose swing to and fro, swishing scent particles into the oversized nostrils. The Bloodhound's deep body and heavy bones give it stamina to trail a scent for hours, and its squat toes and well-padded feet provide excellent shock absorption over rough ground. □ But those who live with this massive beast know that it is far more than just a search engine. This breed is curious, sensitive, independent, and highly intelligent, traits that can make it tremendously challenging to live with. Left alone, even just for a few hours, the Bloodhound may choose to amuse itself by ripping the stuffing from the couch or digging the siding from a wall. A true pack hound, it prefers the company of others, be they canine or human. □ To the uninitiated, the Bloodhound may appear to be lazy. But the truth is that it puts its intensity on indefinite hold until truly needed.

Of the Dogge called a Bloodhounde in Latine Sanguinarius *. . . applying to their pursuit, agilite and nimbleness, without tediousnesse . . .* —JOHANNES CAIUS, *OF ENGLISHE DOGGES* (1576)

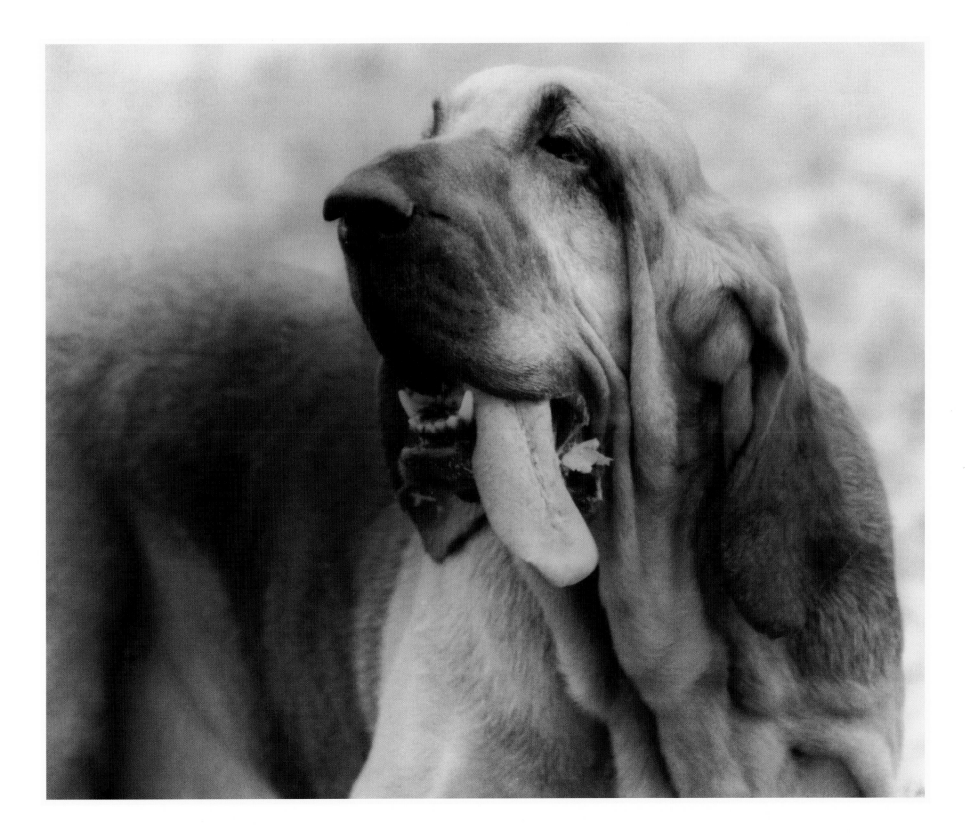

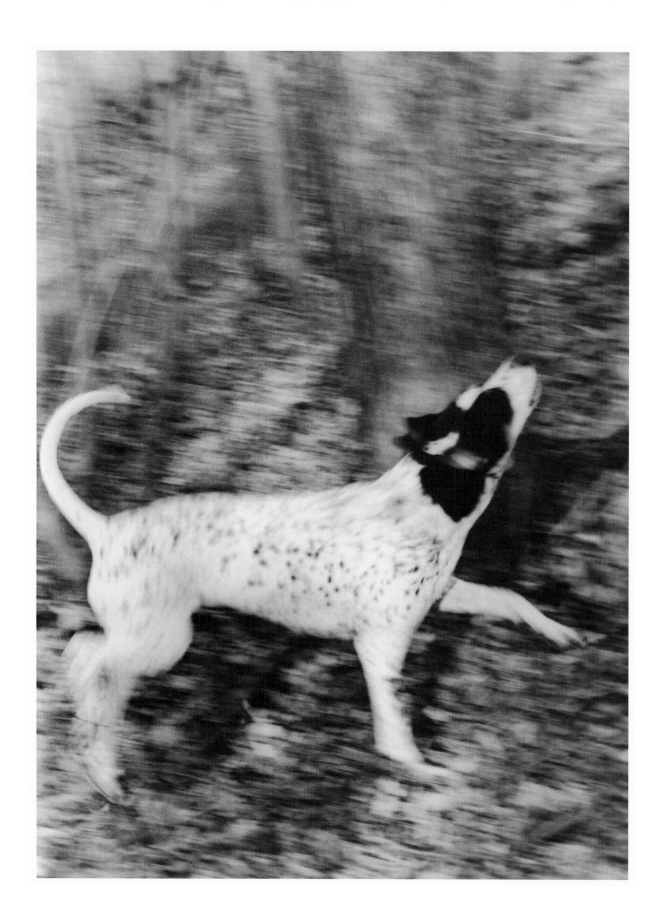

THE COONHOUND POSSESSES A SHARP SENSE OF SMELL and the ability to track, chase, and corner prey on the ground or in the trees. ☐ In colonial America, Foxhounds were imported for the fashionable sport of foxhunting. But the European Foxhound proved inadequate to hunt prey that retreated to the safety of a tall tree, including raccoon, opossum, bobcat—even cougar and bear. Unable to hold the scent, the Foxhound became confused. Breeders began crossing the Foxhound with the Bloodhound to improve the breed's sense of smell and its ability to tree game, as well as follow it to ground. ☐ While slower than the Foxhound, the Coonhound unfailingly tracks by scent alone. Once treed, the Coonhound remains below its prey baying victoriously until the hunter arrives. ☐ The Coonhound's coat is short and dense and its muzzle shows the typical hound flews. Developed from the dependable, extremely cold-nosed Foxhound, over time the Coonhound has evolved into multiple breeds with distinctive traits adapted to the challenges of specific climates, differing terrain, and regional hunting techniques. Some dogs developed webbed toes to aid them in tracking game across streams and through swamps. In the northern states, night-hunting Coonhounds became popular. Coonhound breeds include the American English, Black and Tan, Bluetick, Redbone, Treeing Walker, and Plott Hound.

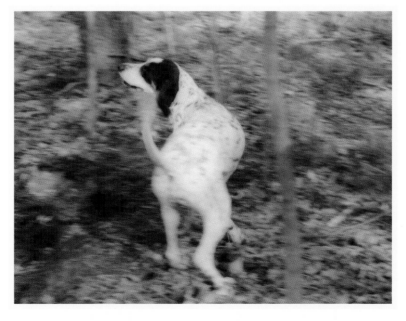

DACHSHUND

IN THE FIFTEENTH AND SIXTEENTH CENTURIES, western European breeders sought to develop a measured and deliberate breed that worked close to the ground. The French focused on the Basset Hound as a hunter's solution; the Germans created the Dachshund, or "badger dog." Although physically the Dachshund appears extreme or awkward, German foresters intentionally designed it to track and kill a variety of game, particularly the burrowing badger.

Bred to track like a hound and hunt like a terrier, the Dachshund is fearless. Tenacity and strength of spirit embolden the dog to enter directly into its prey's lair. Small limbs allow the Dachshund to slither over earth, rocks, and roots without becoming entangled or stuck. The slightly toed-out front enables it to move dirt to the sides of its flexible body. Long hound ears and almond-shaped eyes offer protection from debris. The broad chest enhances lung capacity necessary for its underground work, while its tail base is strong enough that the hunter can pull it off prey, if need be.

Crosses with terriers and spaniels produced the wirehaired and longcoated varieties and the original larger dogs were bred down to hunt smaller prey. The resulting miniature Dachshund possesses the same daring inquisitiveness and tenacity that is characteristic of its standard-size forebear.

A Dachshund is clever, lively, and courageous to the point of rashness . . .

Any display of shyness is a serious fault.

—AMERICAN KENNEL CLUB, *THE COMPLETE DOG BOOK* (2006)

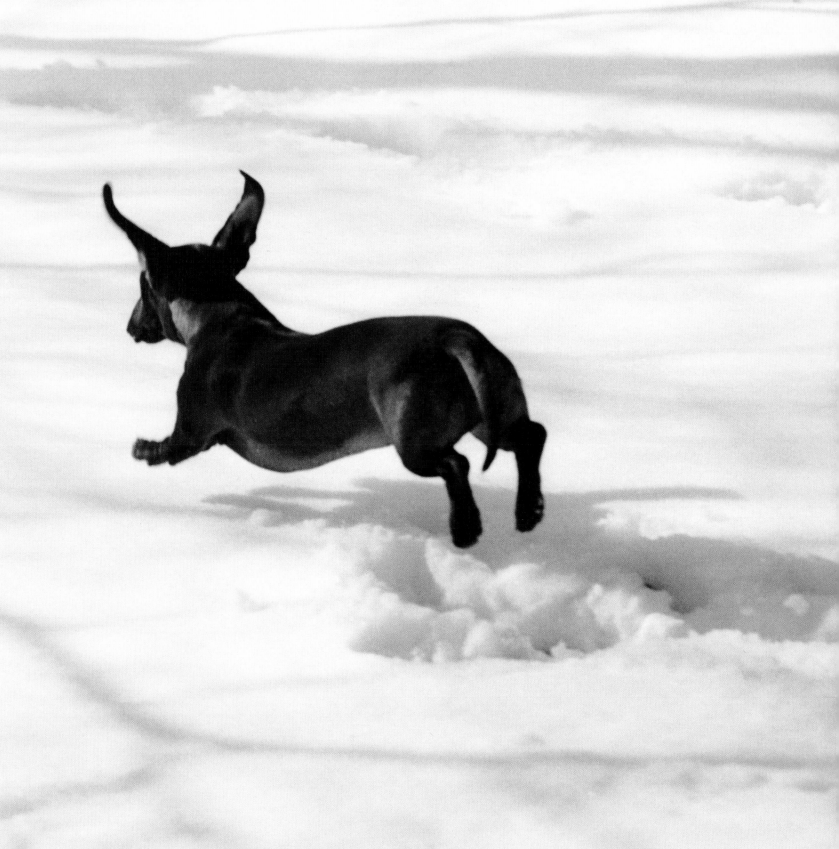

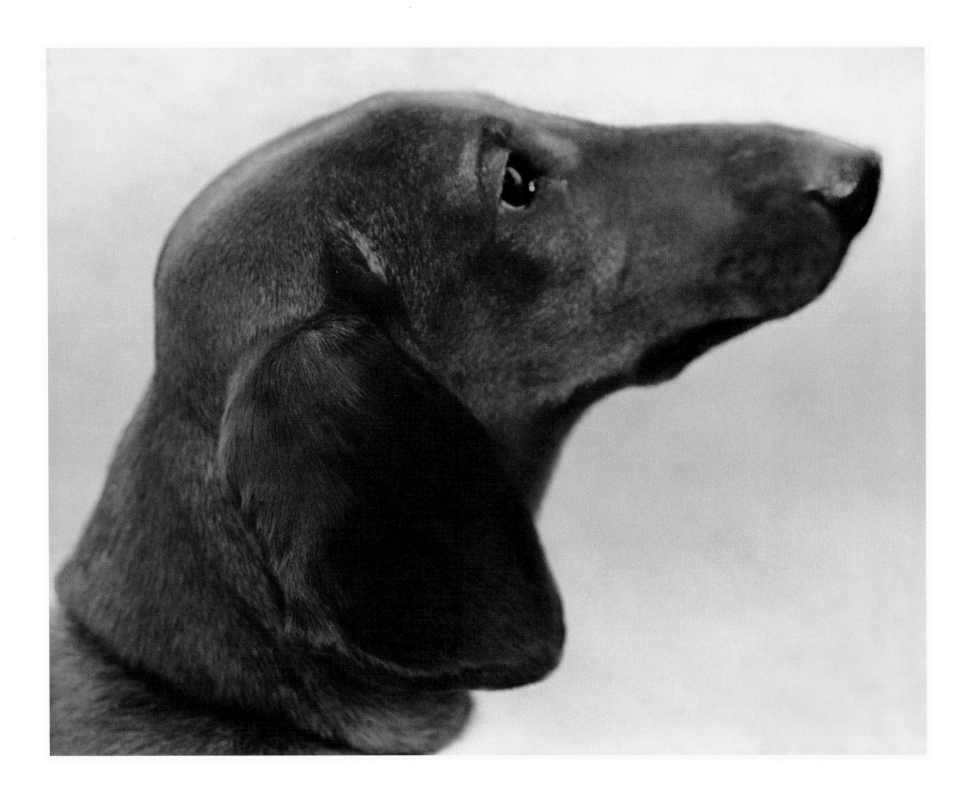

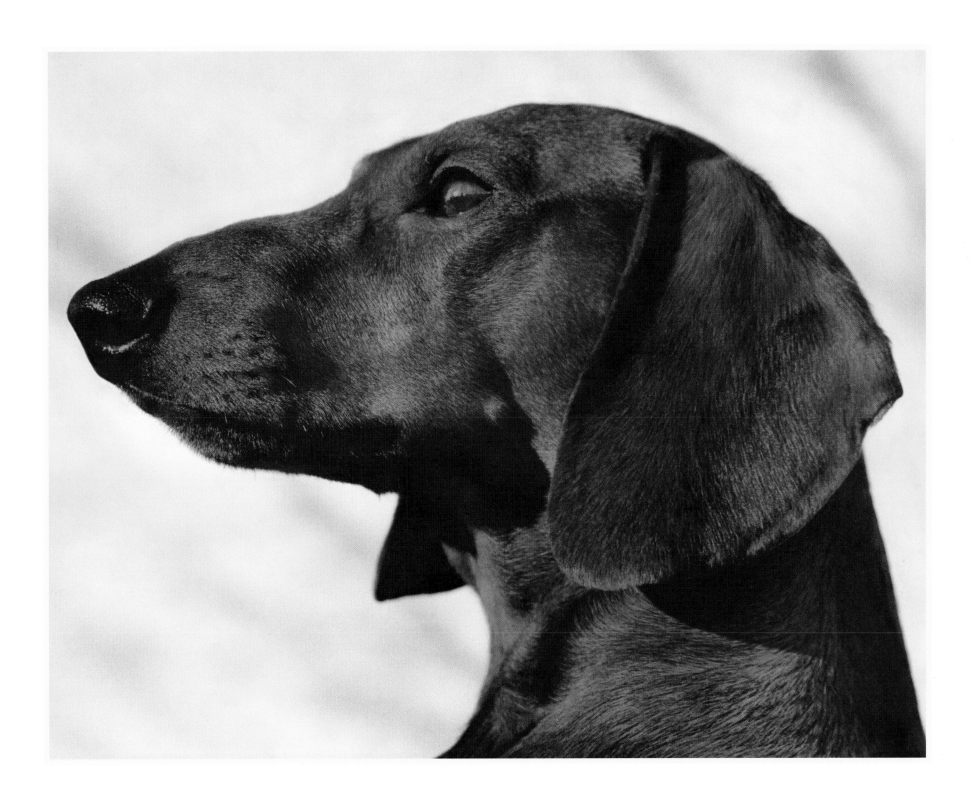

GREYHOUND

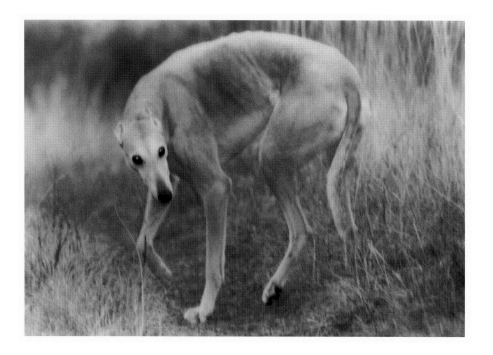

DEPICTED IN CARVINGS ON EGYPTIAN TOMBS AS FAR BACK AS 3500 BC, the Greyhound is one of the most ancient and venerated dog breeds. Prized for its sleek, elegant build, great speed, and fierce hunting skill, the Greyhound has nearly always been counted as a member of the aristocracy, despite the breed's more egalitarian and easygoing disposition. ☐ In 1016, King Canute decreed that only the nobility in England could own a Greyhound, and any commoner caught hunting with one would see the dog's toes mutilated. More valuable than a serf, the punishment for killing a Greyhound was the same as for an act of murder. ☐ Even in the New World, the Greyhound kept company with some important people. During the Revolutionary War, George Washington was accompanied by a Greyhound named Azor. General George A. Custer was especially fond of Greyhounds and other coursing breeds and traveled with a pack of as many as forty hounds. ☐ Built for speed, with a deep chest, long legs, powerful hindquarters, and an extremely supple spine, the Greyhound is one of the fastest land animals. A sprinting Greyhound can reach speeds of up to 45 miles per hour, and the breed vies with the Saluki of Arabia for the title of "fastest dog."

A greyhound should be headed like a snake and necked like a drake, backed like a beam, sided like a bream, footed like a cat and tailed like a rat. —THE BOOK OF ST. ALBANS (15TH CENTURY)

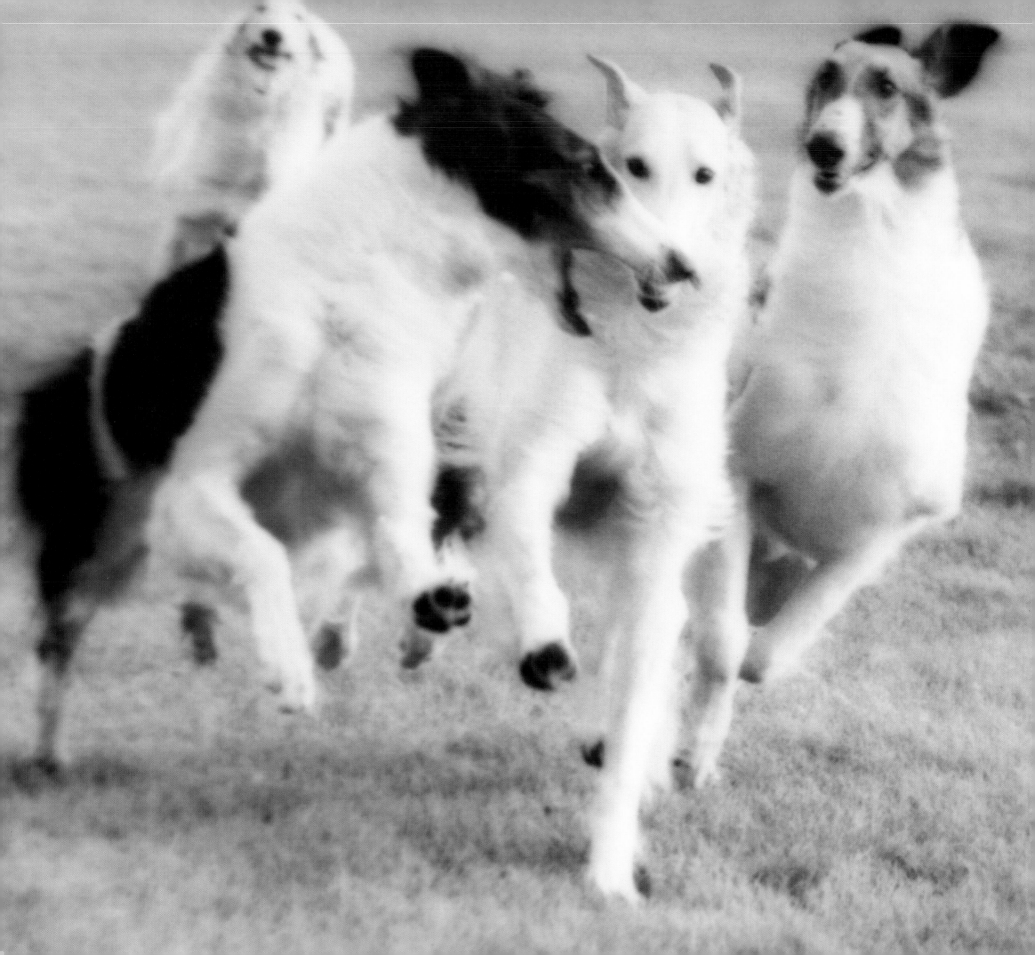

Lithesome grace and proud, dignified mien stamp the Borzoi indelibly with the hallmark of blood and breeding. He is the siegneur of all dogs, the great aristocrat of dogdom.
He looks down with amused indifference upon the common mob of canines; such a sturdy squire as the beagle he ignores; he even snubs that splendid old gentleman the foxhound; he is inclined to patronize his cousins, the greyhound and the deerhounds.
—WILLIAMS HAYNES, "DOGS OF ALL THE RUSSIAS," *HOUSE AND GARDEN* (JULY 1916)

THE REST OF THE WORLD KNOWS THE BORZOI as a breed of Russian wolfhound whose aerodynamic construction makes it a swift hunter, but Russians use the word *borzój*, which means "swift," as a generic term referring to all hounds. ☐ Originally bred for hunting on open terrain, the Borzoi relies on sight as opposed to scent. Russian aristocrats are thought to have perfected the breed by importing sighthounds from Arabia and crossing them with native Tartar coursing hounds or long-legged herders that could withstand the harsh winters. The resulting Borzoi boasted long, lean legs and a deep chest coupled with a slightly arched loin and powerful hindquarters—an extremely agile and powerful frame built to chase, catch, and hold its quarry. ☐ Primarily employed to hunt wolves that had overrun the country, more than one hundred Borzois were commonly included in the grand hunting parties of Russian czars. Beaters on foot, accompanied by a pack of Foxhounds, drove the wolves from the forest into the open field where the huntsmen and Borzois waited. A trio of Borzois—usually one dog and two bitches—worked in concert to capture, pin, and hold the quarry until the mounted hunter arrived to finish the kill with his dagger, or to gag and bind the wolf for release. ☐ Valued not just for its courage, agility, and hunting abilities, the Borzoi was cherished for its gentle nature and refined aesthetic, its flowing lines and poised elegance in motion or repose. Borzois graced the palaces of Russian nobles until the 1917 revolution, when the Bolsheviks slaughtered the Borzois because of their association with the nobles. This beautiful and loyal breed might have died out had it not been for their export to England beginning in 1875, and to the United States and other countries shortly thereafter.

SCOTTISH DEERHOUND

A most perfect creature of Heaven ... strength to pull down a bull, swiftness to cote an antelope.
—SIR WALTER SCOTT, *THE TALISMAN* (1825)

LARGER AND HEAVIER IN BONE AND BUILD THAN ITS COUSIN the English Greyhound, the rough-haired Scottish Deerhound was bred to sprint across the Scottish Highlands and pull down the red deer independent of the hunter.

Long in spine and leg, with a powerful curve to the loin tucked up at the waist, the Deerhound easily propels itself uphill. Its long, supple tail serves as a counterweight and rudder when turning and leaping. Generous but compact feet, solid hocks, and strong elastic pasterns protect it from impact on the hillside, energize its rebound, and speed it on its way. A full Greyhound-like chest—not so deep as to minimize its turning agility—houses a large heart and efficient lungs that enable this true sighthound to catch and immobilize a stag, and use its strong-jawed bite to pull it down.

Largely unchanged in appearance for centuries, the Scottish Deerhound's crisp, coarse coat protects it from the Highland elements. Its soft, small rose ear and trusting, friendly character mark it as a member of the European sighthound family so highly valued as companion animals by wealthy landowners.

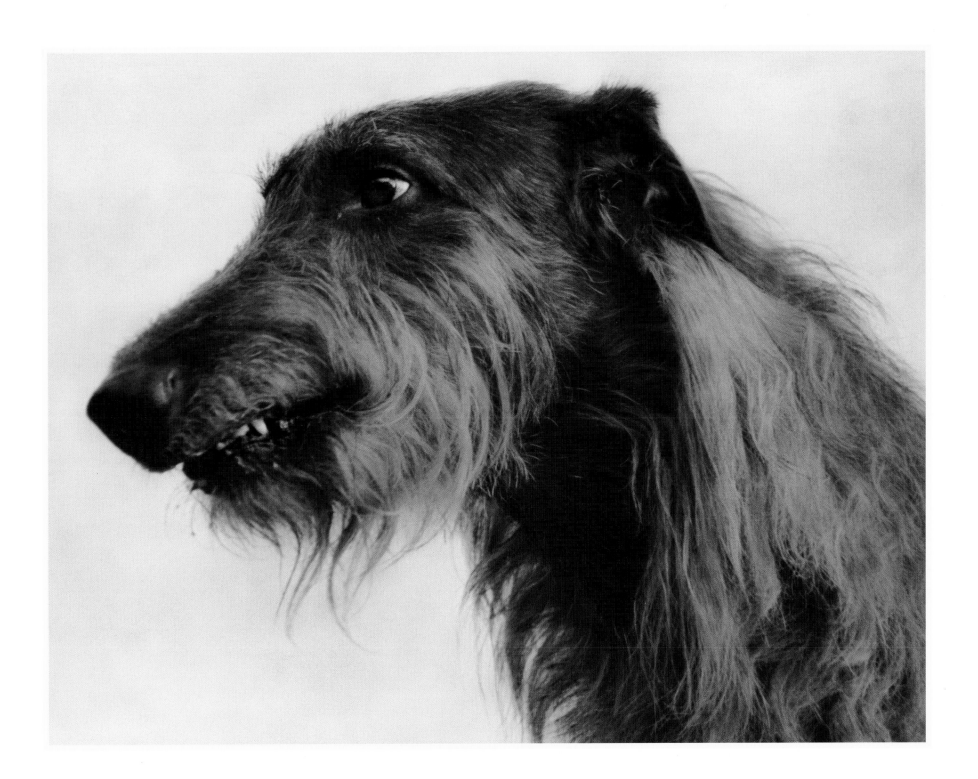

THE OUTSTANDING CHARACTERISTIC OF THE RHODESIAN RIDGEBACK is the erect trail of hair that runs along its spine. This ridge, or *verkeerderhaar* (incorrect hair), runs in the opposite direction of its coat and lends the dog a moody, renegade aura. ☐ The Khoikhoi of South Africa used a jackal-like dog with a forward ridge of hair growing along its spine for hunting. The Boer farmers, who settled near the Khoikhoi in the sixteenth century, crossed this native dog with the breeds they had brought with them, which most likely included Danes

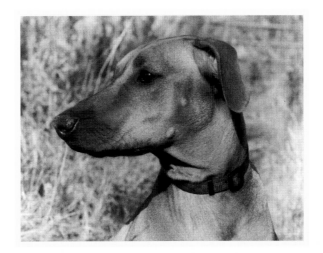

and Greyhounds. The dog's reputation includes a mythic ability to stalk and kill lions, but in reality the Ridgeback was used to distract the lion and deplete his energy to prepare him for the Boer hunter's kill. ☐ Although lions, cheetahs, and other game teetered toward extinction with the development of the hunting rifle, the Ridgeback still carries the legend of the lion hunter; its careful affection and quiet dignity are often mistaken for the aloofness and ferocity of a ruthless hunter.

The Ridgeback, singly or in a pack, will silently track the lion to its lair and only
on discovery of its quarry will it give tongue; tantalizing, feinting, darting in and out, just beyond the reach of
those fearful slashing claws, with the nonchalance of a matador; harassing and wearing it down until
that majestic creature, bewildered by such elusive impudence and weary of trying to shake off its tenacious
nuisance, presents a sitting target of injured majesty.

—CAPTAIN T. C. HAWLEY, *THE RHODESIAN RIDGEBACK: THE ORIGIN, HISTORY AND STANDARD OF THE BREED* (1957)

PHARAOH HOUND

THE PHARAOH HOUNDS' STRIKING RESEMBLANCE to the royal dogs depicted in ancient Egyptian art leads many people to believe that they originated in Egypt. However, recent research indicates the Pharaoh Hound originated on the islands of Malta and Gozo, where the breed has been preserved in its purest form for several thousand years.

Regardless of the Pharaoh Hound's true ancestry, history relates the existence of a sighthound in Egypt with noble bearing and muscular lines who hunted its prey with grace, power, and speed. The "red long-tailed dog" is emblazoned with a white "star" on its chest, believed to reflect moonlight to aid the hound in its ritual nocturnal hunts. Affectionate and playful, the dog returned at daylight to guard and protect the Pharaoh's children.

The Pharaoh Hound is said to be the only dog that blushes. Triggered by excitement or satisfaction, it literally glows—the nose, ears, and lovely amber eyes flushing a deep pink rose.

The red long-tailed dog goes at night into the stalls of the hills.
He is better than the long-faced dog. He makes no delay in hunting,
his face glows like a God and he delights to do his work.

—TRANSLATED FROM A LETTER WRITTEN DURING THE NINETEENTH EGYPTIAN DYNASTY

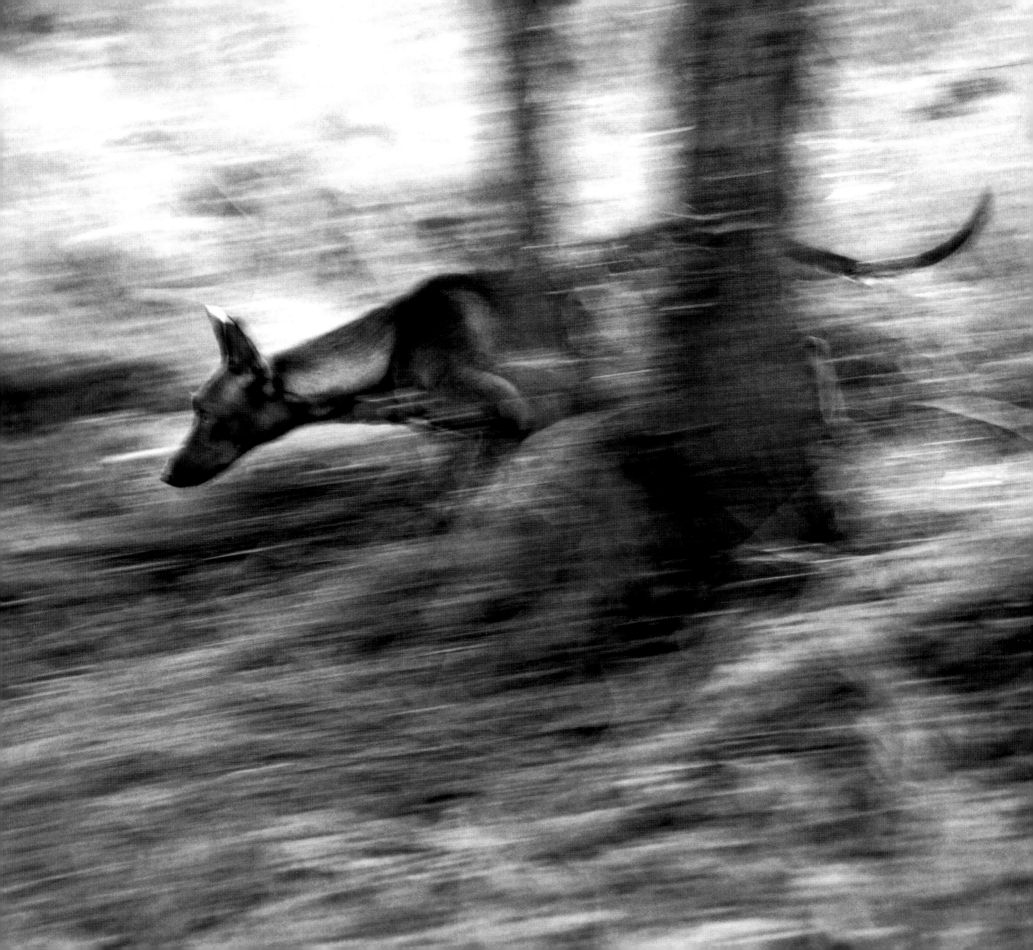

Embracing Ferocity *KEVIN KLING*

I GREW UP IN THE COMPANY OF DOGS: neighborhood dogs, stray dogs, farm dogs, house dogs. The book that turned me into a reader was Jack London's *White Fang*: "The wolf in him lingered and the wild in him merely slept." I learned early which neighborhood dogs we could pet and which to avoid, what dog would take teasing and which one snarled at eye contact, which houses to pedal by fast on your bike or where you could coast. To be on the safe side when encountering a strange dog, figure ferocity was a given. It was a matter of degree and the trigger mechanism. Even with this knowledge, sometimes it was simply a matter of being at the wrong place at the wrong time.

My uncle had hunting dogs and although he didn't hunt with them, he swore they were quality hound dogs. His back yard was full of dogs and old cars. Whenever he bought a new car he tore the doors off his old one, parked it out back and it became the new doghouse. The dogs loved it and often sat in the front seat like they were going somewhere. My uncle loved to sit in a lawn chair framed in the proscenium of his garage door with a cold Schlitz tallboy beer and a cigarette, surrounded by his dogs. My dad said my uncle was the kind of guy who smelled "all the flowers all the time." Sometimes he'd have a bar-b-que smoldering. His ribs were incredible. He told me the secret of good bar-b-que: "There's three things I never wash and one's my grill." One time, while he was sitting around "practicing for when I get old," he pointed at his dog and said, "Look at that darn dog. Been staring at that dead butterfly for two hours. Two hours. And I ought to know, I been watching it the whole time." My uncle couldn't have found a better dog. In his world, time spent with his dog did not count against life.

When Odysseus returned from his travels, his old dog was the only one to recognize him. When the world turned on Nixon, why did he turn to Checkers? I'm taken by the observation in medieval bestiaries about curing internal illness by lying next to a dog. The dog cures not only what ails us, but more importantly, what we can't see. Martin Luther said he wished he could pray "like that dog looks at meat."

I love watching dogs dream. In some cultures it was important to watch the dogs sleep the night before the hunt. The dreaming dog, chasing as it slept, was the one to bring the next day.

When you hunt with my brother, you hunt. There are no weather conditions too harsh, nor is any sign of fatigue permitted. When you do finally take a break to have a sandwich, it's made and eaten en route to the next field and there are usually pheasant feathers on the knife he's using for the mayonnaise. He has had many good hunting dogs but rarely one that could sustain the demanding rigors of his quest. Then, one spring, he got a yellow Lab pup with a pedigree a mile long, complete with national hunting titles on both sides. That fall, I asked him how the dog was working out and he said, for the most part, he was pleased. The dog had an incredible nose but was pretty unfocused, so over the winter my brother hired a trainer. That really helped with the obedience, but he still wasn't sure about the dog's heart. One day the trainer was demonstrating a method of holding a dog, "guaranteed" to prevent the animal from getting free. My brother asked the trainer to put his dog in the hold. The trainer did so. My brother left the room and came back moments later wearing his hip waders and holding a twelve-gauge shotgun. My brother said the dog

Who better to entrust your soul than something that would fight for you with a dog's ferocity?

was waiting for him at the front door wagging his tail. The two have hunted successfully ever since.

I love pheasant hunting with my brother. Most of all, I enjoy watching his dogs work. The fact my gun has remained on safety for five years frustrates him to no end. Last year he shouted across the cornfield, "You'll never hit anything with that smile on your face." I can't help it. Seeing those dogs do what they were meant to do is bliss.

A friend of mine was pheasant hunting recently with her German shorthaired retrievers. Three generations of hunting dogs. It was the puppy's first hunt and he was bounding all over the place. The oldest dog was thirteen and this was quite possibly her last hunt. She had been a tireless hunting companion throughout the years. The third dog was a four-year-old and in her prime. Although the dogs worked well, it was a slow morning. Finally, a rooster got up, and my friend shot and saw it drop up ahead. The three dogs took off, the four-year-old in the lead, followed by the veteran, and then last came the puppy, excited but clueless. The four-year-old found the bird and was returning with it, when suddenly she stopped and gently passed it to the older dog. The older dog took the bird several steps, then stopped and gave it to the puppy to finish the retrieve.

Are we paired with the dog we deserve?

If that's true, I immediately think of Charger. Charger was one of those big, goofy dogs that carries a log around all day, the kind of dog that would've joined the army for the food, a mutt with claims to all seven dog groups. Every year I'd watch the Westminster Dog Show and at the end, when they'd announce Best in Show, I'd yell, "Charger, you won, you won!"

He never saved my life, or if he did, he never let on that he had. But when he passed away, I cried buckets. In the words of Kipling: "Brothers and sisters, I bid you beware, of giving your heart to a dog to tear." Despite this warning, we do give our hearts to these creatures.

Is this because dogs are our last connection to nature? Or does it come from a recognition, a connection with our own nature, a force lurking in our own genetic weed bed, wanting at times to fight with tooth and claw, other times to act blissfully uninhibited?

For me, the answer is simple. Charger was my friend.

Now we have two dachshunds. I learned that when people see a dachshund, they have to yell, "A wiener dog!" Like "A rainbow!" "A Shriner!" "A shooting star!" "A clown!" "A nudist colony!" I've also learned that dachshunds were bred to hunt badgers. At first I felt sorry for the little dachshund—until I owned one. Now I pity the badger. I guarantee you'll never see a more "can do" attitude in a more "can't do" body than a wiener dog. But I've fallen hard for them, the same way so many high school girls fall for the wrong guy. There's an irresistibly attractive force at work when something that's a bit feral loves you.

I've heard that the Aztecs bred Chihuahuas to lead them across the great river into the afterlife. It makes sense. Who better to entrust your soul than something that would fight for you with a dog's ferocity? This story also gives me solace. I like to think that someday I'll see Charger again, waiting for me on this side of the river to cross together into peace. My guess is he's probably sitting in the smoking lounge right now with a bunch of Chihuahuas.

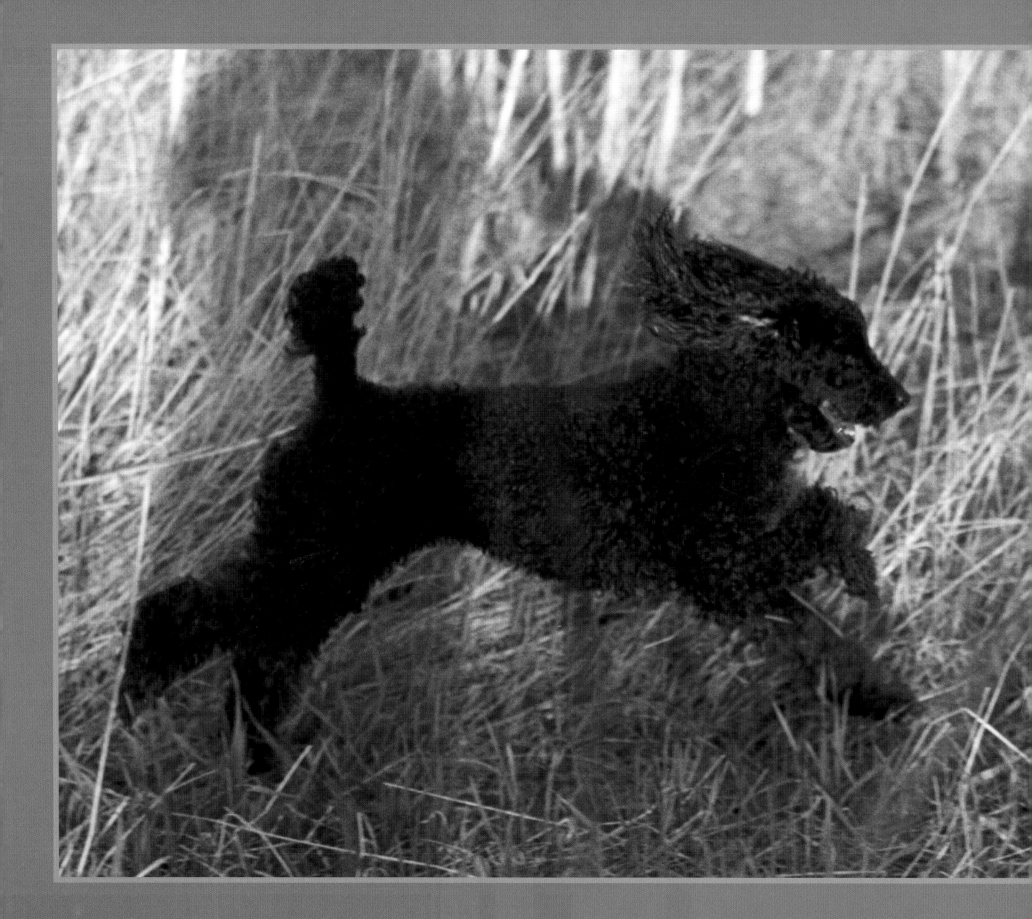

diverse in form
and function

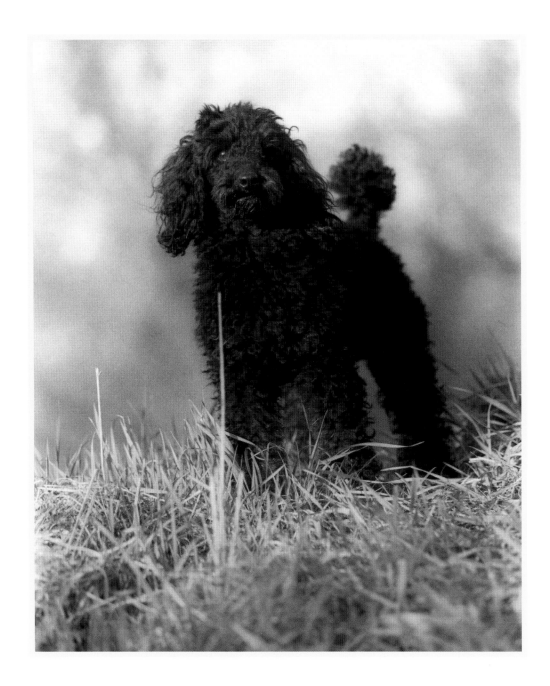

*My Poodle can do anything your Lab can do. However, in the evening your Lab
wants to sleep by the fire and dream, and my Poodle wants to be a fourth at bridge and tell naughty stories!*
—ANNE ROGERS CLARK, *DOGS IN REVIEW* (JULY 1997)

DESPITE ITS EFFETE APPEARANCE, THE POODLE WAS ORIGINALLY A HUNTING DOG. An especially adept water retriever, its coat was clipped to keep the joints and vital organs warm while swimming in icy water (common Poodle haircuts reflect this historical purpose). ☐ A renowned breeder and dog show judge, Anne Rogers Clark, instructs that "the

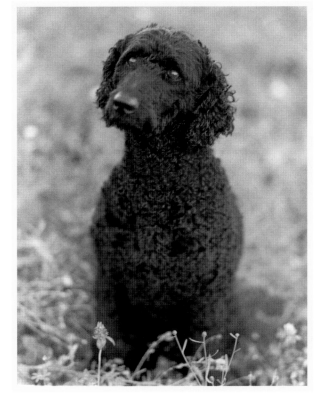

Poodle must have the strong legs and deep body that the retrieving breeds have—really, 'row boats with legs!' must have a mouth large enough to carry a large rabbit or goose, (this is the Standard; the Miniature and Toy being bred down) and a neck long enough and strong enough to carry its retrieve above the ground cover to the waiting hunter, which may be a half mile ... The Poodle must have legs of sufficient bone to support muscle that will allow it to work in heavy cover, swamp, or water not deep enough to swim in." ☐ The Poodle's beginnings lie in Russia, Germany, and France. The name Poodle comes from the German word *pudeln,* which means "to splash about in the water." The Russian Poodle's body was said to resemble a Greyhound; in Germany, the thicker-bodied Poodle sported a woolly coat. The Poodle was known in France as *caniche,* or "duck dog." ☐ They are all active and extremely intelligent dogs. Once used in traveling circus acts, today Miniatures are the most popular variety, perhaps owing to their reputation as sprightly, clever dogs. ☐ Toys were in vogue among the nobility in late eighteenth-century France. Many in King Louis XVI's court pampered their diminutive pets. The Toys of the House of Bourbon, however, enjoyed a gentler fate than that of the king and his wife, Marie Antoinette, whose execution signaled the end of France's absolute monarchy.

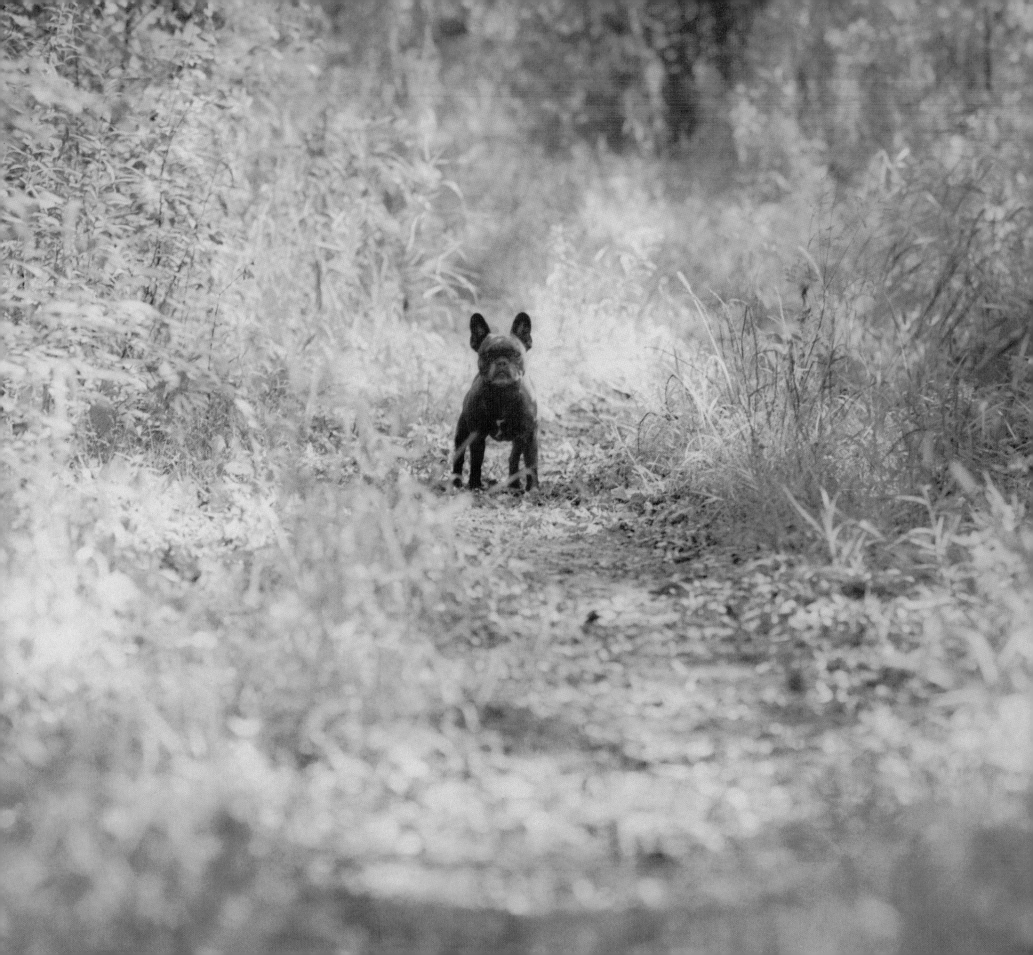

A clown in the cloak of a philosopher. —OLD FRENCH SAYING

A GREAT DEAL OF SPECULATION SURROUNDS THE ORIGINS OF THE FRENCH BULLDOG, presumed to have begun when a cull of reputable Bulldog breeders in England resulted in the dogs being carried to French shores during the industrial revolution by migrating Nottingham lace workers seeking employment.

Its distinctive characteristics—small size, flat face, and endearingly odd proportions—earned it immediate popularity among Parisian courtesans. Through their carriage drivers and bordellos, these *belles de nuit* (ladies of the night) introduced the unconventional dog to the upper classes. The exclusivity that ownership of this rare breed implied—combined with the audacious allure of its association with Parisian courtesans—enhanced its desirability among the affluent. As an expression of the avant-garde, the French Bulldog occupied the laps of artists, eccentrics, and those who only wished they were part of the artistic set.

American tourists discovered the petite French Bulldogs and began bringing them home, where dedicated American breeders worked to preserve the breed's distinctive batlike ears. Even though at first sight it looks like a miniature Bulldog, its erect ears, characteristically flat skull, small size, and active nature set the French Bulldog apart.

SHIBA INU

IT TAKES NO FEWER THAN THREE WORDS TO DESCRIBE THE OLDEST AND SMALLEST OF JAPAN'S DOGS. The Shiba Inu is described as *kan-i* for its intrepid bravery, composure, and mental strength; *ryosei* for its good nature; and *sobuku* for its refined and open spirit—its natural beauty of the soul. ☐ Several theories surround the ancient origins of its name. *Inu* means "dog" and *shiba* means "brushwood," which suggests the dogs may have been named for the brushwood bushes where they hunted.

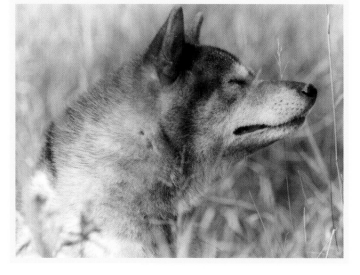

The fiery red color of the Shiba is also the color of brushwood leaves in autumn. An obsolete definition of the word *shiba* means "small" or "dwarf." These explanations are often combined; thus, the Shiba Inu is frequently referred to as the Little Brushwood Dog. ☐ The Shiba are believed to be one of six descendents of dogs brought to Japan some nine thousand years ago by the Jomonjin, Japan's earliest known immigrants. These early dogs were crossed in the third century BC with dogs brought by another group of immigrants. Their offspring are characterized by pointed, erect ears and a sickle-shaped tail. ☐ Commonly found in the mountainous areas near the Sea of Japan, the Shiba were valued as adept hunters who could maneuver adroitly on the steep mountainsides to flush birds, small game, and the occasional wild boar. ☐ Though hardy, the Shiba can be catlike in nature; it hates being dirty and instead of barking, it might prefer to purr, yodel, or even scream like a panther—a vocalization employed with characteristic boldness to register its objection to doing anything contrary to its nature, like walking on a leash.

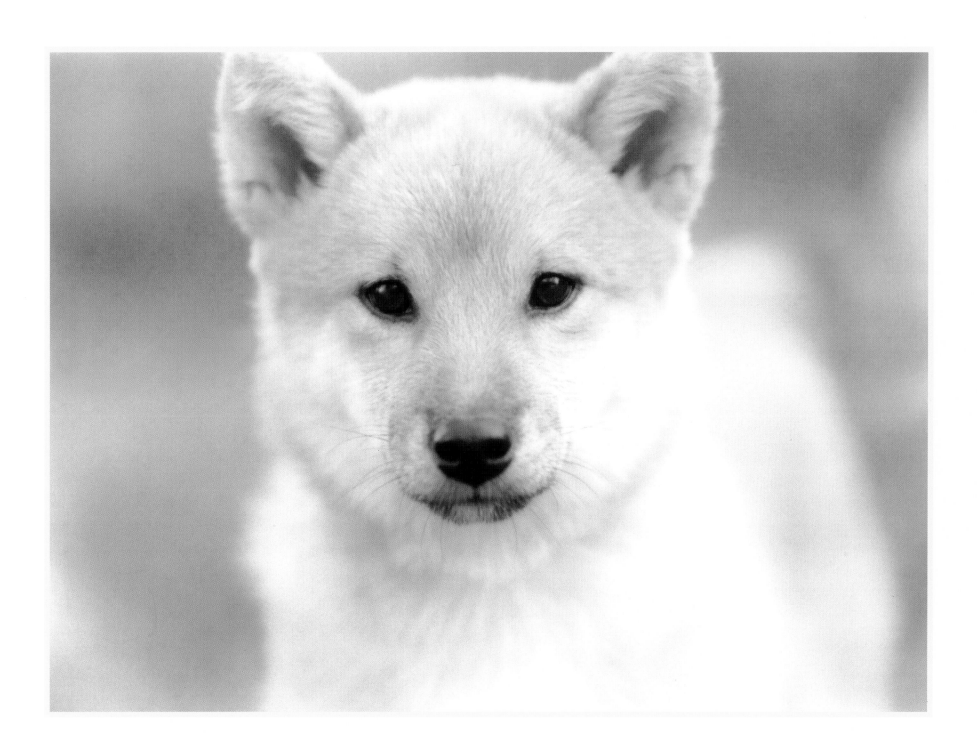

TIBETAN TERRIER

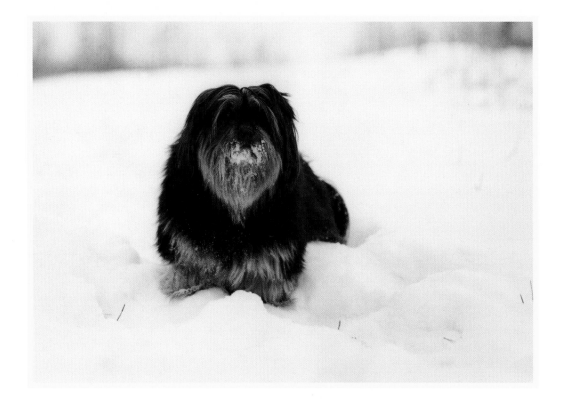

TIBETAN MONKS NEVER SOLD THESE SPECIAL DOGS, but instead bestowed them upon those who had imparted a great service. Rare visitors who braved the perilous journey to the Lost Valley were often given a Tibetan Terrier to guard them on their return to the outside world. The fortunate owners cherished these companions who served as caravan dogs, watchdogs, guardians of the flock, infrequent retrievers, and good luck charms. Known as the Holy Dogs of Tibet or Luck Bringers, they are intelligent, loyal, and affectionate companions. □ The Tibetan climate—snowy winters on the high planes, summer heat in the desert, and the heavy precipitation of the high Himalayas—shaped the Tibetan Terrier. Not actually a terrier, the Tibetan Terrier was named for its size;

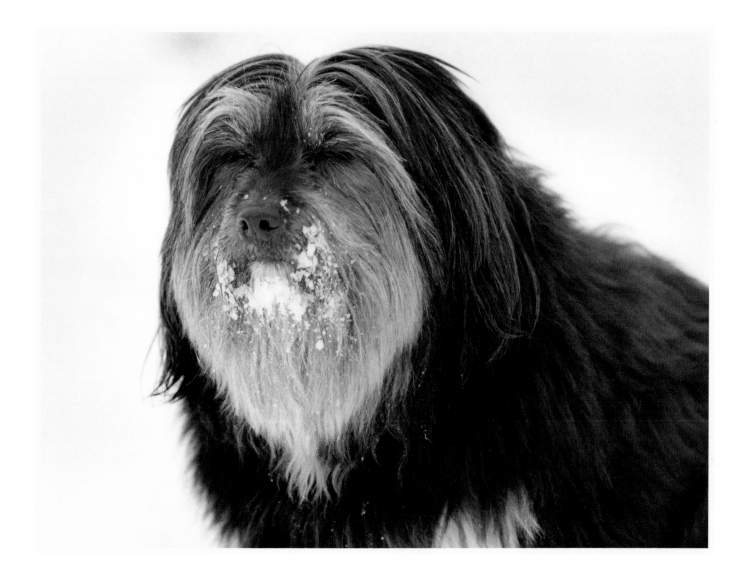

it does not possess the terrier's disposition, structure, or manner of movement. But many of its traits allowed it to flourish in a climate where other breeds could not. □ Its double coat ensures warmth in the winter; long eyelashes allow it to see through the flowing facial hair that protects it from stinging blizzard snows. Its large, round feet developed like snowshoes and provide the proper traction when traversing rocky terrain or the snow's crust. Unruffled by the humid summer heat, the Tibetan Terrier naps or maintains a meditative pose during the unbearable parts of the day. □ The Tibetan Terrier's moderation in all things and exaggeration in none enlightens as to how this naturally evolved breed successfully survived the transition from remote ancient Tibet to the modern world.

BOSTON TERRIER

BOSTON TERRIERS HAVE BEEN CALLED MANY THINGS—Bullet Heads, Round Heads, American Terriers, and Boston Bulldogs—but the description that rings most true is the "American Gentleman."

This intelligent, sprightly dog isn't precisely a terrier, although its lineage includes a number of terriers. According to the *Boston Globe*, the terrier "was born and bred in the workingmen's taverns and stables that lined Charles Street . . . in the 1860s and '70s." Robert C. Hooper of Boston is credited with breeding the father of all Bostons, a Bulldog/English terrier cross named Hooper's Judge. Hooper was hoping to recreate the dogs he grew up with as a youth in England.

By the late 1880s, the breed had become so popular that enthusiasts formed the American Bull Terrier Club, but some people took umbrage at the association with Bull Terriers and the breed was later renamed for its Boston birthplace.

The Boston's dapper looks, gentle, good-humored temperament, and American origins made it one of the most popular companion animals in the United States during the first half of the twentieth century.

An active, game, trappy little fellow, fit for my lady's carriage or as a friend of the working man.
—A. CROXTON SMITH, *THE POWER OF THE DOG* (1911)

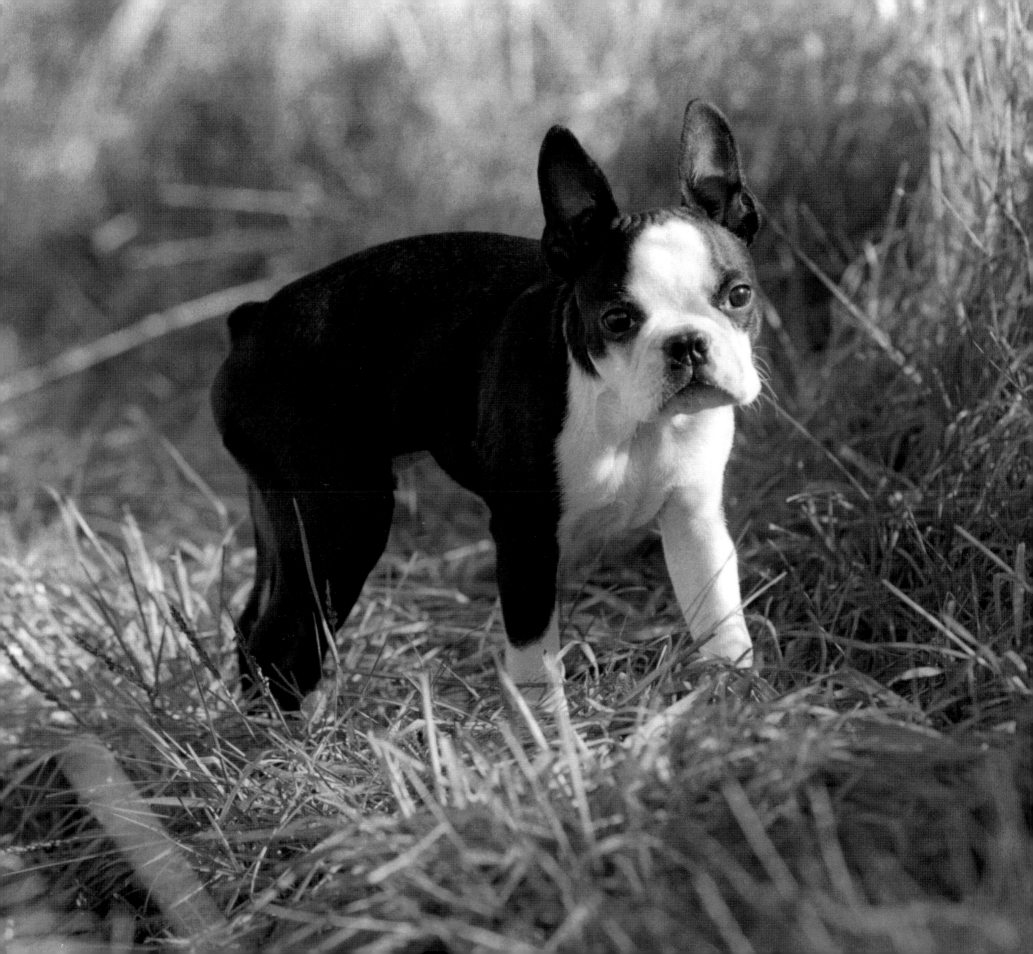

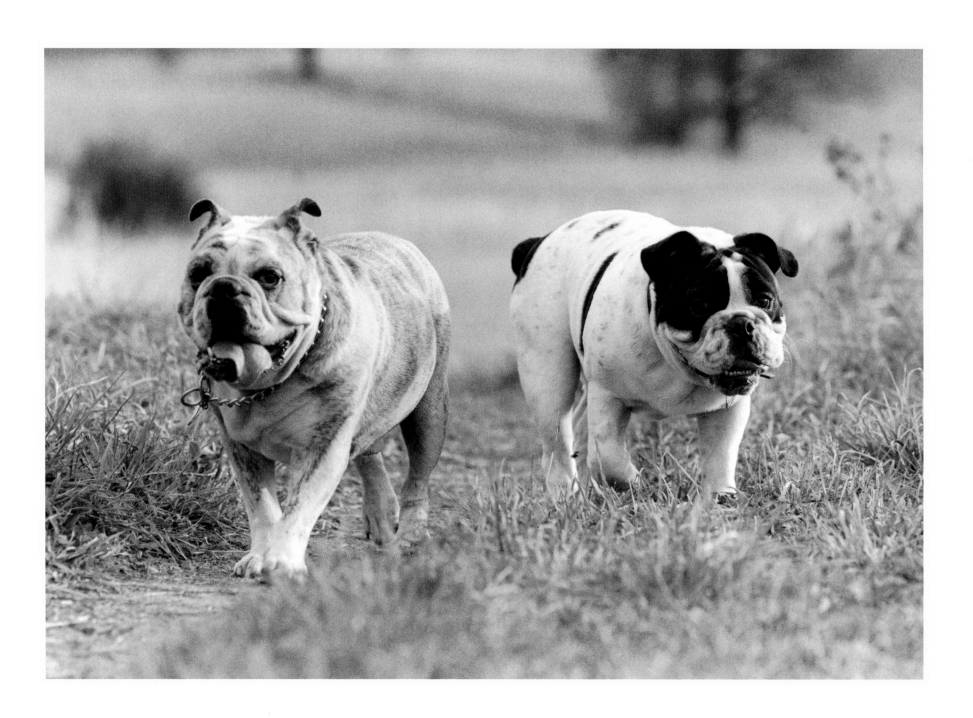

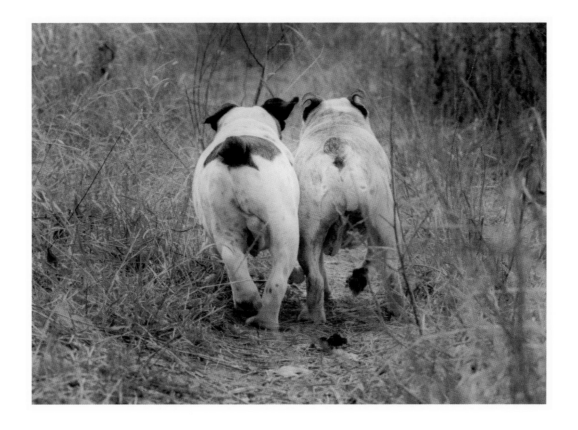

THE POWERFUL BULLDOG WAS BRED FOR A GRUESOME PURPOSE: to bait, throw, and pin a bull. Although this violent custom offends us today, the blood sport evolved because early British Bulldog owners and butchers thought the process served to "tenderize" the animal's meat. □ Every bit of the Bulldog's exaggerated body was engineered to accomplish its work; the mighty undershot jaw and short-faced nose allowed it to grasp onto the bull while continuing to breathe, and the wrinkles on its head functioned as gutters to divert the bull's blood. □ Its triangular build, with a wide-set front and narrow hindquarters, offered an efficient mix of solid grounding, maneuverability, and agility. Once it had latched on to a bull, the Bulldog's broad chest kept it from being easily upended while its narrow rear legs could reposition easily without relinquishing its grip.

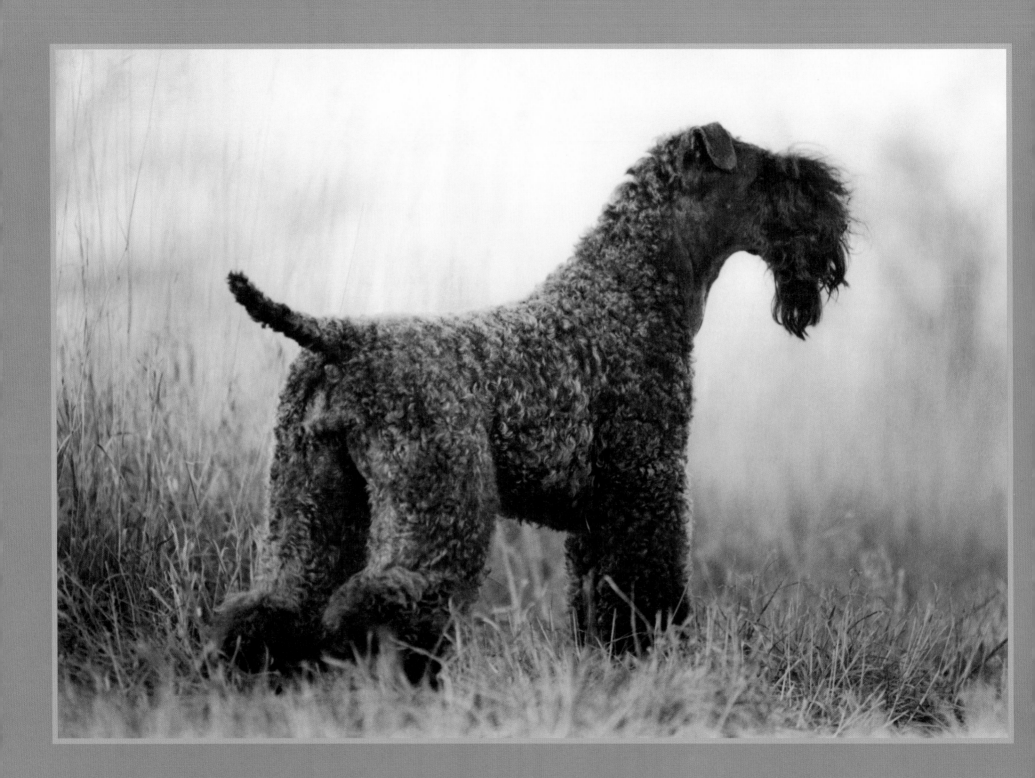

TERRIERS

terra – of the earth

KERRY BLUE TERRIER

LIKE ITS PURPORTED ANCESTOR the Soft Coated Wheaten Terrier, the origins of the Kerry Blue Terrier are shrouded in myth and speculation. It may have come over on a doomed Spanish Armada expedition in the late sixteenth century.

Many Kerry admirers believe contributed to its silky single ability. The Kerry was said to be an otter, single-handed, in says Irish farmers crossed the with the Irish Wolfhound for gray color. Kerry Blue Terriers companions and were used for livestock, and hunting—their them from badgers and other Like the Wheaten, the Blue's

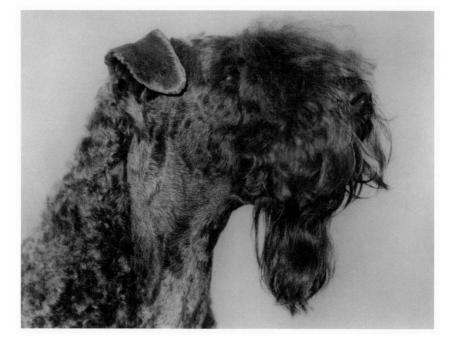

that the Portuguese Water Dog coat and exceptional swimming the only dog that "will tackle deep water." ☐ Breed lore Black and Tan English Terrier the Kerry's hunting nose and lived in the farmers' homes as guarding property, herding abundant eyebrow protected earth-burrowing predators. ☐ dense, wavy, soft coat sets it

apart from other large terriers. Its striking color—there are references to the "dark survivors" and "blackish blue" terriers indigenous to County Kerry as far back as the eighteen hundreds—makes this Irish Blue Terrier a source of national pride.

His temperament is well nigh faultless, if a slight tendency to diminish the cat population be excepted.
He is . . . unrivalled as a ratter, charming as a companion, trustworthy as a watchdog.
—FANCIER E. M. WEBB (1922)

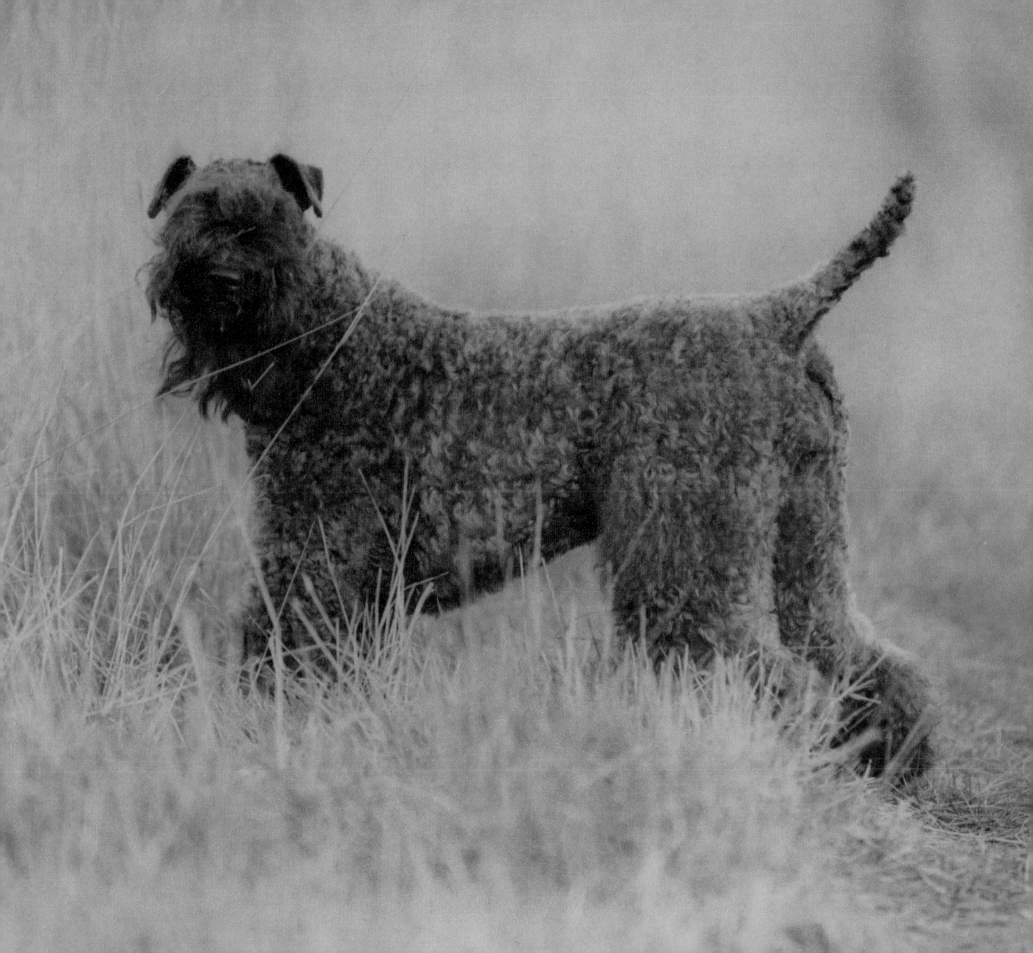

BORDER TERRIER

QUICK ENOUGH TO FOLLOW A HORSE and small enough to follow a fox to ground, this hardworking, determined dog was bred and shaped in the Cheviot Hills, the craggy, highland border region between England and Scotland, to help farmers and shepherds control fox and vermin. ☐ Distinguished from other terriers by its otter-shaped head, which, combined with its slim body, enables it to slip comfortably into tight crawl spaces, the Border has a longer and suppler back than other terriers. Its short, thick undercoat and intensely wiry outercoat protect it from the harsh conditions of its native land. Coat colors vary from red, grizzle and tan, blue and tan, or wheaten, and most feature a dark muzzle. ☐ Amiable, affectionate, obedient, and easily trained, the Border Terrier gets along well with other animals and is good with children. In the field the Border is considered as "game as they come"—tough as nails and just as fearless when going to ground.

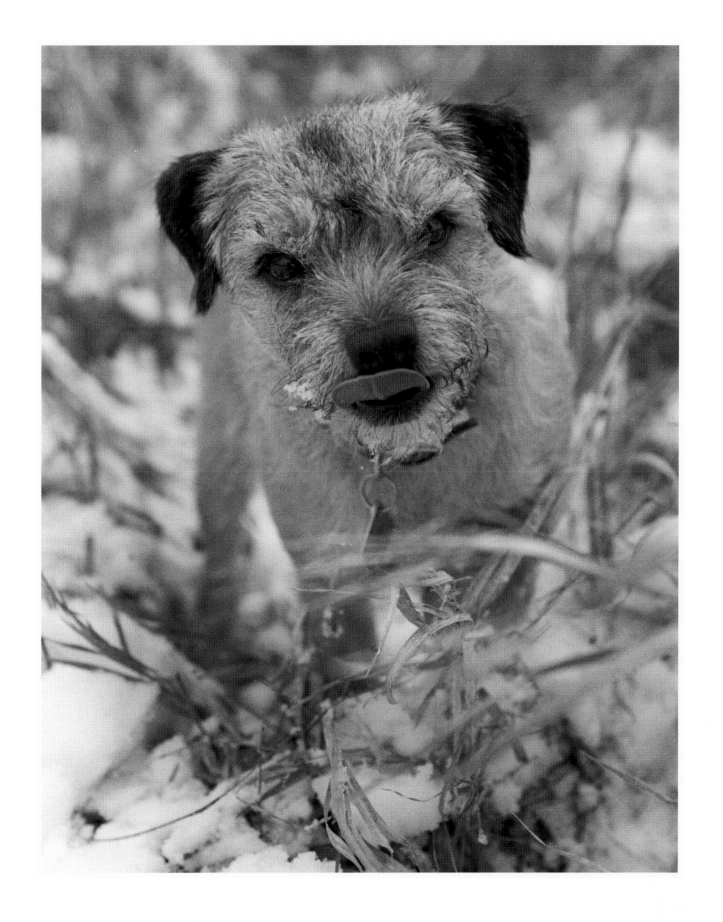

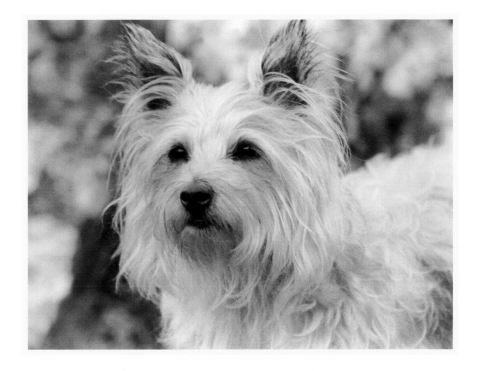

PILES OF STONES, OR CAIRNS, found on the ancient Isle of Skye and in the western Scottish Highlands were used to identify memorials or property boundaries. They also provided hiding places for small mammals. A working breed, the Cairn Terrier earned its keep ferreting out foxes, otters, and weasels that had taken up residence in the cairns. □ A regular feature on Highland landscapes by the late seventeen hundreds, these small terriers, originally known as Short-Haired Skyes or Little Skye Terriers, are thought to be the result of crosses with the now-extinct White Terrier and the now-extinct Black and Tan Terrier. The Cairn shares lineage with the Scottish and West Highland White terriers. □ Sturdily built, Cairn Terriers have short legs and large feet with thick pads suited for clambering over the rocky and rugged Highland terrain. A double coat with a coarse outer layer offers protection from the elements, and big teeth and strong jaws make them able hunters.

BULL TERRIER

KNOWN FOR ITS UNIQUE EGG-SHAPED HEAD, the Bull Terrier is the product of a successful experiment to create the ultimate fighting dog. The dog's origins can be traced to 1835, when England outlawed bullbaiting and sportsmen turned to dog fighting. ☐ As its name suggests, the Bull Terrier is the product of crossbreeding bulldogs with terriers, and around 1860 dedicated breeder James Hinks produced an all-white dog that would later earn the nickname "the White Cavalier." ☐ *The Complete Dog Book* describes the Bull Terrier as "a dog for sportsmen in times when life in general was more strenuous and of rougher, courser fiber—when dog fights were allowed and well attended. As fight dog or 'gladiator' of the canine world, such a dog had to be of great strength, agility, and courage The dog was taught to defend himself and his master courageously, yet he was not to seek or provoke a fight—and so the white variety became known as 'the white cavalier,' a title which he bears with distinction to this day." ☐ Additional crossbreeding eventually resulted in a inherited health problems. Deafness the white coat, so a brindled coat was either white or colored, standard or challenge of the ban on ear cropping, a dog with today's upright ears. The was introduced to the world in 1917. completely lacking a stop—a stunning

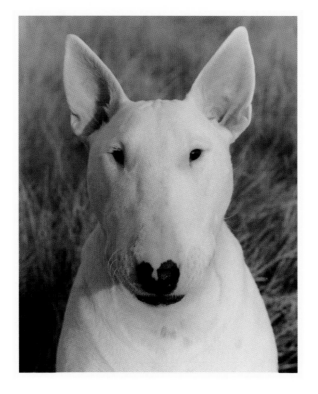

dog with a longer face. Bull Terriers also and albinism are often associated with later introduced. Today's "Bully" can be miniature. ☐ Breeders next tackled the and it took several years to accomplish first modern Bull Terrier, Lord Gladiator, It was the first dog with a skull profile example of selective breeding.

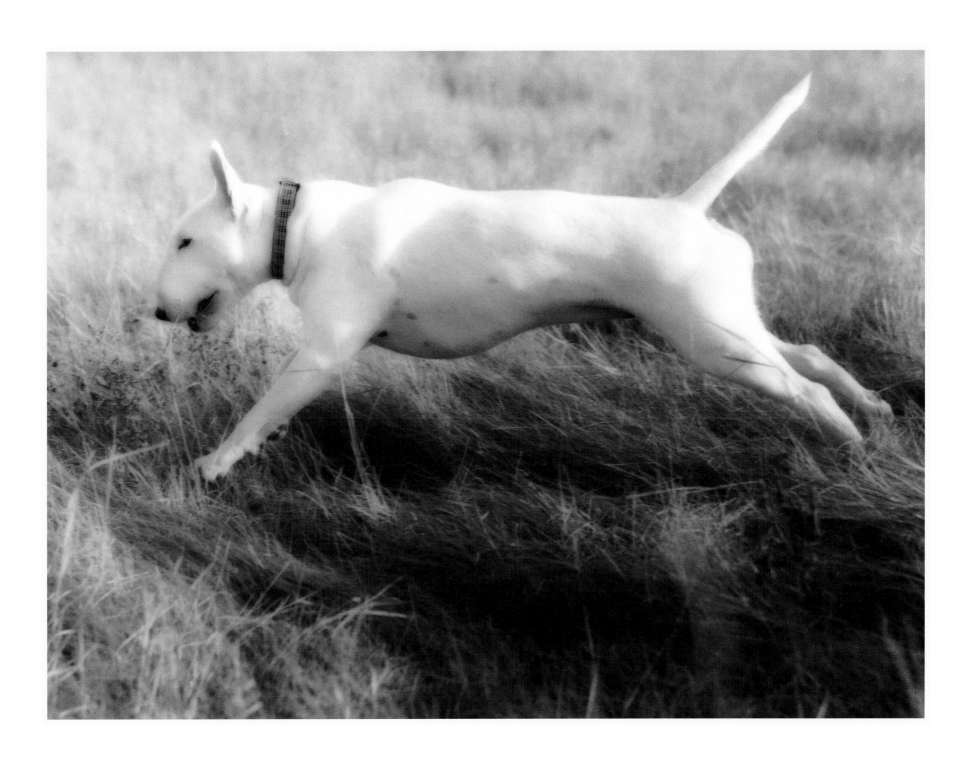

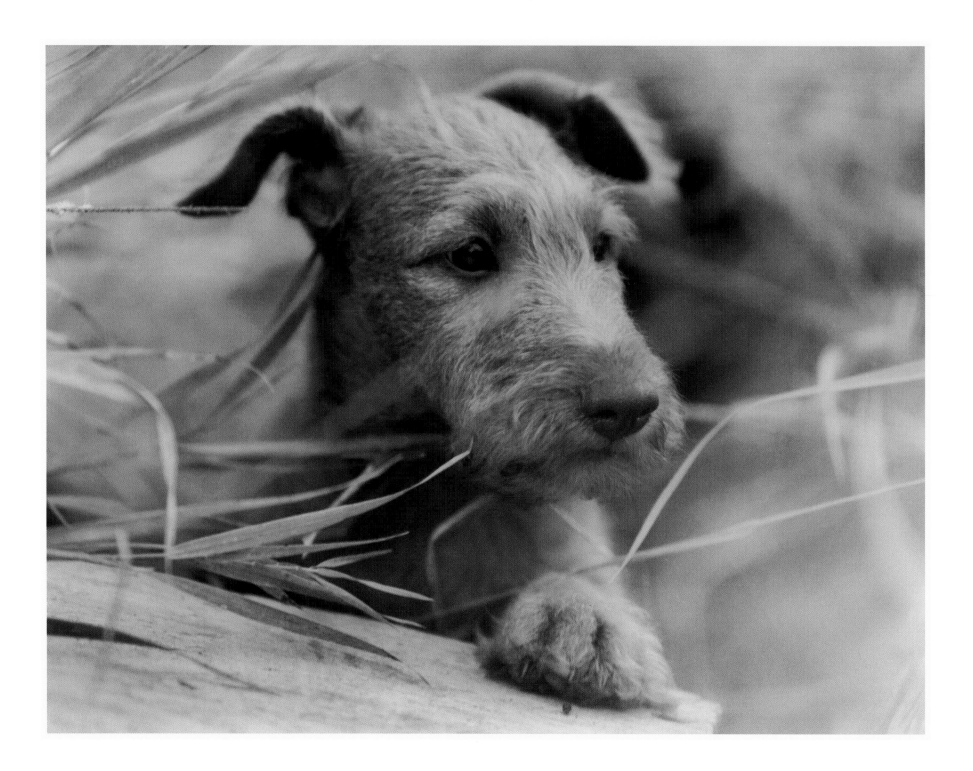

THE IRISH TERRIER IS A COMBINATION OF FEISTY HUNTER AND AFFECTIONATE COMPANION. These handsome auburn dogs served on Irish farms in the eighteen and nineteen hundreds performing typical terrier functions such as hunting badger, rabbit, and vermin; protecting property; and herding cattle. This adventurous breed has a rough double coat, a perspicacious mind, and the distinction of being the only all-red terrier. □ Like other terriers, the Irish was not a dog of nobility but rather a proud comrade of the common man. Independent-minded to a fault, it may recklessly bolt after small game; most have a proclivity for water, and can be trained to retrieve both on land and in water. A quick learner, it tends to use its knowledge selectively, preferring to chase after prey and dig where it pleases. □ The Irish came into its own as a separate breed by the late nineteenth century, likely having been crossed with other leggy terriers, such as the Kerry Blue, the Wheaten, the now-extinct Black and Tan, and possibly even the Irish Wolfhound. Strong and lithe, the Irish is endowed with longer legs and a longer body than other terrier breeds, traits that provide it with endurance, speed, and power. □ The Irish also exhibits a slightly different temperament than its cousins; its innate curiosity and joie de vivre earned it the nickname "Daredevil."

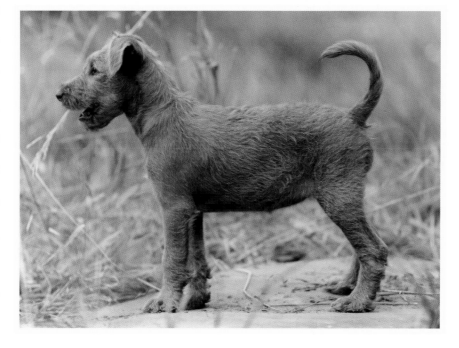

A growing lad could wish no finer friend to grow up with; mischief overlooked by the one will certainly be exploited by the other!

—THE INTERNATIONAL ENCYCLOPEDIA OF DOGS (1971)

SOFT COATED WHEATEN TERRIER

EIGHTEENTH-CENTURY IRISH PENAL CODE prohibited tenant farmers from owning a dog worth more than five pounds, making the Wheaten the bargain of the canine world. Used to hunt small vermin, otters, and badgers, the Soft Coated Wheaten was commonplace in southwest Ireland. □ This "poor man's wolfhound" is unique among its terrier brethren. Its coat is a pale yellow, the hue of milled wheat flour. Although bred to be a tenacious working dog suited to the damp climes of the Emerald Isle, it has a silky, wavy, single-layered coat. □ Like many terrier breeds, there is much speculation surrounding the Wheaten's origins. Some people link the Wheaten back to the red Irish Terrier; others believe that the breed is at least as old as its "daredevil" relative. What is certain is that the Wheaten, Irish, and Kerry Blue terriers share an analogous long-limbed, boxy appearance. One theory suggests the Soft Coated Wheaten is an ancestor of the Kerry Blue, and that when Spanish Armada ships wrecked on the coast of Ireland in 1588, the blue dogs that swam ashore found terriers with a soft wheaten coat waiting to greet them.

THE REVEREND JACK RUSSELL WAS NOT ONLY A MAN OF THE CLOTH, but a celebrated mid-nineteenth-century British hunter. Nicknamed the Hunting Parson, he avidly pursued fox hunting until his death at age eighty-eight and directly contributed to the evolution of the Parson Russell Terrier. ☐ Many foxhunters of the time used smaller, shorter-legged terriers to bolt foxes that had gone to ground, bringing the terrier on horseback to the fox's lair. Reverend Jack sought to create a new terrier with longer legs

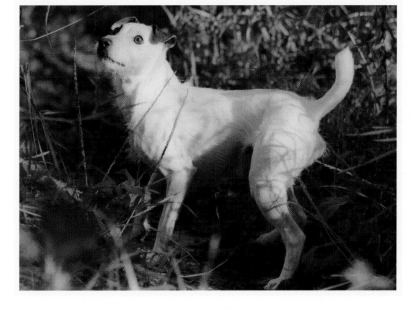

that could follow the hounds and immediately bolt the fox and keep the hunt going. ☐ A series of crosses began with Trump, a Fox Terrier-type bought on the spot from the milkman. Breeding with bull-and-terrier dogs produced the preferred white coat (to aid in differentiating the terrier from the fox), but also a more antagonistic nature. Since this sometimes resulted in a dog that spoiled the sport by silently killing the fox underground, the breed was crossed with the Beagle to soothe its aggression and add to its baying capability. ☐ With straight legs and a narrow chest, the subsequent breed is close to the same size as a fox, enabling it to follow the fox down its hole without difficulty. The docked tail measuring nearly four inches allows the hunter to yank the dog from the burrow if necessary. Its coat is dense, straight, and tight, giving it a smooth appearance from a distance. With its bold yet cautious temperament, intelligence, independence, and keen instinct, it's no surprise that the Parson Russell often finds the fox before the hounds.

FOX TERRIER

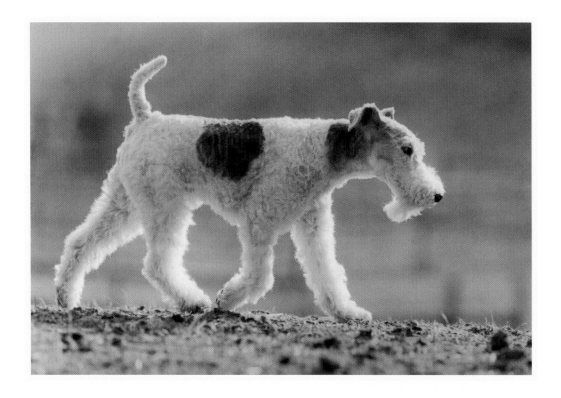

IN EARLY NINETEENTH-CENTURY ENGLAND, THIS QUICK-WITTED AND NIMBLE TERRIER was developed to hunt with a pack of Foxhounds. Mounted hunters carried the small dogs in a sack or box until the hounds had driven the quarry to hide. When the fox "went to ground," the Fox Terrier would bolt the animal and help to conclude the hunt. Hunters preferred the white-coated Fox Terrier to others, as it was easier to distinguish from its prey in dim light. Like the Foxhound, the Fox Terrier is well proportioned and designed to traverse great distances quickly. □ The Smooth and the Wire fox terriers are considered separate breeds, with the Smooth sporting a more V-shaped head. Both are elegant-looking dogs with black or brown markings on a predominantly white coat. Rarely used for hunting today, the Fox Terrier still retains its strong subterranean instincts and if left unattended, will happily spend time digging in search of potential prey.

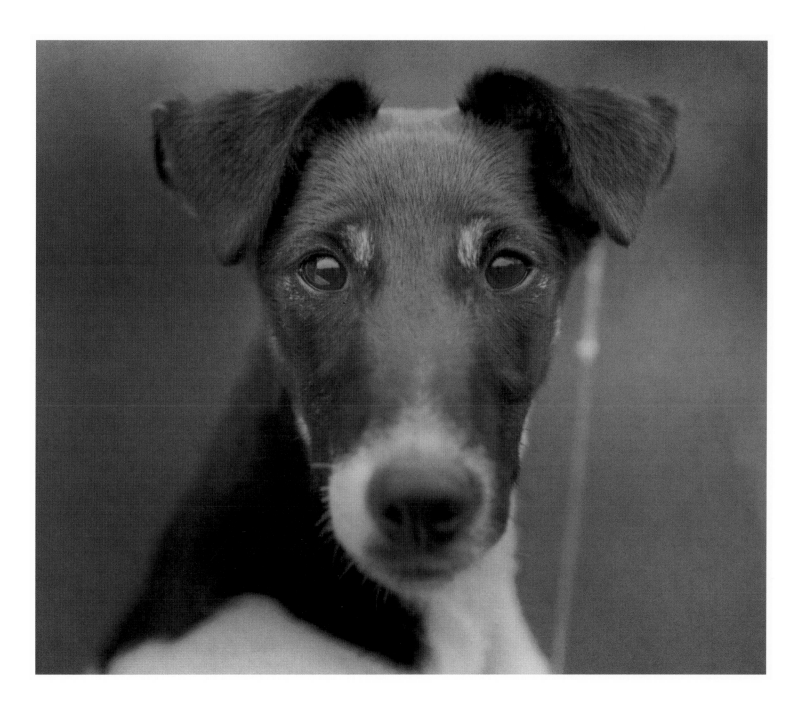

Foxes are not so often unearthed as they formerly were, yet many a day's sport would be lost without the terrier.

—WILLIAM YOUATT, *THE DOG* (1854)

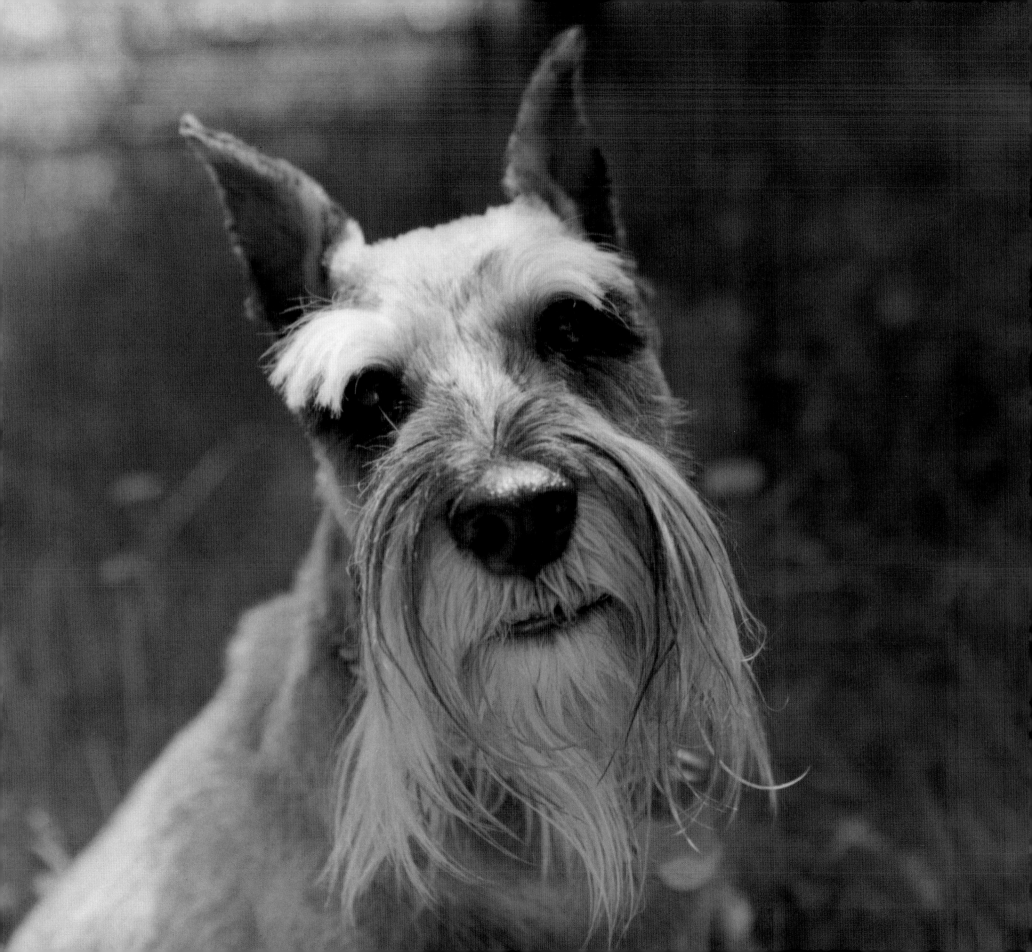

IT'S NOT HARD TO SEE WHERE THIS BREED GETS ITS NAME: *schnauze* is the German word for "muzzle," and the Miniature Schnauzer's long whiskers and leg furnishings lend it a distinctive and elegant appearance.

This miniature relation of the Standard Schnauzer first appeared around the beginning of the nineteenth century and is thought to be the product of crosses between small Standard Schnauzers and/or Miniature Pinschers with Affenpinschers and Poodles.

The Miniature Schnauzer is sturdy and squarely built; its coat is a wiry mix of silver and black and sometimes all-black. The salt-and-pepper color results from the light and dark banding of each hair, rather than the mixing of light and dark hairs.

While its standard-sized forebear excelled as an all-around farm dog, working as stock tender, ratter, and drover—even baby-sitting the family's children, earning it the name *Kinderwatcher*—its miniature cousin has more in common with the terriers, most of which were bred in the British Isles to go to ground after assorted vermin. The Miniature Schnauzer is alert, spirited, and intelligent, but its German bloodlines and happy temperament set this breed apart from others in the group. A loyal companion, the Miniature Schnauzer is now primarily a family dog, as at home in the city as it is ranging across country.

Getting Away from Language *TEMPLE GRANDIN*

THE WORLD OF THE DOG is a sensory-based world instead of a language-based world. Oliver Sacks wrote about a man who gained an enhanced sense of smell for a short period of time. The man discovered that there was a whole world of smell that he had never imagined before. Think about it! When a dog visits the local fire hydrant, he knows all the dog gossip in the neighborhood. Who was there? When were they there? What is their social rank? Are they are friend or foe? That is a lot of information and no words are required.

As a person with autism, I live and think in a visual world. When I think about something, pictures pop into my head. When I think about going to the doctor, I see the doctor's office. Dogs know that they are going to the veterinarian when the car makes certain turns. They have a sensory-based memory of sights and smells along the way that lead only to the vet's office. Animals should have a good first experience with new things, such as the veterinarian's office, so they will not fear it in the future. If the first experience with a new place, person, or thing is scary or painful, the animal may become really afraid of it.

People who love dogs and other animals must take care to prevent the formation of fear memories. Dogs will make visual, auditory, and touch associations with things that may seem odd to us. A dog may learn to fear the place where he was hit by a car, instead of the car itself, because that is what the dog was looking at when he was hit. On the positive side, certain sights and sounds may also have a good association. A dog can tell the difference between the sound of his owner's approaching car and another car of the same brand. Both animals and people with autism attend to sensory detail.

Animals that have been rescued from an abusive environment may have fear memories that are difficult to overcome. I knew a horse that was afraid of black cowboy hats. Someone had thrown alcohol in his eye during a veterinary procedure and the horse was looking at this black cowboy hat. From then on if anyone came near him with a black cowboy hat, he would rear. White cowboy hats and ball caps had no effect. The fear was very specific because it was based on visual memories instead of words. Another animal was afraid of the sound of a nylon jacket. In this case, getting rid of the offending jacket solved the animal's problem. Often, if one can figure out what the scary thing is and simply remove it from the animal's life, the animal will stop being afraid.

The neuroscientist Joseph LeDoux discovered that the brain does not allow a fear memory to be erased. To put it in computer terms, a fear memory "file" can be closed, but it can never be deleted. To condition an animal to get over its fear requires the brain to send a signal down to the emotion center, the brain's amygdala, to close the file. In animals with high-strung genetics, closing the fear file is often difficult.

How can we help an animal to get over a fear? Dr. Nancy Williams, a dog behaviorist, has found that pressure applied to the body can help a dog get over thunderstorm phobias. I can really relate to this because I built a squeeze machine to help me reduce anxiety. When puberty arrived, I had nonstop anxiety and panic attacks. The machine applied pressure along both sides of my body with foam-padded panels. Dr. Williams wraps a dog's body with either ace bandages or wide bandage wraps that are used for horses' legs. She finds that the horse bandages work best. Therapists working with autistic children have found that the most relaxing effects of pressure last for about twenty minutes. Deep pressure is applied with a weighted vest for twenty minutes and then taken off for about thirty minutes. Pressure on a dog's body will work best if it is done for about twenty-minute intervals and then removed for at least twenty minutes. Another little tip for petting dogs is to stroke them instead

Shut your eyes and try to think like a dog with no words.

of patting. Firm stroking, like the mother dog's licking, works best. Patting may be interpreted as hitting.

The dog's world is a sensory world, and to understand the dog you need to start thinking in sensory details and then place the different details into categories. Pictures, smells, and sounds can be put into categories of positive things and negative things, food items or non-food items. Making categories is the beginning of visual thinking.

You need to shut your eyes and try to leave the world of language and enter the world of sensation. To help you do this, I will further describe visual thinking. My mind works like Google for images. If somebody says a word such as "teacup," the first image that pops into my head is a teacup at a hotel. I then see the cups on a ride at Disneyland and then I see a tiny "teacup" poodle. My brain's internal Internet search engine then starts bringing up all the poodle pictures. I see a poodle at our next-door neighbor's and a poodle my mother had. Now, one may ask, how did I get from a hotel teacup to Disneyland cups to poodles? There is an associative logic that is not linear. People ride inside the teacups, and the next picture that flashes into my imagination is a tiny "teacup" poodle that somebody had photographed while it was sitting inside a large teacup. The visual association between the two pictures is a living being sitting inside a teacup.

How can this explanation of my visual thinking help you to understand your dog? You need to understand how the brain forms categories with visual and sensory-based information. This will help you figure out how your dog's brain organizes information. Pictures are placed in categories and these categories are based on visual features. I know a dog that became terrified of hot air balloons because a balloon revved up its burner over her house. The fear then spread to red plastic balls on power lines and then to the rear end

of a tanker truck going over the top of a hill. These were all round objects. However, other round objects, such as traffic lights and round globe lamps at the shopping center, were ignored. I had to think in pictures to determine how this dog had categorized her fears. In my mind I visualized both the feared and the non-feared round objects. The feared objects were all round objects against the sky. The non-feared objects were all round objects against a dark background. Traffic lights in my town are surrounded by a black rectangular piece of metal, and the globe lights at the shopping center were mounted on a brick wall. The fear memory had spread to other round things, but in a very specific way.

I will now give you another example. A horse had become afraid of blue lead ropes because he had fallen over backwards and a blue lead rope had fallen over him. The fear then spread to a tool with a long blue handle. The "bad" category in the horse's brain was long, slender blue things. Horses and dogs have partial color vision and they see blue and yellow very clearly. Red may appear gray.

As I said before, get away from language and think in pictures. Animals form categories in their brains of things that they are afraid of. When an animal has a scary or painful experience, the fear memory usually forms as either a visual, a sound, or a touch sensation "file." Other objects that have a visual, auditory, or tactile similarity may also be put into the fear memory file. In the nylon jacket example, the animal was abused by someone wearing a nylon ski jacket. The animal formed a fear memory based on the sound of the nylon rubbing together. Other thing things that sounded similar may also be feared. You need to close your eyes and think in pictures and sounds to figure out how the dog has categorized things it fears.

Shut your eyes and try to think like a dog with no words.

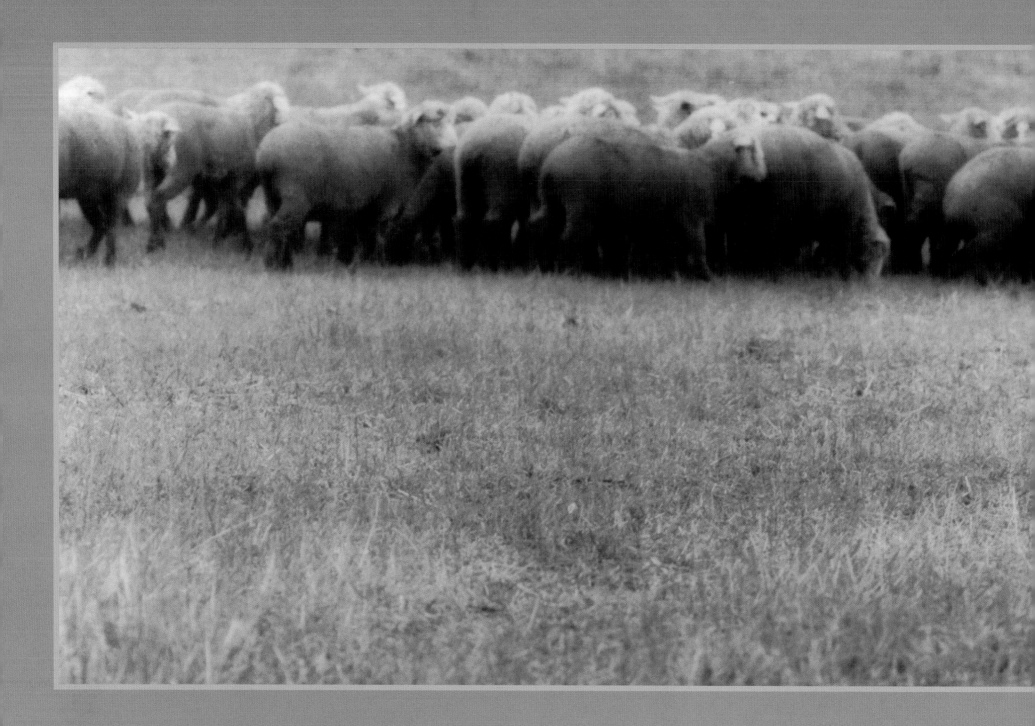

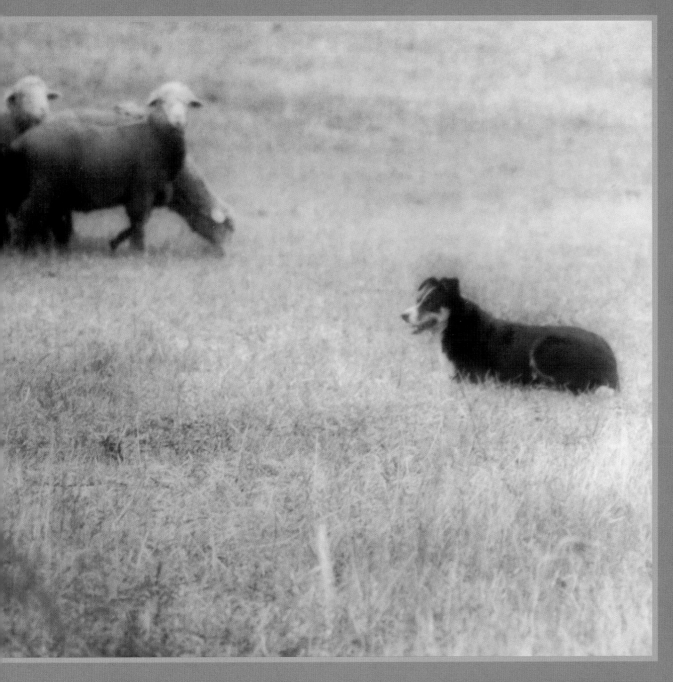

HERDING

for the wayward flock

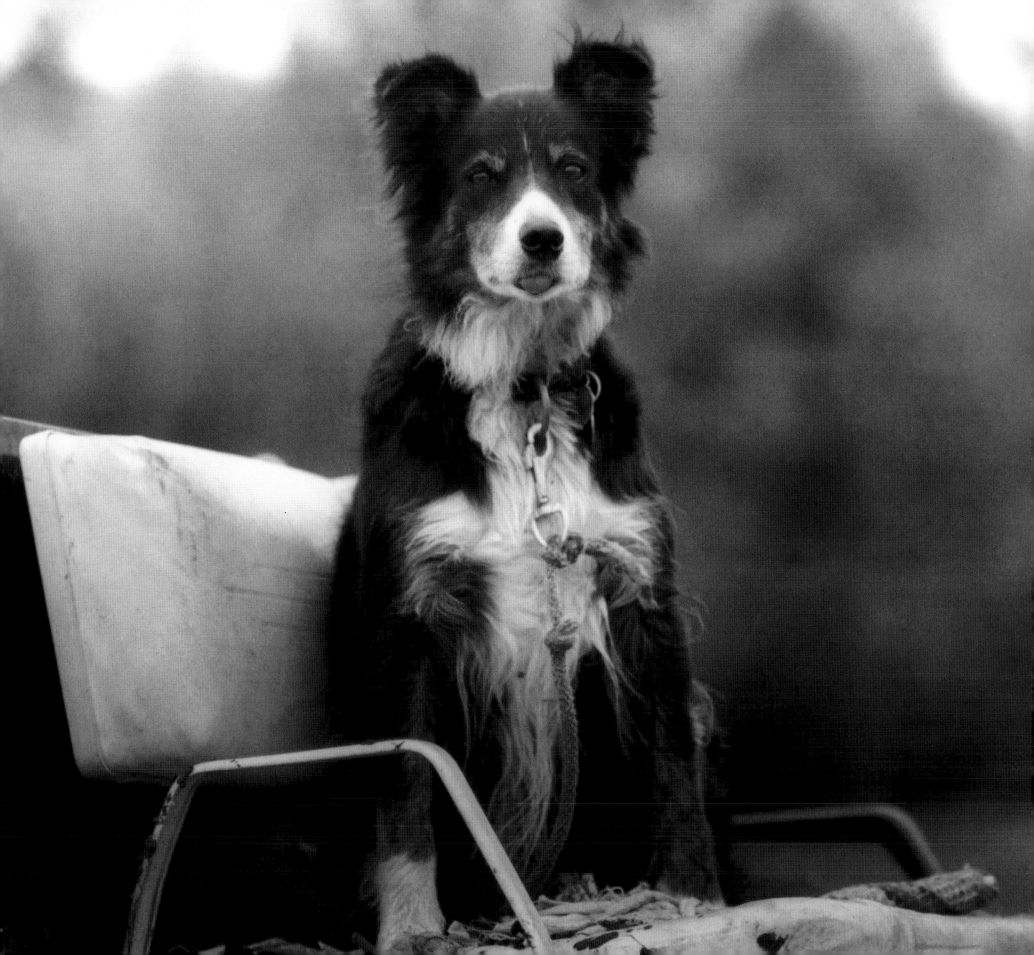

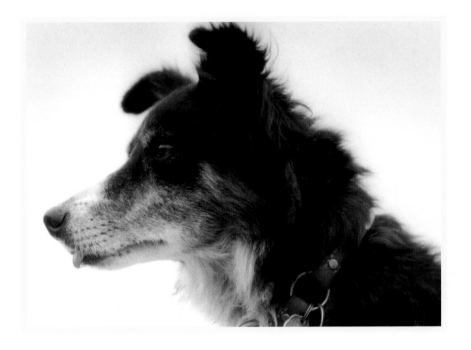

THE HISTORY OF THE BORDER COLLIE IS INTERWOVEN with the history of the early wool trade and livestock farming in the United Kingdom. Originating in the border country between Scotland and England, these dogs were bred and selected for working ability, endurance, and trainability. ☐ Working long days in harsh climates and on rugged terrain, the Border Collie often covered fifty or more miles each day. Its relative size and speed dictated which type of livestock—sheep, goats, or cattle—a dog would tend. This "stealth worker" gathered and fetched the livestock with sweeping runs outside the herd, controlling the beasts with an intense eye and stalking-style movement. Its white markings on the neck, chest, legs, and tail made it visible at night. ☐ With its remarkable instinct and sharp ability to reason, the Border Collie is capable of working independently out of its master's sight.

GERMAN SHEPHERD DOG

AFTER WITNESSING A HERDING DOG NEARLY BESTED BY A PETULANT FLOCK, a German cavalry officer was inspired to create an all-purpose, uniform working dog, and he devoted the rest of his life to the pursuit of the definitive breed. At a dog show in 1899, Captain Max Emil Frederick von Stephanitz bought a male that exhibited the ideal characteristics: completely alert, substantive and muscular, acutely intelligent, trustworthy, protective, and fearless, yet not hostile. □ Soon thereafter, von Stephanitz founded the Verein fur Deutsche Schaferhunde (Association for German Shepherds). The club developed a breed test and forbid the breeding of any dog that could not pass its strict requirements. This exclusivity led to the rapid evolution of the consummate working breed. Unlike other herding breeds, the German Shepherd did not use the eye but rather worked the furrow, or patrolled the field periphery, to keep the herd from leaving the property. Its instinct served to control a querulous flock and maintain the herd's safety. □ At the turn of the twentieth century, von Stephanitz, aware of increasing industrialization and the declining need for herding dogs, believed the German Shepherd's abilities would deteriorate if not adapted to other areas of service. When World War I began, von Stephanitz volunteered some of his dogs for military service. The German Shepherd quickly adapted, serving as sentry and messenger, and rescuing wounded soldiers. Employed again in World War II, the breed displayed heroic feats of bravery and loyalty. Many returning soldiers brought their steadfast German Shepherds with them, introducing the highly skilled and noble breed to the world at large.

Remarkable in his unswerving loyalty to his master, irrepressible in his high spirits,
never idle, always in motion, good-natured but not a flatterer, a constant pleasure to the eye.
—MAX EMIL FREDERICK VON STEPHANITZ (1899)

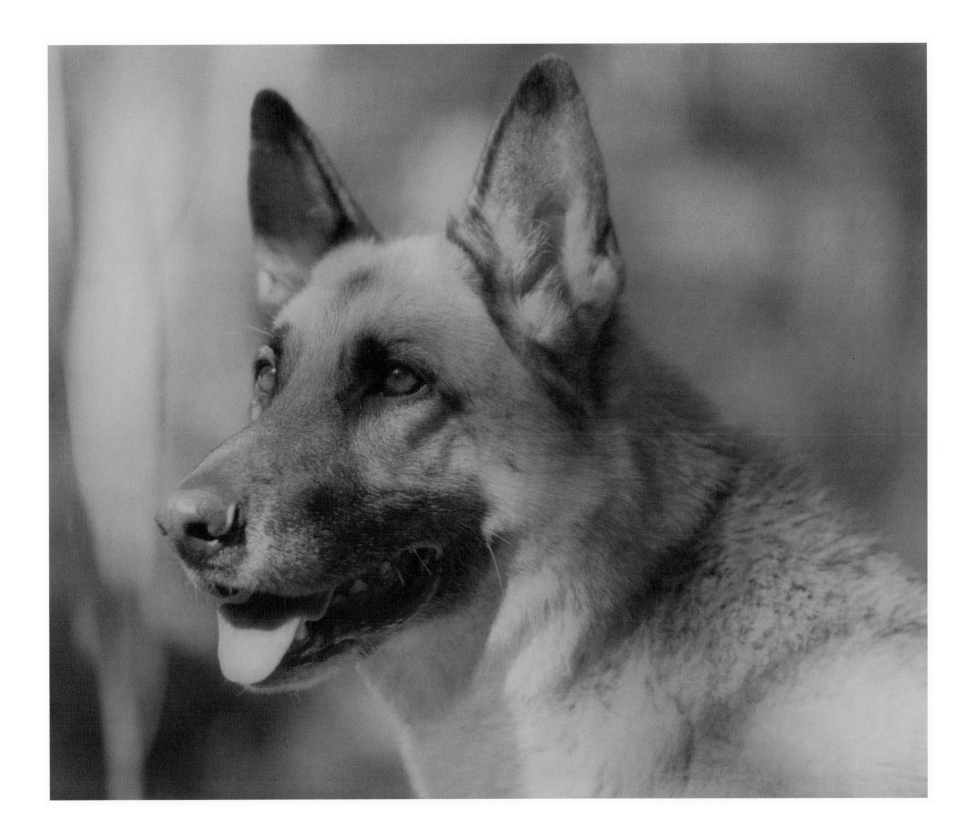

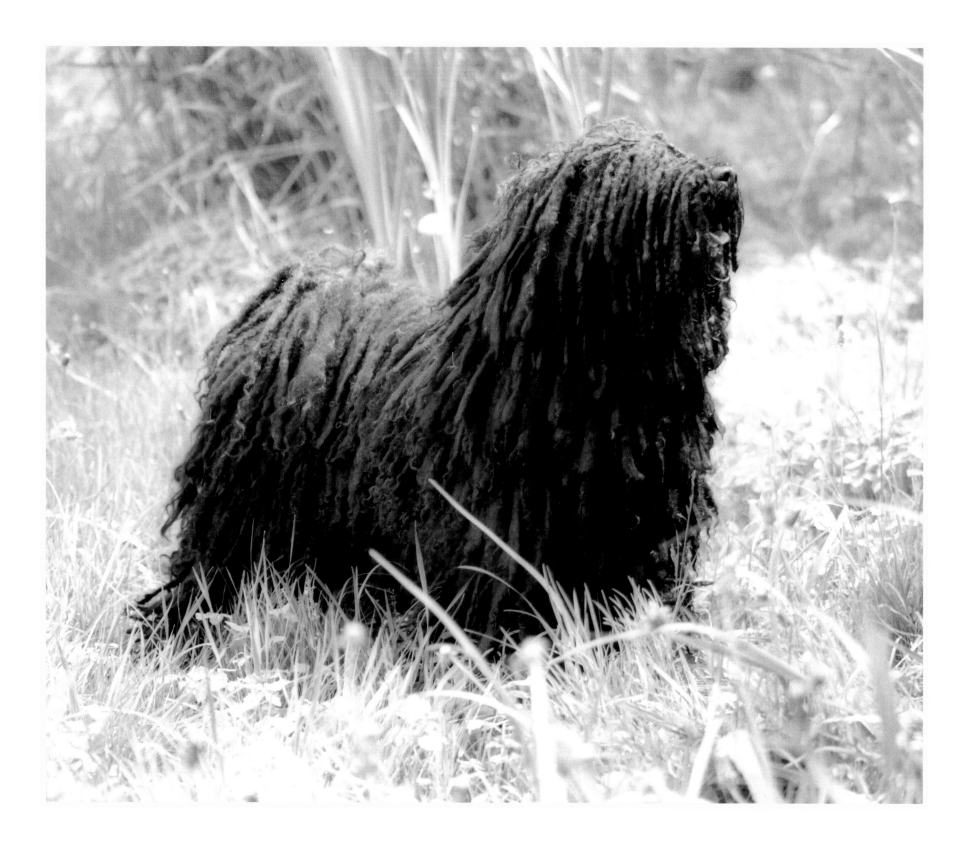

BROUGHT INTO HUNGARY BY THE MAGYARS, the Puli breed has been a part of the lives of Hungarian shepherds since the ninth century. Considered unmatched at working sheep, the value of a Puli (plural *Pulik*) was equal to a shepherd's yearly salary. Its worth contributed to its almost mystical relationship with nomadic shepherds, who were often quoted as saying, "It's not a dog, it's a Puli!"

given to anyone other than the shepherds were ruthless in breed's keen working qualities, physically and mentally sound, drover and a flock guardian, animals from the villages and vast plains, moving them for from other herding breeds, it speed, swiftly returning to the next command. It doesn't herd The Puli was not to be sold or shepherd or family member; their efforts to maintain the insisting it prove itself to be agile, and driven. □ Both a the Puli gathered up stock took them to graze on the miles along the roads. Different performs a task with incredible shepherd's side ready for the with the traditional eye; instead, it is trained to run along the backs of the sheep when they are massed together, energetically turning its body and accompanying its efforts with a high-pitched bark. □ The Puli's solid-color coat is made up of two layers: a dense, long overcoat resting on a soft, wooly undercoat. The layers tangle into long, matted cords that reach to the ground and protect it against the elements. Cords also drape over the eyes, resembling vertical window blinds that sway as it moves, but don't doubt the Puli's ability to see.

The Puli, through his hair, sees better than you. —OLD HUNGARIAN SAYING

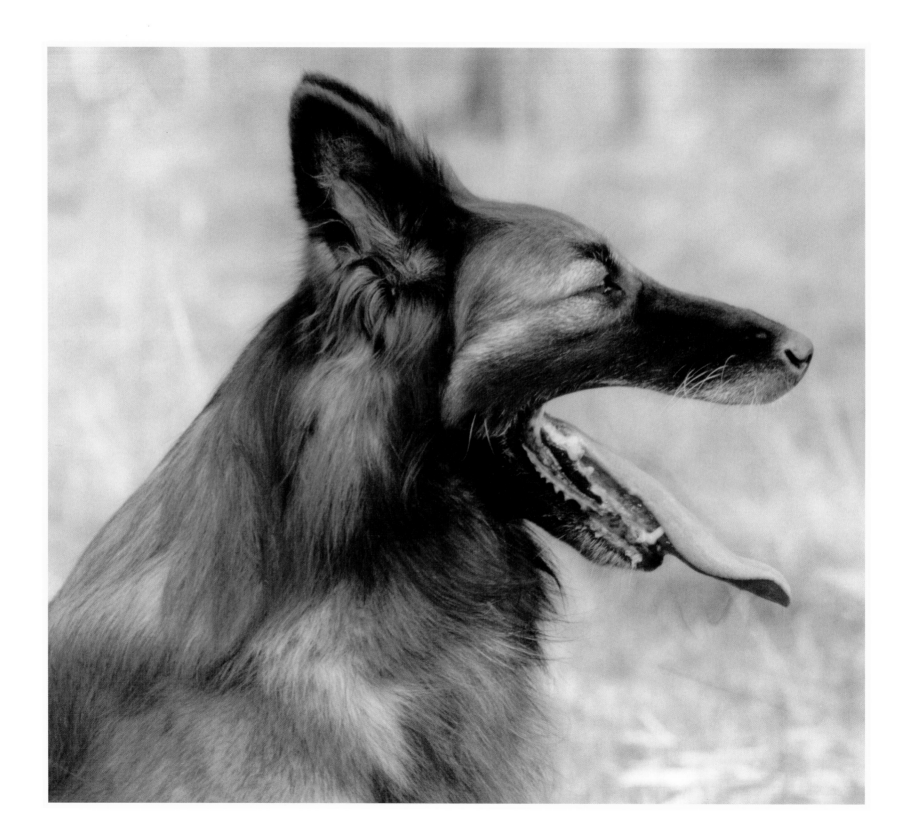

THE BELGIAN TERVUREN IS KNOWN IN ITS COUNTRY OF ORIGIN as the *Chien de Berger Belge*, or "Belgian Shepherd Dog." Shepherd dogs were common across Europe for centuries, but in 1891 the Club du Chien de Berger Belge (Belgian Shepherd Dog Club) was formed to determine if there was a true shepherd dog of Belgium. The Tervuren owes its name to the village of Tervuren, the home of M. F. Corbeel, an early devotee of the breed. It shares many characteristics with other Belgian herding dogs, such as the Belgian Malinois and the Belgian Sheepdog. All are medium sized, with erect triangular ears and brown eyes. The Tervuren is distinguished by the coloring of its thick double coat, which runs from rich fawn to russet mahogany with varying degrees of black overlay, including a black mask.

Belgian farmers employed the Tervuren as a general purpose herding and guard dog and its protective instincts and proficiency with sheep and cattle earned it the description of "moveable fence." The Tervuren can be seen in photographs dating back to the late nineteenth century. Graceful and elegant, the Tervuren offers great intelligence, sensitivity, and stamina and now is often found working as a companion, therapy, or search-and-rescue dog.

Splendor of evening clothes for the Tervuren, who, in addition to the beauty of his long coat, has magnificent warm color with shades of fire, or the delicacy of grey with its clever shadows.
—JACQUELINE AUBRY, *LE BERGER BELGE (THE BELGIAN SHEPHERD)*

BEARDED COLLIE

Should you, while wandering in the wild sheep land, happen on a moor or in market
upon a very perfect gentle knight, clothed in dark grey habit, splashed here and there with rays of moon;
free by right divine of the guild of gentlemen, strenuous as a prince, lithe as a rowan,
graceful as a girl, with high king carriage, motions and manners of a fairy queen, should he have a noble
breadth of brow, an air of still strength born of right confidence, all unassuming; last and most unfailing test
of all, should you look into two snow-clad eyes, calm, wistful, inscrutable, their soft depths clothed on
with eternal sadness—yearning, as is said, for the soul that is not theirs—
know then, that you look upon one of the line of the most illustrious sheep dogs of the North.

—ALFRED OLLIVANT, *OWD BOB* (1898)

THE BEARDED COLLIE, KNOWN AND REVERED IN SCOTLAND as the Highland Collie, the Mountain Collie, or the Hairy Mou'ed Collie since at least the early seventeen hundreds, was a devoted companion and steadfast worker most often used on the rocky terrain of the Scottish hillsides to herd sheep and cattle. Scottish drovers, shepherds, and cattle merchants valued the breed's intelligent, obedient nature and strong work ethic. □ As with most dogs not favored by the nobility, there are no extant records of this breed. It is known, however, that there have been herding dogs with shaggy coats and hirsute faces in Scotland and other parts of Europe for many centuries. Some sources trace the Bearded Collie's misty origins to 1514, when a Polish merchant trading sheep for grain introduced the Polish Lowland Sheepdog to Scottish farmers. The farmers were reported to be so impressed with the dog's abilities, they began to breed it with local dogs. While the "Beardie" has enjoyed intermittent favor as a show dog, this dependable breed has never lost touch with its hard-working roots.

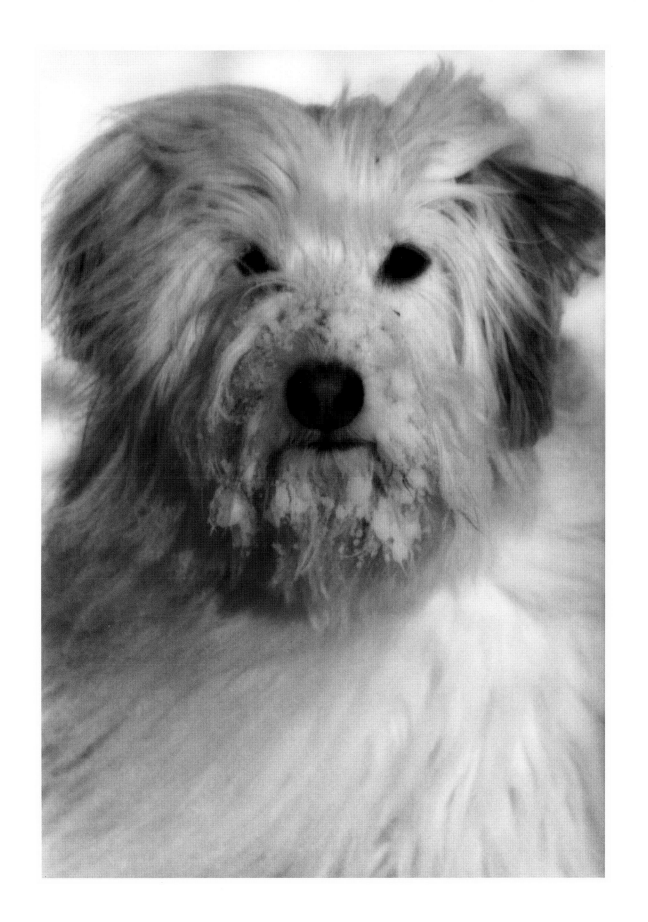

BOUVIER DES FLANDRES

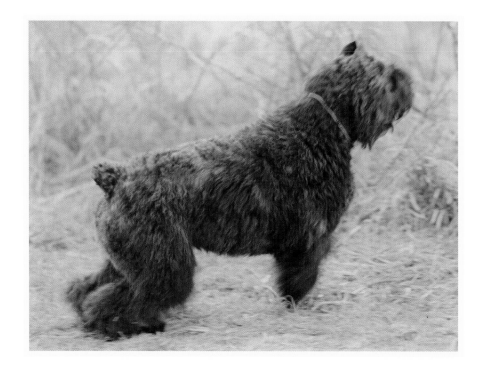

THE BOUVIER DES FLANDRES IS ALMOST LITERALLY A WORKHORSE OF A DOG. In eighteenth-century Flanders (a region of Belgium and northeastern France) horses were primarily owned by the upper classes, and farmers used dogs for a variety of chores, such as pulling carts and churning milk. □ All cattle dogs were called *bouviers* (cowherds), and each region stuck its own tag on the dog to identify its origin; hence, the Bouvier des Flandres. In fact, most early breeders of the dog were farmers or butchers, and the Bouvier didn't develop uniform characteristics until the nineteenth century, when veterinarians noticed discrepancies among dogs of the type and began documenting desired traits. □ In the twentieth century, the breed began its famous assignment as an international courier to the French Resistance in northern Europe. Its dark coloring, speed, and intelligence aided its undercover efforts, but the Nazis caught on to the ruse and began shooting Bouviers on sight. Few of these dogs survived World War II; many of those that did were recruited by police departments for their superior sensory abilities.

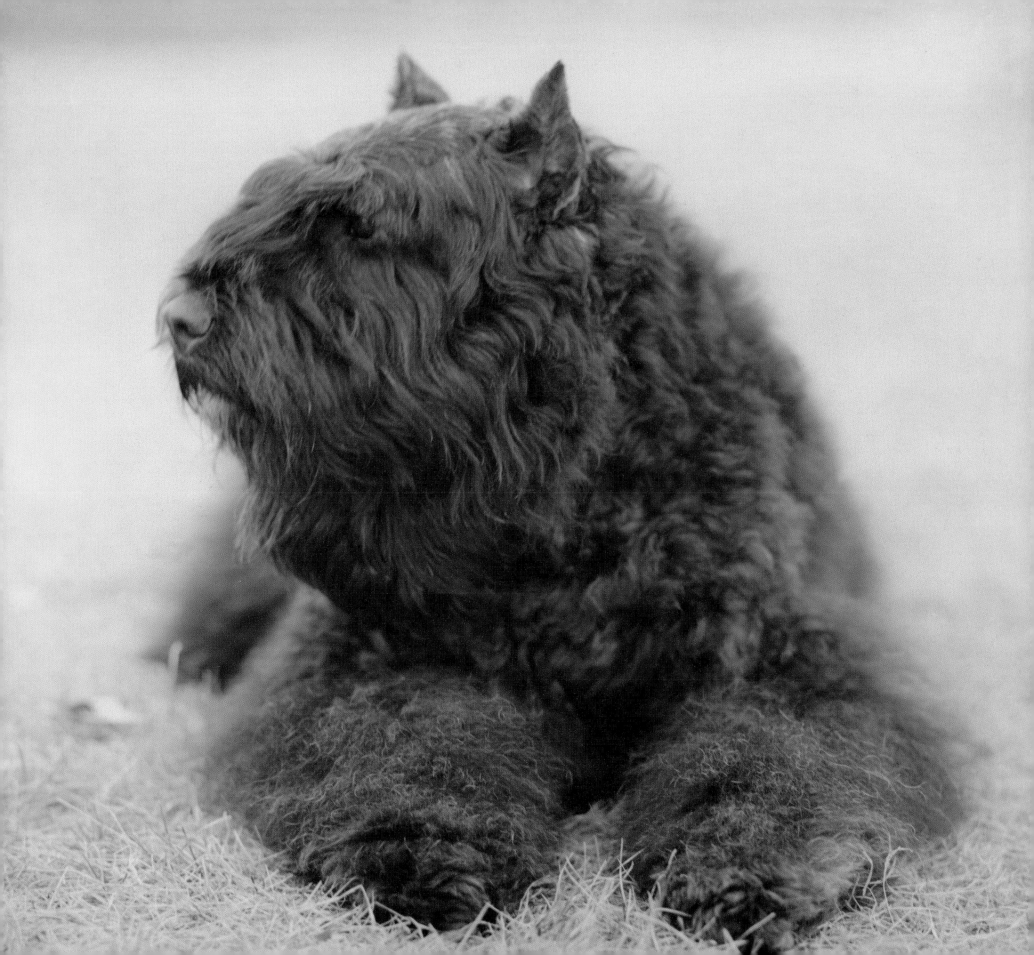

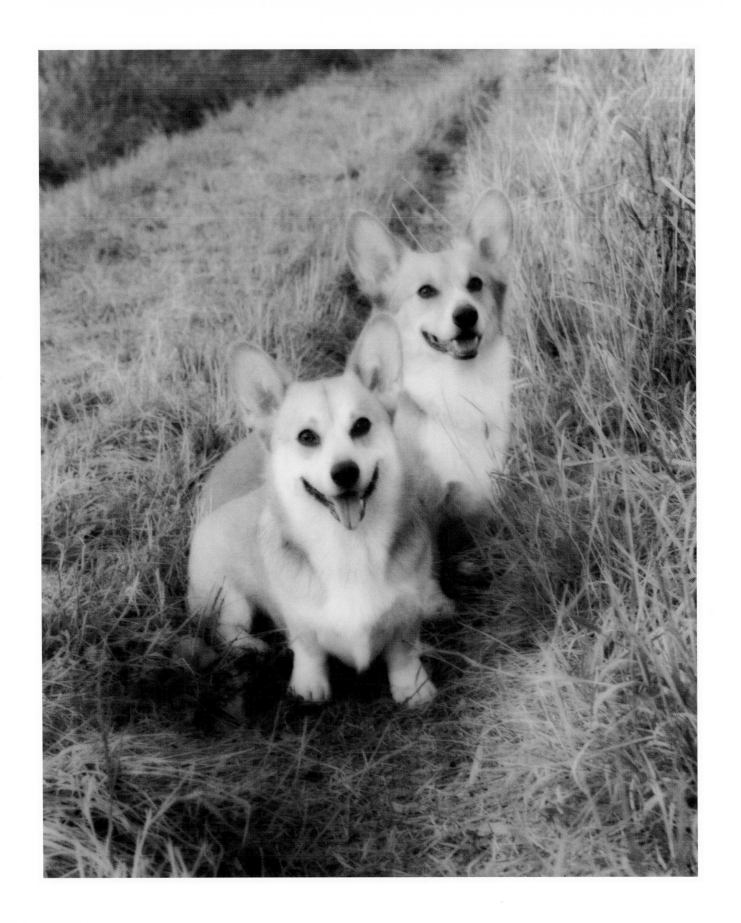

LEGEND HAS IT THAT THE PEMBROKE WELSH CORGI IS AN ENCHANTED DOG, and that the fairies and elves of Wales used him to pull fairy coaches, work fairy cattle, and serve as a steed for the fairy warriors. Even today, people with keen eyes and understanding hearts may see the marks of the "fairy saddle" in the coat over the shoulders. ☐ Originally an all-purpose worker, the Pembroke Welsh Corgi was once invaluable to farmers in Wales. These four-legged farmhands escorted cows to common grazing land by nipping their heels and barking. Their low stature allowed them to roll out of the way of flying hooves. Corgis still maintain this habit when chasing each other. Other tasks included rodent control and guarding livestock and humans. ☐ Both the Pembroke and Cardigan Welsh Corgi are ancient breeds, possibly dating back to the tenth century. In the 1850s, Corgis worked on almost every farm in Wales— the spitz-influenced Pembroke

with its naturally docked tail in the southern region, and the teckel-influenced long-tailed Cardigan in the north. ☐ By the early twentieth century, when farmers began raising sheep in fenced pastures, the Corgi's purpose was lost. Farmers needed long-legged dogs to herd their sheep, and Border Collies eventually replaced the Corgi as the all-around farm dog.

AUSTRALIAN SHEPHERD

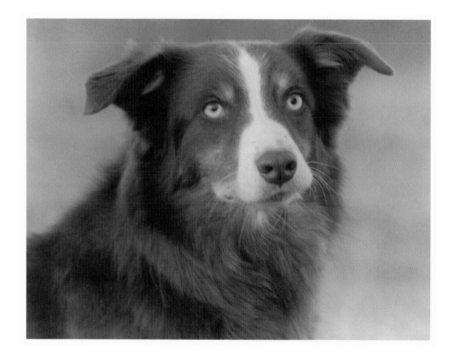

THE AUSTRALIAN SHEPHERD'S NAME IS MISLEADING. Basque shepherds from Europe first immigrated with these herding dogs to Australia to acquire the country's resilient sheep, and then brought those Australian flocks to the United States in the eighteen hundreds. When the Americans saw these hard-working dogs herding Australian sheep, they assumed the dogs were also Australian. □ Sharply intelligent, the Australian Shepherd possesses a keen, independent herding ability, using a loose-to-medium "eye" to control an entire herd with its gaze; a more intense eye is employed to command stubborn animals. □ Its striking appearance also won American admirers. Slightly longer than tall, and of medium size and bone, the Australian Shepherd sports a variety of coat coloring that allows for individuality within the breed. High-set triangular ears and a wide variation of eye color highlight its expression. □ A kind, loyal companion to the lone shepherd or rancher, the Australian Shepherd has an intense need to be near its owner and requires significant human interaction to maintain its emotional well-being.

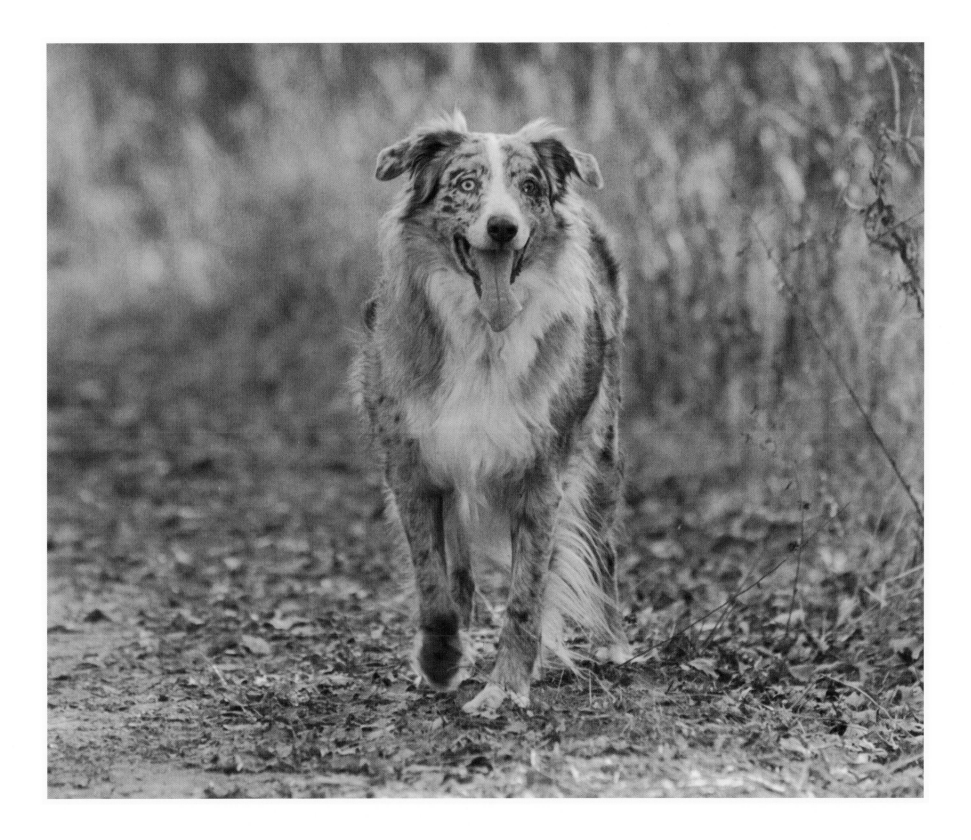

Ishkoniganiisimoog – The Rez Dogs *WINONA LADUKE*

THERE ARE MANY JOKES AND STORIES told today about our "rez dogs," the various versions of canine that have come to live on the reservations of Native America. Reservation (*ishkonjigan* in the Ojibwe language) comes from the same root word as "leftover," that is to say that we both reserved these lands with the foresight that future generations would need them, and also that these lands were likely the "leftovers" from the demands of American expansion. Let us say simply that the rez dog is of similar history—these are the dogs that are the most resilient.

Our rez dogs can elude officers of the law, the wheels of a fleeing vehicle, eat oatmeal and grease for more than a few days, and face down animals of many sizes, smells, and levels of quilled armor. These are traits that are admired in our dog friends, and the resilience and tenacity of our dogs reflect on their companions with two legs. I have three rez dogs myself, all from great pedigrees. For many years I had a rez dog imported from a Canadian Indian reservation. I was so proud of our breeding techniques and choices— *"Mother was a sled dog, daddy was a rez dog."* And a more recent rez dog was imported from just one reservation over—and aptly named *Wahompi* (Soup) in reference to a Lakota ceremonial practice of dining on puppies. This dog, however, ended up happily in a fine middle-class home somewhere near Bemidji, and today her offspring frolic in the suburbs of Minneapolis, carrying on fine rez-dog activities in other human worlds.

The stories are told that the dogs always lived with the humans. That is to say that Nanaboozhoo, our first human-spirit being (born of the West Wind and Winona, a human woman, and descendant of Sky Woman), traveled with Ma'iingan (the Wolf) as a companion for many years. It is said that Nanaboozhoo and, subsequently, the humans were taught much about relationships, extended family systems, loyalty, and the keen powers of observation. The Anishinaabeg, for instance, are noted for our extended-family system of parenting, which has evolved from the teachings of the Wolf. That is why, to this day, the Anishinaabeg have a committed relationship with the Wolf, and retain a *dodaem* (clan) of the Wolf on the White Earth Reservation and on most of the other more than one hundred Anishinaabeg reservations in North America.

Now, somewhere along in history, a new relative came to be with the Anishinaabeg, called the *Anishmimoshag* (Dogs). They are also referred to as *Odayi*, which is related to the word *ode* (my heart), in reference to the close relationship of the Anishinaabeg to the Dogs.

Wenjiiwaad Animoshag, The Origin of Dogs, adapted from Truman Michelson by Alex DeCoteau:

Once upon a time two Anishinaabeg were paddling a canoe on the ocean towards the North and it became very windy, so they got blown out to sea. They didn't see any land. It was very windy, they didn't capsize, and they were out in the ocean for a very long time . . . Eventually they were blown to shore overseas. When they landed, they saw the tracks of a great being (*Gichi Anishinaaben*). So then they were scared, they carried their canoe inland, and then they hid under the canoe. After a while they heard something hit and when they looked they saw a great big arrow there. So then they were really scared. Soon they were approached by a great being, they were spoken to.

"My little brother, don't be scared. I am the one called 'Misaabe' (Giant), I am not harmful to people," they were told. They saw a caribou hanging from his belt, that's what he was shooting. That Giant eats them. So then they were picked up by that Giant . . . The Giant carried them under his clothing . . . to his home. After awhile, a Wiindigoo (Cannibal) . . . came in. The Wiindigoo said to the Giant, "You have some people." The Giant had hid them in his house,

The dog carried much of the wealth of a people, not to mention continuing
the guarding of the human world and the world of the domesticated animals (awakaan)
from the world of the other animals.

before the Wiindigoo came in. "I don't have any people", responded the Misaabe. "Sure" ("*Geget,*") said the Wiindigoo. Eventually the Wiindigoo became angry, as did the Giant. There was a wooden bowl in the house, and the Giant pried it up with a stick and there was a puppy (*bashkwadaash*) under the bowl, who was a pet of the Giant. "Go Bashkwadaash, go fight that bad being", commanded the Misaabe. Sure enough, the puppy gets up, he shakes, and then he starts to go get big. Gradually as the dog shakes himself, the dog gets bigger. After the puppy got big the Wiindigoo left. The Giant encouraged his dog to kill the Wiindigoo, so the Dog fought the Wiindigoo until he killed him. After he killed him, the dog returned to under his bowl.

The Misaabe said to the people, "I wanted to see you and give you this pet of mine. It's time for you to go home, and there are no dogs over there in your land. Maybe you can put him to use. He will act almost like a person." . . . Then the Giant talks to his little pet and instructs him, that "bashkwadaash", to take the humans home. The dog starts to get bigger, and the Giant places the humans on the dog's back and says, "take them straight to their country". Then the puppy took off running, across the ocean. When they get to land, the dog gets smaller to the size of a dog. Then the Anishinaabeg and the dog became friends, and all of those dogs come from that original puppy, who also became known as the *Animosh* (Dog).

While the humans would become fast friends with the Dog, the story is also told that the dogs became vilified by the other animals. This story has to do with the falling out of favor of humans with the other animals. The Anishinaabeg, it seems, were seen to have become disrespectful of their relationship to the other animals. The deer, beaver, and other relatives found that the Anishinaabeg were not as thankful as they should be for the food offered by these animals, that the Anishinaabeg did not tend to the forest and care for the prairies as they should, and that they did not attend to the dances and ceremonies which acknowledged their relatives.

So the animals held a great council at which they discussed their displeasure with the humans. All animals were in attendance, including the dogs. Now, at this time, it's said that the Anishinaabeg and the other animals all could speak the same language, and at this council the animals became so disgusted with the Anishinaabeg that, after long debate, they decided to speak their own language, and exclude the humans. The dog listened to all of this deep debate and discussion, and then ran back to the house of the Anishinaabeg and told them what was being discussed, who had made which points, and what was to happen. This action was viewed as paramount to treason by the other animals (*awesiinyag*), who now vilified the dog. The dog was banished from the lodges of the other animals, and told that he would now live forever in the human world—never to be treated as a full member of a human household, and never to be treated again as a full member of the world of *awesiinyag*. And, to add insult to injury, when the other animals would see the dog, they would battle him, and vice versa; there would be no understanding between them. So it is said that this was the great falling out between the animal world and the human and dog world.

Indeed, the Anishinaabeg and other Indigenous peoples benefited greatly from the presence of the dog. The domesticated creatures were one of the primary methods of travel or portage for the Anishinaabeg, and most other Indigenous peoples, prior to the arrival of the horse. The "travois," as it was called, was a backpack dragged behind a dog, used by many a family when moving camp in the Great Plains of North America. The dog carried much

of the wealth of a people, not to mention continuing the guarding of the human world and the world of the domesticated animals (*awakaan*) from the world of the other animals.

The Europeans who came to the continent marveled at the technology and strength of the dogs. In 1541, Francisco do Coronado forged onto the plains in a fruitless search for gold and observed hunting parties using large, wolflike dogs as beasts of burden. The dogs could carry packs of up to 50 pounds on their backs, or pull a travois loaded with up to 250 pounds of game or belongings. Two hundred years later, in 1765, the Hidatsa were "discovered" by the white people, who again marveled at the travois. Prince Maximillian of Denmark was also impressed by the dogs of the Mandan, Arikara, Cree, and Assiniboine communities along the Missouri River, noting in 1833, "We already saw above a hundred of them, with many dogs, some of which drew sledges, and others, wooden boards fastened to their backs, and the ends trailing on the ground, to which the baggage was attached with leather straps." With the advent of the horse, by the mid-nineteenth century dogs were supplanted as the primary mode of transportation for both people and communities.

In the Great North Woods (*Anishinaabeg Akiing*), the summertime travel was by canoe and the wintertime travel was always with a dog sled. Dog teams served a central purpose in our communities to help hunters move between camps and to move entire families. My children's grandfather, James Small, is a Cree elder from James Bay in Canada who was born and raised in the northern bush and traveled by dog sled throughout the winter. Today, I laugh, because one can observe his descendants raising great teams of dogs for no apparent reason except that rez dogs and sled dogs seem to suggest a genetic memory of a relationship to their history and a lifeway that existed for a millennium.

Karl Bodmer, *Dog-Sledges of the Mandan Indians*, ca. 1839.
Minnesota Historical Society

The John Beargrease Marathon, one of the most renowned sled-dog races in the continental United States, was named after an Anishinaabeg man from the Grand Portage Reservation on the shore of *Gichi Gummi* (Lake Superior). John Beargrease was raised in the village of Beaver Bay and lived the traditional Anishinaabeg lifestyle of the woods, ice, and trap lines. Between 1879 and 1899, Beargrease and his brothers were the mail carriers from Grand Marais to Two Harbors as no road existed between these two villages, just a small trail passable only by sled dog. The four-hundred-mile round-trip trail is today the site of an annual late-January sled-dog race, which brings in mushers from around the world. The dog race continues the great tradition of the sled dog and the rez dog for all to see.

The White Earth Reservation is restoring the status of the dog in our community. Several sled-dog teams have been mounted from our reservation and now compete regionally in a growing and vital tradition. And, in 2005, the first annual Rez Dog Competition was held at the Pine Point Powwow, where families paraded their best contestants. Judged for wiliness, fortitude, tenacity, and unusual breeding, the rez dogs of White Earth could stand up to any other dogs in the world in all of these categories.

I walk outside and watch Komodo, Biiboon, and Maria scatter, chasing raccoons, rabbits, or an occasional grouse, marveling at their tenacity. They are rez dogs to their core. While, inside, my children may watch the din and pomp of the Westminster Dog Show—outside, the proud Anishinaabeg rez dogs await their human friends to continue that path laid out millennia ago. The descendants of Bashkwadaash live here in their original territory, Anishinaabeg Akiing, and continue their duties of fighting off Wiindigoos and guarding Anishinaabeg households through the winter.

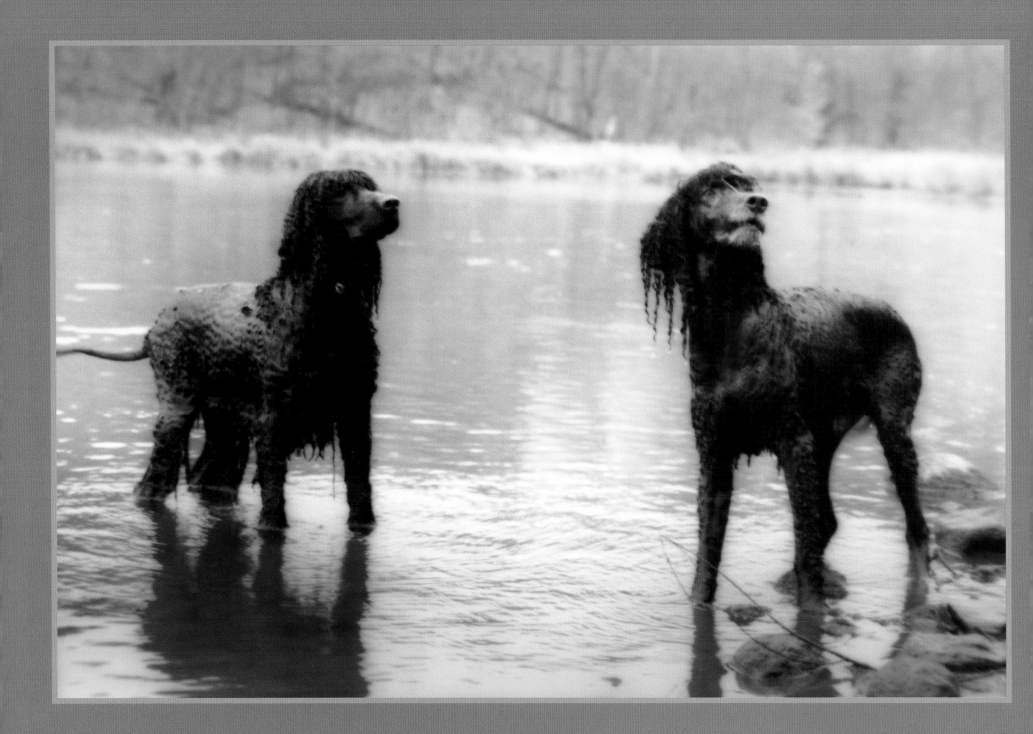

SPORTING

bred for
pond and field

THE IRISH WATER SPANIEL—its characteristic topknot, rattail, smooth face, and liver-colored coat of curls—was bred to hunt, flush, and retrieve wild waterfowl in bogs and marshes. □ In 1834, a dog was whelped in the kennels of Justin McCarthy in southern Ireland. "Boatswain" created such a sensation as a hunter that he was used widely at stud and is considered the

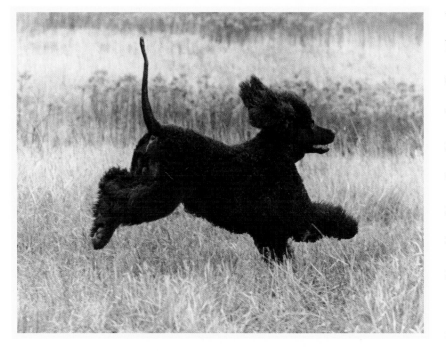

foundation sire of the breed
to reveal the details of his
genetics behind Boatswain will
theory involves a combination
Poodle. However, dogs of his
in the area of the River Shannon
descended from Boatswain are
largest of the spaniels, this dog
pointing, flushing, and retrieving
its forte is as a water retriever.
geese, the Irish Water Spaniel

today. McCarthy chose not
breeding program, so the
always remain conjecture. One
of the Afghan Hound and the
general type were described
centuries earlier. □ Dogs
greatly valued as hunters. The
is tireless in the field, locating,
game with enthusiasm. But
Strong enough to handle even
is known to dive underwater

to retrieve wounded game. Its powerful hindquarters drive its body through the water, propelled by large webbed feet. Its deep barrel chest adds stability. □ Covered, except on its face and tail, with short curls that are slightly oily to repel water, the Irish Water Spaniel has a curious appearance that seems to match its mischievous nature, but this dog is all business at the drop of a bird into water.

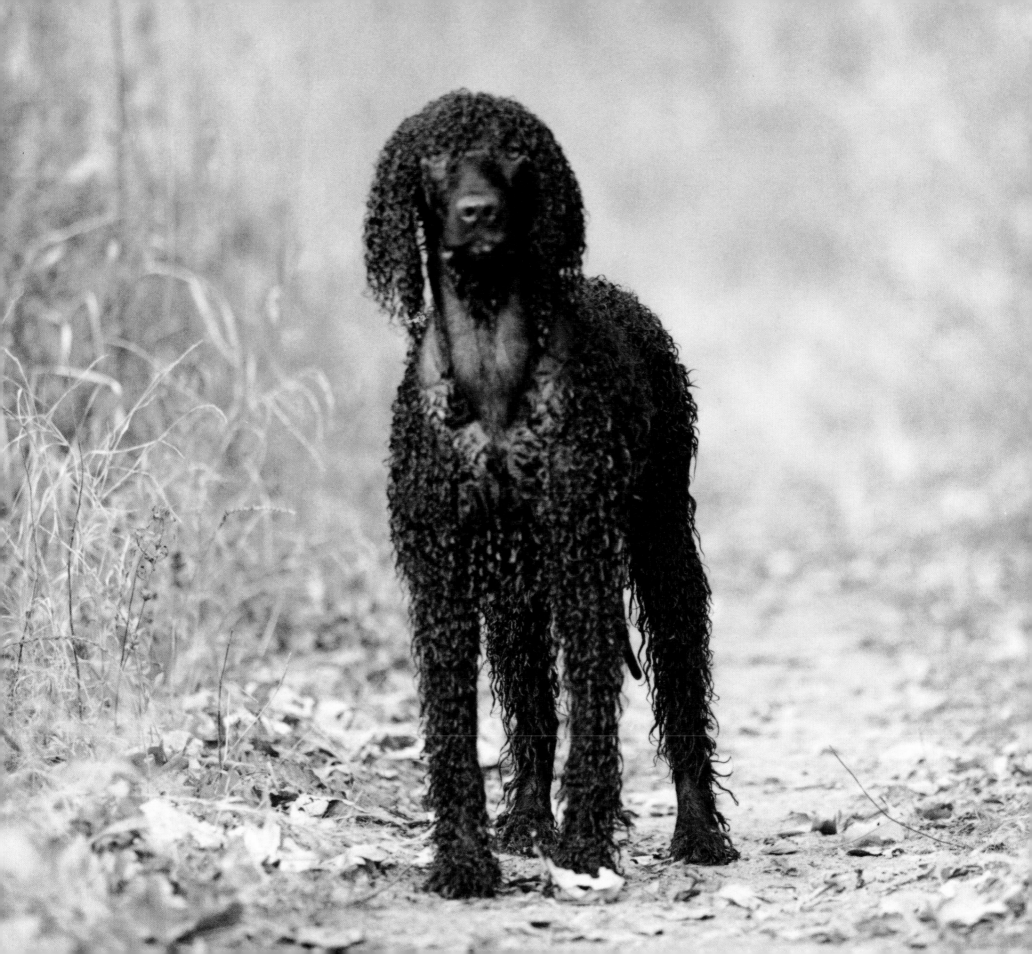

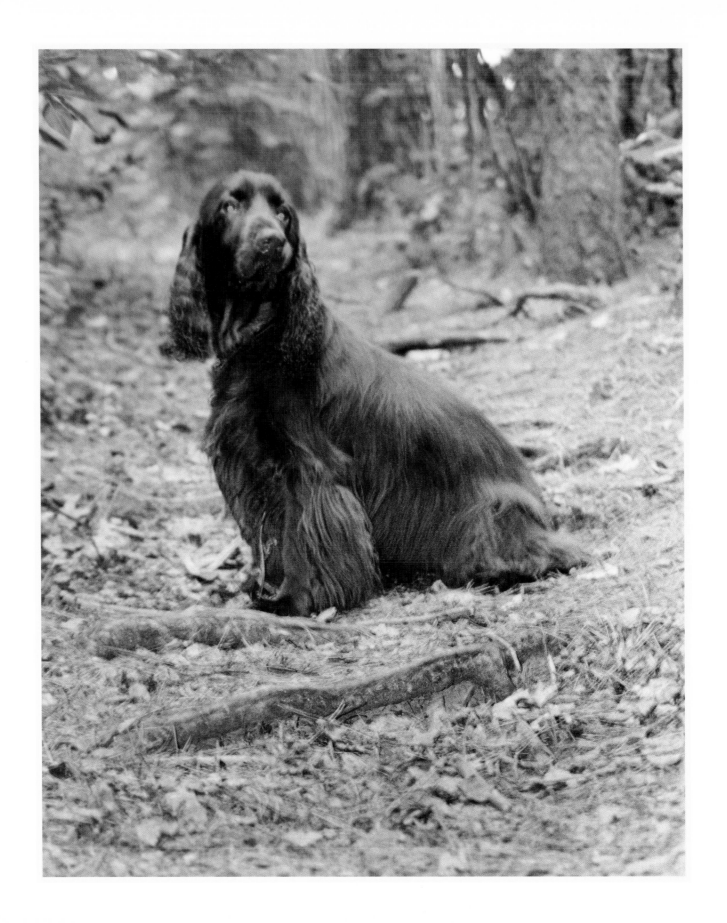

*The one priceless dog is the perfect spaniel . . . most ancient of our gundogs and most useful,
being able to understudy, in an emergency, all the other members of the family, be they pointers, setters or
retrievers, while none of these can return the compliment.*
—WILLIAM ARKWRIGHT, IN AN INTRODUCTION TO H. W. CARLSON'S *SPANIELS* (1914)

FROM THAT LOFTY DESCRIPTION, THE FIELD SPANIEL FELL TO NEAR RUIN, the victim of over-engineering. Developed in the eighteen hundreds to flush birds for gun hunters, spaniels diverged into two breeds: those used for field and those used for water. Further division emerged among field spaniels according to their size, eventually distinguishing the larger Field Spaniel, used for flushing grouse and quail, from its smaller, woodcock-hunting Cocker cousin.

Sometime after the emergence of the formal dog show, show breeders began to exaggerate the characteristics of the Field Spaniel. One breeder in particular, English dog-fancier Phineas Bullock, emphasized breed characteristics such as a large, heavy head, an elongated swayback body, and short, crooked legs. *The International Encyclopedia of Dogs* records a host of uncomplimentary descriptions of the result: "sluggish and crocodile-like," "German sausage," and "caterpillars."

No longer useful to hunters, this popular breed fell out of favor. The Field Spaniel dwindled to near extinction and might have become extinct but for the efforts of some fanciers to restore many of its desirable traits through crosses with English Springer Spaniels. Although it regained its more upstanding posture, the breed never regained its popularity.

BRITTANY

None swifter, when his master gave the word,
Leapt on his course to track the running bird,
And bore it back—ah, many a time and oft—
His nose as faultless as his mouth was soft.

—ROBERT C. LEHMANN, *THE DOG'S BOOK OF VERSE* (1916)

MEDIEVAL SPANIELS WERE DIVIDED INTO HAWKING DOGS AND COUCHING DOGS. The former drove birds into the air for the hawks, while the latter set and held birds for the net. The Brittany, named for the French province where it originated, is the closest modern breed to the original couching spaniel of medieval Europe.

In the early nineteen hundreds, French sportsmen began crossing spaniels with English pointing dogs whose owners hunted in France. This crossbreeding resulted in two characteristics that set it apart from other spaniels: an inherent pointing instinct (unlike the Cocker and English Springer spaniels, which flush their game from the cover), and a tendency to range over the ground as it points game (like setters and pointers). Hence, while originally known as the Brittany Spaniel in the United States, the name was changed to just Brittany in 1982.

Bred to be a compact hunting dog, the Brittany is smaller than the other pointing breeds, allowing it to find game more easily in heavy cover. It was also employed by poachers to slip under the fences of upper-class estates. A sharp nose and classic point not only give it style, but after the point the Brittany can retrieve from land or water.

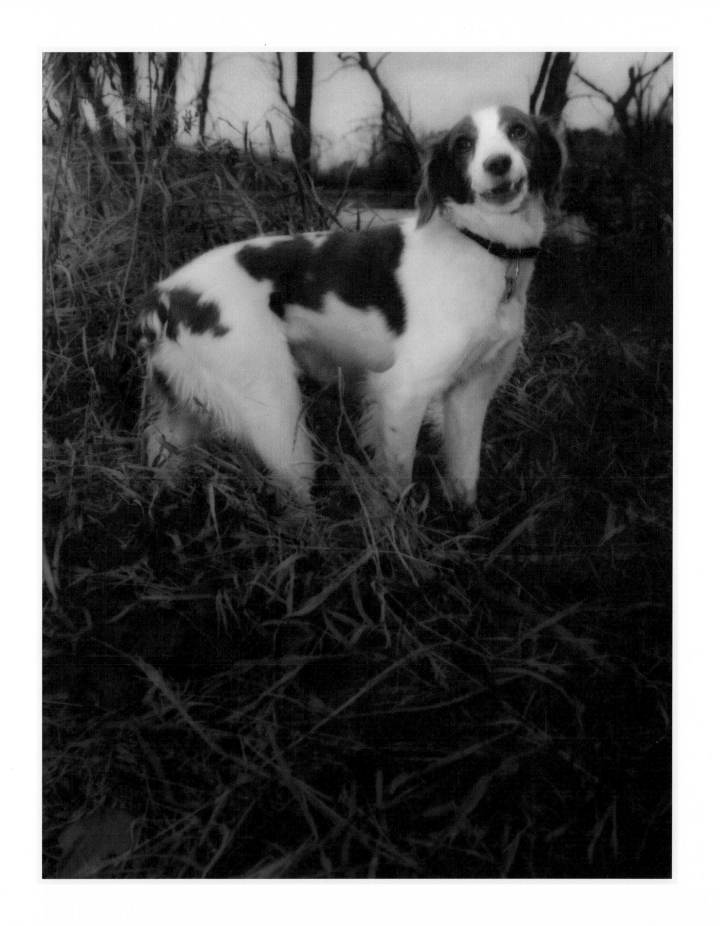

WHILE THEY MAY BE RECOGNIZED AS TWO DISTINCT BREEDS, the English Cocker Spaniel and its American brethren share a common love, the thrill of flushing the fast-rising woodcock from its woodland nest; indeed, the Cocker Spaniel's name derives from that of its beloved prey. ☐ Developed for just such a task by hunters in the early eighteen hundreds, the English Cocker's size—smaller than the Field or English spaniels—was ideally suited for flushing and retrieving woodcocks and other birds in dense brush. It so excelled at its mission that American sportsmen began importing the breed during the second half of the nineteenth century. ☐ Over time, the breed's American descendants began to take on different characteristics, including shorter muzzles, rounder heads, and longer coats. The difference became so pronounced that the American Kennel Club eventually recognized the English Cocker and the American Cocker as separate breeds.

IRISH SETTER

LIKE ALL CONTEMPORARY SETTERS, IRISH SETTERS ARE BELIEVED to be descended from the setting spaniel, which would quietly drop to its belly, or "set," when it found the birds. The hunter would then cast a net over the area, flushing and ensnaring the birds (and sometimes the dog). In the early eighteen hundreds, the gun replaced nets and hunters demanded a setter with a more upright pointing style. A crouching setter was harder to see and thus easier to shoot by mistake. □ Physically, the Irish Setter is the most pointerlike (i.e., houndlike) of all the setters. Most authorities agree that the breed is a blend of Irish Water Spaniel, Irish Terrier, English Setter, spaniel, Pointer, and Gordon Setter. The solid red setter first appeared in Ireland in the nineteenth century. Its mahogany color became synonymous with dogs of high rank and the breed was revered for its remarkable sporting abilities. □ Watching the setter at work is a breathtaking sight; its muzzle is kept parallel to the ground while the dog searches for game. Its swift gallop is free of noticeable exertion and the body appears to float. On finding its prey, the dog's posture becomes rigid, yet full of energy and deliberation, a model of pulchritude and concentration.

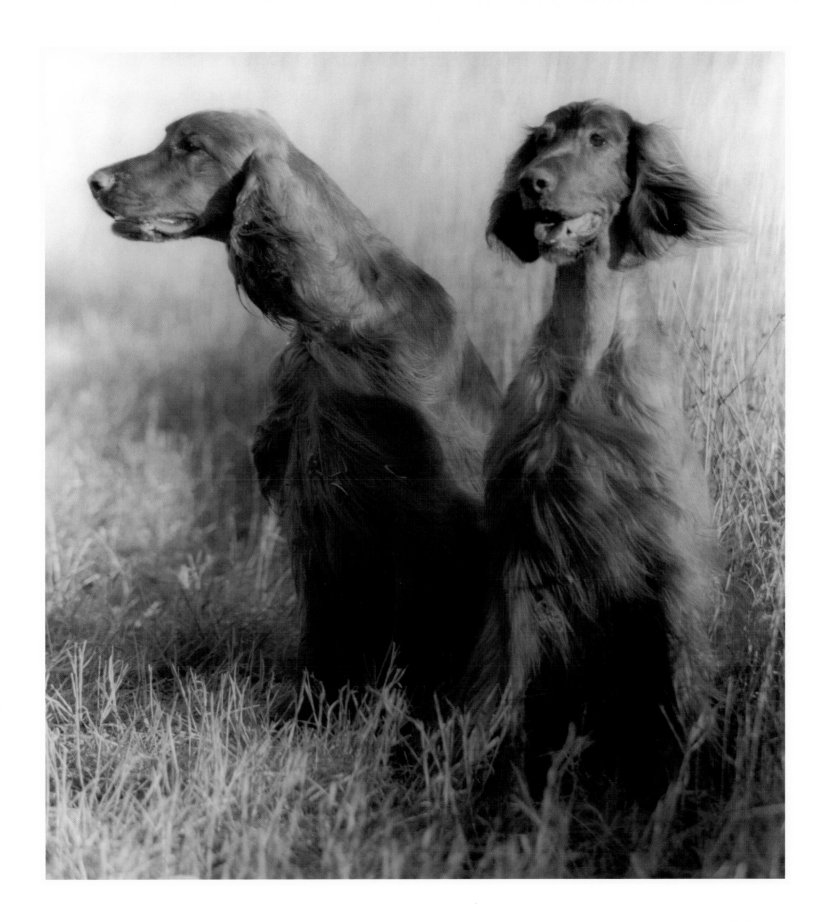

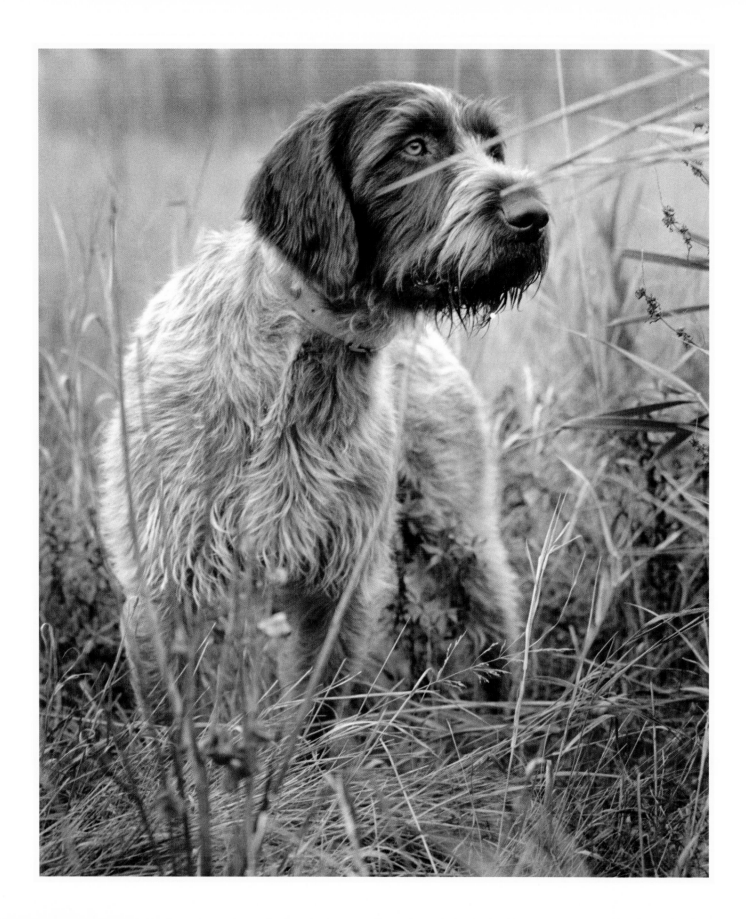

To hunt over a good German Wirehaired Pointer is to experience Nirvana.

You watch her quarter as she processes the scents drifting downwind to her. Her body is constantly in motion,

bounding over clumps of tangled prairie grass, bursting through cattails in the slough, moving from

side to side to narrow down the origin of the pheasant scent, and then . . . suddenly! . . . she is frozen in point, her

body like an arrow aimed at a hidden bird. Not a hair moves. Finally, on command she pounces,

flushing a cackling ringneck into shotgun range. As though shot from a gun herself she is immediately in pursuit of

the downed creature, chasing it through the brush, relentless, until she emerges with her jaws full of iridescent feathers

and bird. Proudly, she trots it back to your group, tail wagging furiously.

After releasing her catch she immediately begins to quarter again, bounding over brush, sifting scent.

To hunt over a Wirehair is to know her soul.

—CAMILLE MCARDLE, DVM, BREEDER, HUNTER

THIS MIRACLE OF A DOG DID NOT JUST HAPPEN. The German Wirehaired Pointer is one of several European breeds developed in the late eighteen hundreds to be versatile all-around hunters. Sportsmen of the time needed a single dog that could find a variety of small game, point and hold them, and willingly retrieve, no matter the terrain. To this end, the blood of many other breeds was intermixed to create the rugged athlete that we know today. Originally called the Deutsch Drahthaar, which translates literally as "German Wirehair," this breed carries the genes of the Poodle, the English Pointer, the Griffon, the Foxhound, and the Polish Water Dog, and inherited their skills and athleticism. □ Thus, the Drahthaar is equally at home on land or in water. Its harsh, wiry coat buffers the dog from thistles and thorns and sheds water away from its body. Agile and beautiful, this devoted companion is always delighted to hunt and delightful to hunt over.

GOLDEN RETRIEVER

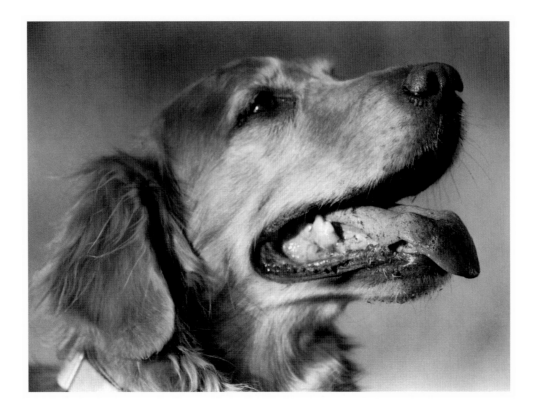

THE FIRST THING THIS BELOVED DOG RETRIEVED were the best traits of some of the world's greatest breeds. The Golden Retriever is the happy result of crossbreeding efforts by Sir Dudley Marjoriebanks, the first Lord Tweedmouth of Scotland. An avid hunter, Tweedmouth sought to develop a breed that would improve on the abilities of the now-extinct Tweed Water Spaniel. He wanted a dog that could work well on both land and in water, that was strong enough to retrieve upland game and large waterfowl, but not so large as to be clumsy or unable to work from a boat. A dog with a tough outercoat that shed brambles, and an undercoat

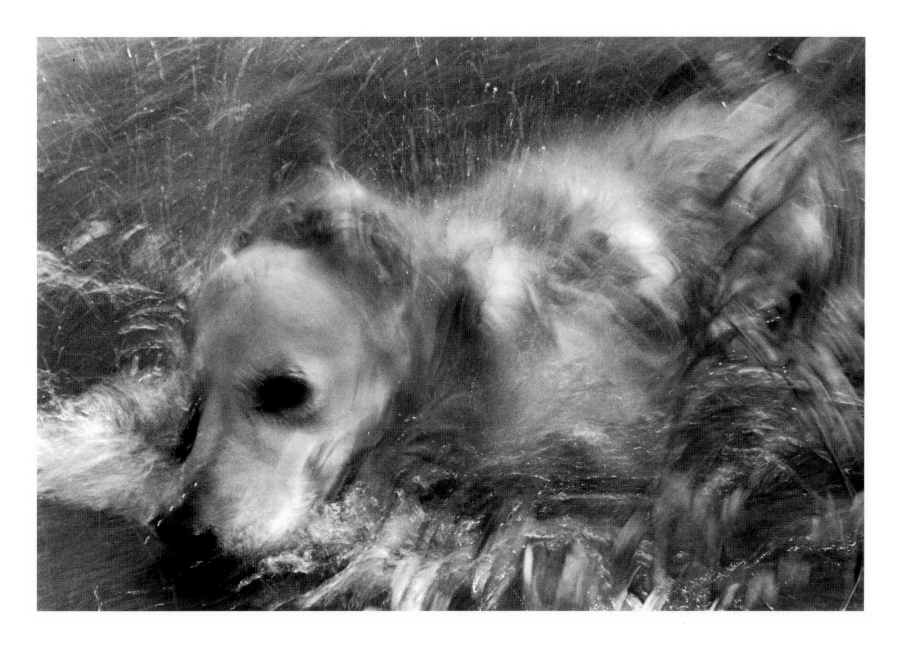

to keep it warm in icy water. A dog with a happy disposition, eager to serve its master. □ Records kept by the gamekeepers at Lord Tweedmouth's estate from 1835 to 1890 show crosses with the Tweed Water and black wavy-coated retrievers to improve the Golden's hunting instincts. Further crosses put the finishing touches on the breed; the Irish Setter added upland hunting skills and the Bloodhound enhanced its tracking skill. By the end of the century, the signature yellow and golden coats surfaced through subsequent selective breeding. The Golden's cheerful disposition and intelligence has endeared it to many non-hunting humans since.

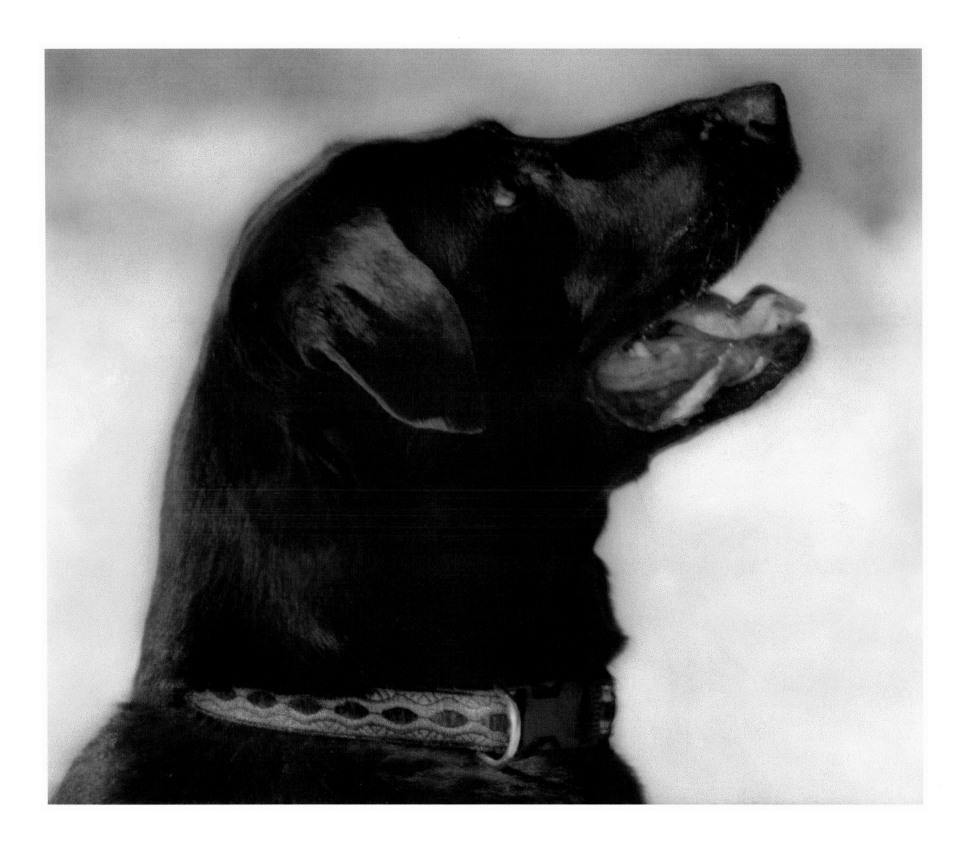

THROUGH TRADE WITH FISHERMEN FROM THE CANADIAN ISLAND of Newfoundland, the ancestors of the Labrador Retriever immigrated to England. Sometimes referred to as a St. John's Water Dog, this sturdy precursor to the modern breed was used primarily for draft work, although it had a penchant for retrieving game on dry land or in water. ☐ Early English breeders, including the Third Earl of Malmesbury, are believed to have given it the name "Labrador" to differentiate it from the Newfoundland

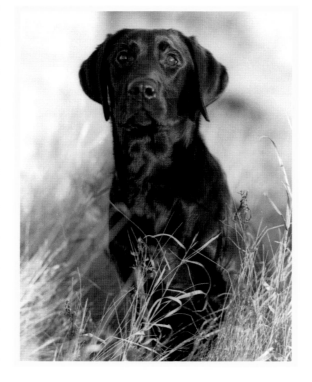

dog. "We always called mine Labrador I could from the first I had from Poole friend. "The real breed may be known by water off like oil, above all, a tail like an Labrador was unmatched for its hardiness towing barges, often working twenty hours swimmer, water beads easily off its smooth of dense hair serves as a rudder against and American Labradors show slight heavier and stockier than their long-legged black, golden, or chocolate brown, the for its eagerness to please and its versatility

dogs, and I have kept the breed as pure as [Harbour] . . . ," Malmesbury wrote to a their having a close coat which turns the otter." ☐ A fisherman's companion, the and stamina, pulling nets in to shore or at a stretch. A strong and enthusiastic undercoat, and its thick, rounded tail the pull of ocean currents. ☐ English variations. The English-bred dogs are American cousins. Whether its coat is Labrador Retriever is revered by hunters in all weather conditions. This medium-

sized breed excels as a retriever on land and in water and has the strength and temperament to hunt for long hours, even over rough terrain. ☐ In addition to its prodigious hunting skills, the Labrador Retriever is highly valued as a family dog for its love of people, its jovial disposition, "kind" eyes, and youthful exuberance.

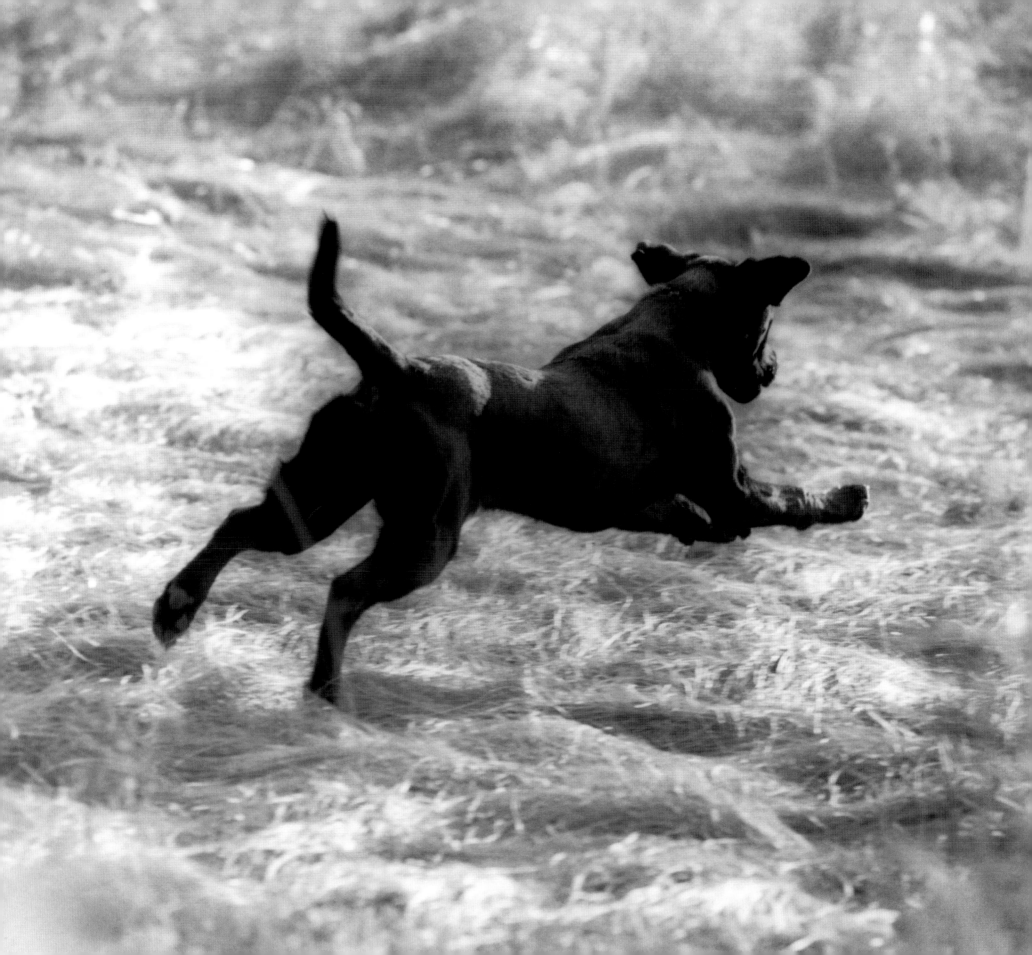

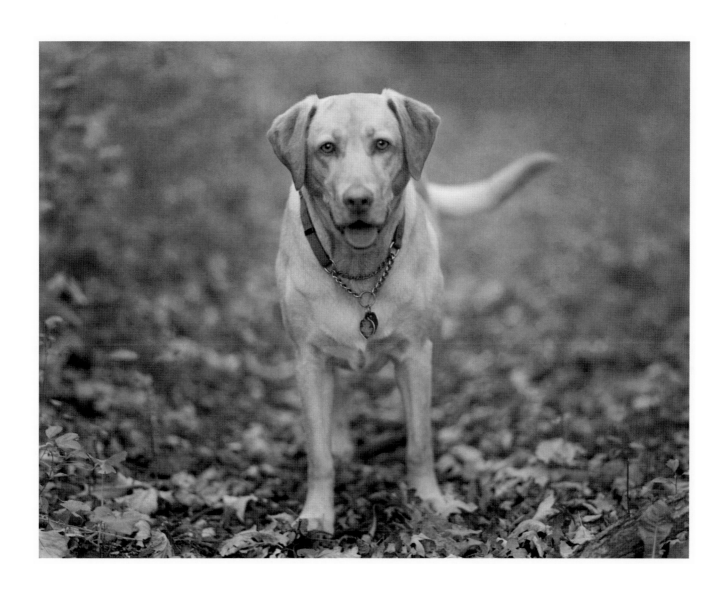

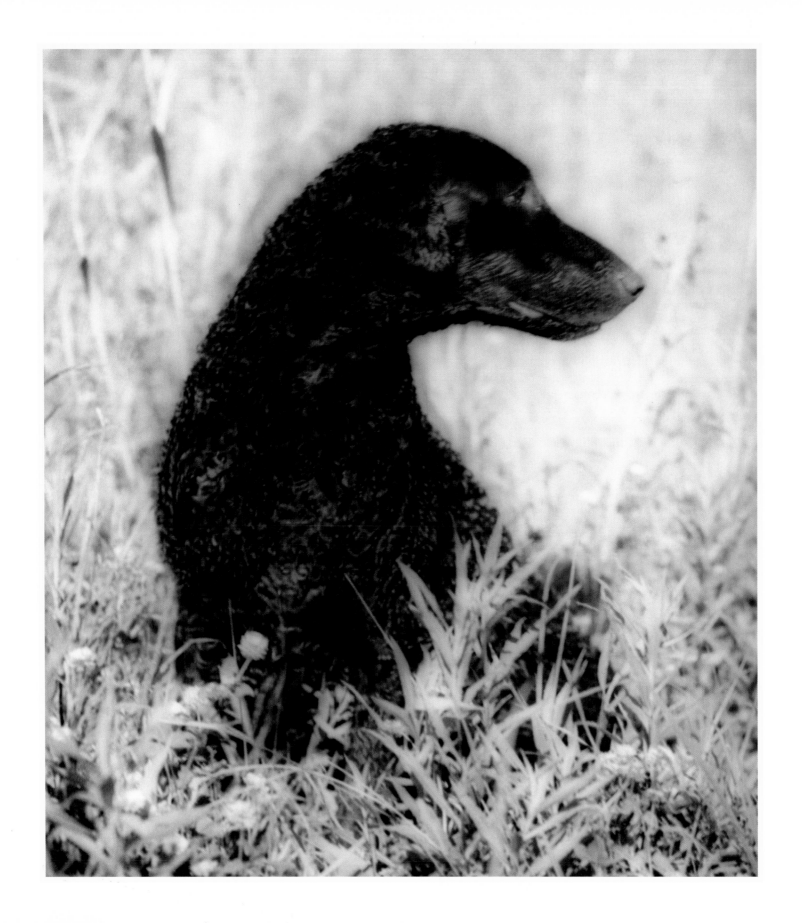

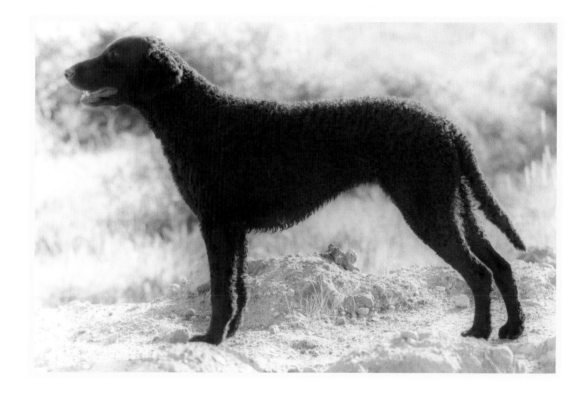

BRITISH SPORTSMEN BEGAN TO REQUIRE A BETTER RETRIEVING DOG DURING THE EIGHTEENTH CENTURY. As guns evolved, hunting shifted to shooting birds in flight, rather than driving slower game on the ground using setters and pointers. Hunters attempted to train these older breeds to retrieve game but found that their signature point was slowly spoiled. Thus began the work to breed a dog that preserved the indispensable characteristics of the setter along with superior ability to locate and retrieve.

☐ The Curly-Coated Retriever evolved from crosses of early British water spaniels with various retrievers and other gundog breeds. They were especially valued by estate gamekeepers and the common man, who used their dogs to locate and retrieve missed game after the gentry hunt. Referred to as a "meat dog" or the "gamekeeper's dog," the Curly-Coated Retriever's exceptional hunting skills could be relied upon to locate and retrieve fowl and small game—and provide dinner for the working man's table.

WEIMARANER

 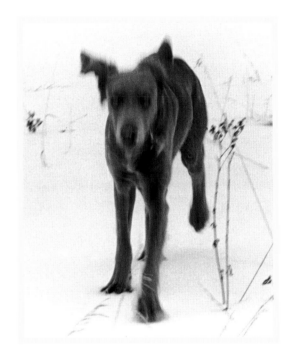

A DOG SIMILAR IN APPEARANCE TO THE WEIMARANER appears in a painting by Sir Anthony Van Dyck from the early sixteen hundreds; but today's Weimaraner is a young breed, dating back only to the early nineteenth century. Developed as a gun dog for tracking and hunting bear, wolves, and other large game, the "Weim" is thought to share its origins with a number of other German hunting breeds, drawing on the bloodlines of the Great Dane, the English Pointer, the German Shorthaired Pointer, and the red schweiss hound (similar to a Bloodhound). □ Weimaraner ownership was restricted to the nobility. Originally known as the Weimar Pointer, its name derived from the Weimar court (located in the foothills of the German Alps), which sponsored the breed. Coveted for its regal appearance, its large expressive eyes, and short, smooth grey-tan coat,

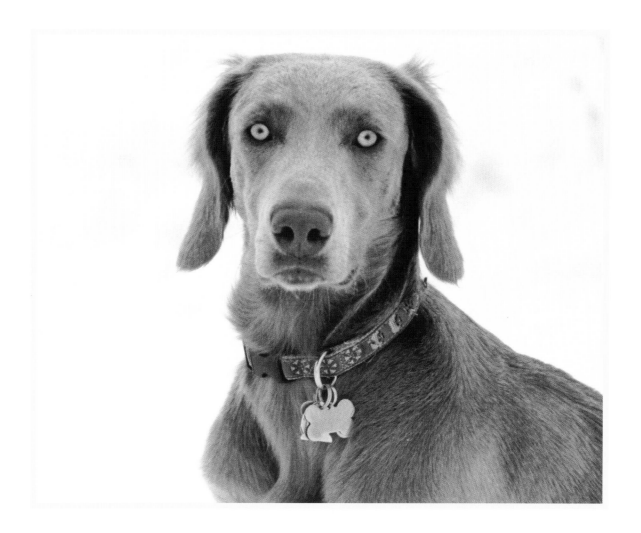

the Weim was raised in the home rather than kenneled. This arrangement, unusual for the time, resulted in a dog that is more dependent on human companionship than most breeds. ☐ As the number of large game animals decreased, breeders concentrated more on developing a dog suitable for bird and sport hunting, and for use as a personal hunting dog. Extreme concern about keeping the breed pure made Weimaraners difficult to obtain, and the breed did not appear in America until the early twentieth century. ☐ A longhaired variety is recognized by and shown in all the major kennel clubs of the world, except in the United States. Although much less common than the shorthaired variety, longhaired Weims are often born into shorthaired litters.

THESE INTENSE HUNTERS NEED HUMAN AFFECTION as much as they need food and water. □ The breed is thought to date back to the Magyars who swarmed over the hot plains of central Europe more than a thousand years ago. Legends persist about its reputed ancestor, the yellow Turkish hunting dog (now extinct). The Vizsla was prized by the Hungarian landowning aristocracy for its hunting skills, intelligence, regal appearance, and warm personality. □ *Vizsla* translates as

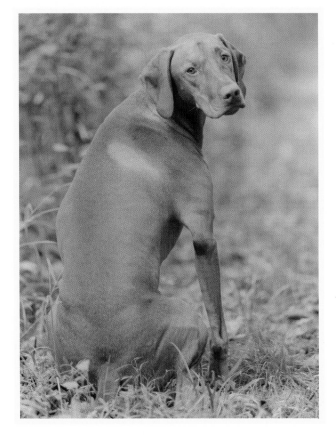

"alert" and "responsive," and this breed both as a pointer and retriever of partridge, and grouse. They are also animal game. The Vizsla's rust-colored time spent in the field. Their catlike runners. They are robust but slightly resembles a sinewy statue ready to the driven, fearless Vizsla can spend an with exhaustion, this hard worker head in the slumbering hunter's lap.

has proved itself superior in the field upland game such as pheasant, quail, used for hunting waterfowl and small coat is often decorated with scars from feet make them quick and elegant built—a Vizsla locked on point come to life. □ Bred for endurance, entire day in the field. Finally, satiated curls up into a tiny ball and rests its Or on the top of his head.

If you own a Vizsla, it lives on top of your head. —OLD HUNGARIAN SAYING

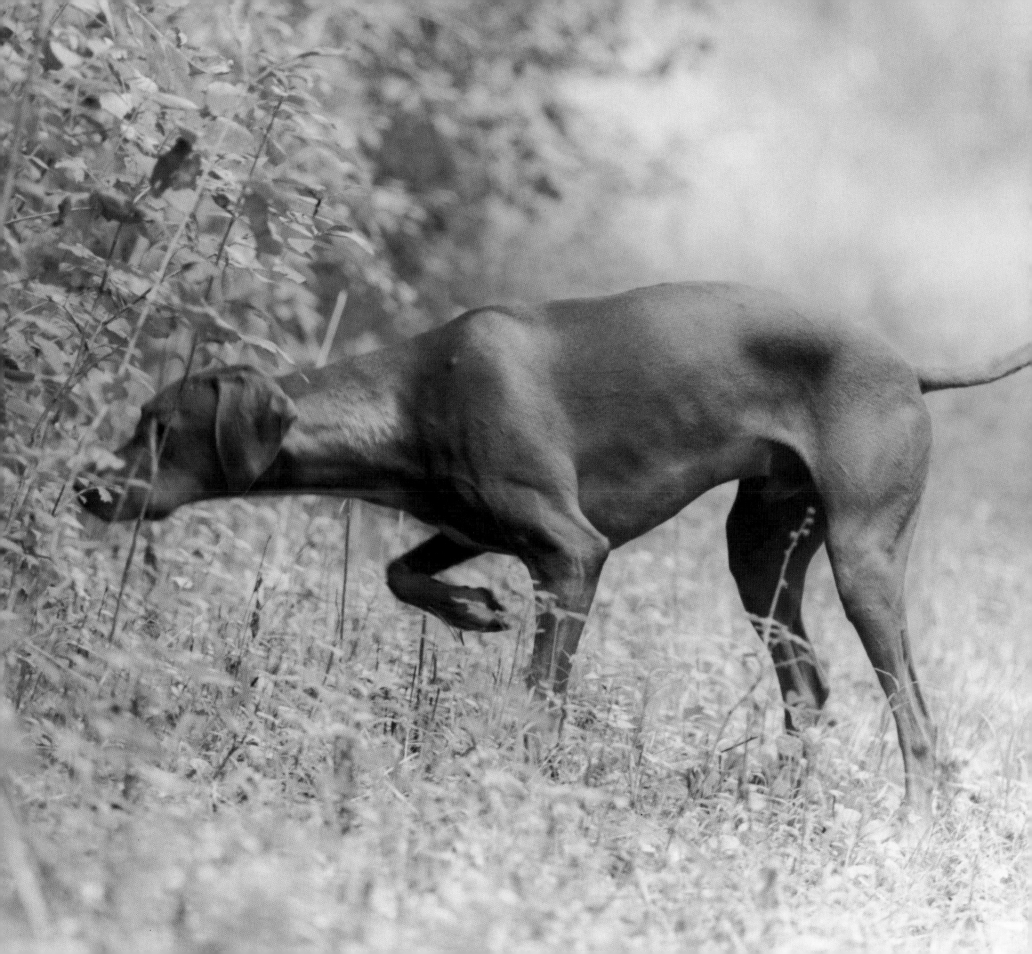

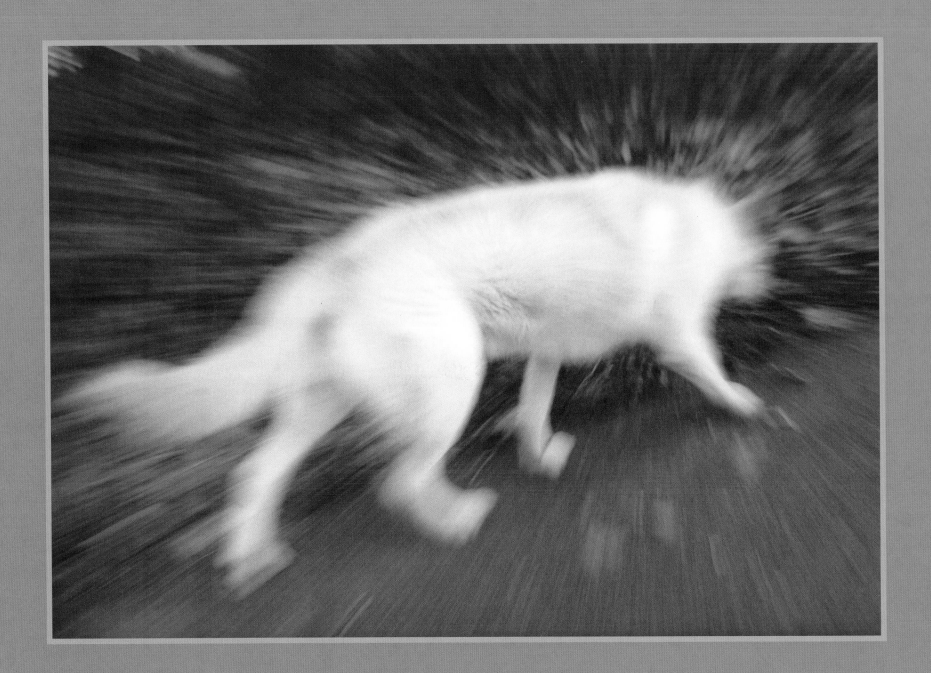

You Dirty Dog! *JAMES HILLMAN*

MELANCHOLY

CURLED NEAR THE BASE OF A PONDEROUS GEOMETRIC STONE a sleeping dog lies by the feet of Dame Melancholy in Albrecht Dürer's early sixteenth century world-renowned etching. Among symbols of the measuring intellect and the passing of time we find a bony, half-starved dog as an important part of an enigmatic cosmology. How does that sleeping dog fit with this state of soul: abysmal dejection, darkened visage, and the intense distant stare of an inspired visionary. There is madness here, riches of imagination, even terror. This becomes our first question: the doggedness of depression, depressive doggedness.

Dürer's image places the dog within a wholly psychological field altogether different from the familiar dogs of the dayworld: the sportsman's hunting dog, the courtesan's frilly dog, the breeder's triumph on show, the willingly harnessed dog pulling its load and the brave rescue dog, the children's romping playmate and the household's favorite and faithful companion. From Dame Melancholy's *familiaris* might we learn something else, something deeper that depression takes us toward.

An animal (*hayyah*), says the *Zohar*, is the highest grade of angel. Which specific kind of angel is the dog? Angels, from *aggelos* in Greek, are bearers of messages; what angelic message does the dog bear? What essential intelligence is embodied in that hairy coat, behind those soft eyes and black muzzle of that angel we call a dog?

I understand "angelic essence" to mean the deepest and highest intention that the animal brings into this world, offering the world necessary qualities specific to each kind of animal. That is the first importance of these creatures, each of them, all of them. That is why they had to be saved on Noah's ark and why for early peoples and still many today, gods first appear as animals.

ANIMALS IN THE PSYCHE

MORE NARROWLY IN TERMS OF HUMAN LIVES, each kind of animal backs a style of human behavior, showing us in their display our traits and our sustaining natures which we have named "instincts." We meet animals out there, in the bush, in the streets, but they also live in the psyche transmitting behavior patterns. Human nature consists not only in the community sitting around the campfire, but also in the beasts in the jungle surrounding. Each of our souls is comprised of tigers of wrath, vultures of greedy hunger, owls of attentive stealth, and parasitical vermin sucking life from anything we fasten upon. Hogs, skunks, and cocks of the walk inhabit the soul's menagerie. All our behaviors, even our faces, as caricaturists have shown, betray some animal trace. The *canidae* (dog, wolf, jackal, fox, dingo) are present in our very structure. Those incisors in our mouths are "canines."

Animal traits in human habits are quite specific. To help sense "dogness" study the cat. These two carnivores, whom we nourish in the bosom of domesticity, never could get along with each other say the legends. They are not fungible—it's not a cat cuddled in Dame Melancholy's lap, else we might read her as a witch. Cats bring with them something magical from far away, from Egypt and the night, fundamentally heathen, pagan (no cats anywhere in the Bible).

Cat and dog tend to divide along a comfortable fault line in our thinking: male and female. Mister Dog and Miss Kitty. Social evolutions follow this fable when they suggest that dogs were domesticated by nomadic hunter/gatherers, a mainly male activity, while cats belong more to settled agriculturalists (along the Nile), protecting the stored crops against mice. More a world of women. Thus, dogs' feet hold up in long cross-country treks; they ford streams and follow scent. They need exercise and they love chasing,

while life with cats is more indoor, intimate and societal, including those traits transferred in terms like "catty," "pussy," "wild-cat," etc. (Puppy love is boys only.) Cats seem never to be fully trustworthy, contrary to the "almost human" qualities seen in dogs, e.g., Rin Tin Tin, Lassie, the German shepherds and St. Bernards, and those guiding the blind and guarding the premises with their un-catlike qualities of courage, loyalty, obedience, responsiveness, and sociability.

Our language, too, shows the animal in our behaviors, and the dog particularly in melancholy. The hangdog look; you cannot teach an old dog new tricks; a dog smells his own dirt first; it's easy to find a stick to beat a dog; the dog returns to its own vomit; helping lame dogs over stiles; if you lie down with dogs, you will get up with fleas; thrown to the dogs; scratch like a dog at a door til it opens . . .

In depression the mind goes on a hunt to find a cause, digs up old bones that have been chewed many times before—past sins, omission, and regrets. Regurgitations as meditations, and one feels oneself to be ugly and smelly, and full of blame. Like a dog the mind chases its own tail, obsessively seizes on a misery and shakes it like a terrier and won't let go. Compulsive repetitions of complaint like a dog barking and barking long after the postman has passed.

Traits shared by the dog and depressed person were long noted and incorporated into common proverbs. They also belonged to "diagnosis by analogy," the use of images for grouping and understanding sufferings before modern times. *Acedia*, that melancholy sloth and silent obsessive despair afflicting monks, was sometimes indicated by the dog (as in Dürer's engraving). Old Saturn, god of winter, darkness, and cold—and melancholy,

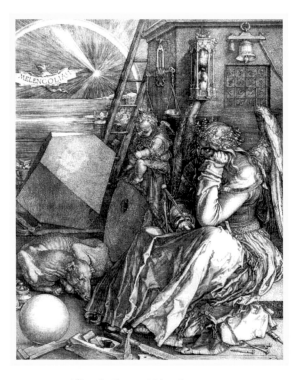

Albrecht Dürer, *Melencolia 1*, 1514.

could also be seen in the horny old goat; the lonely moose in a wintry swamp, his head burdened by the huge weight of its processes; the elephant, its gray, somber bulk like the very body of depression; the camel, who could continue on for days in a deserted condition. Emblems of sadness each, speaking our feelings more vividly than can psychiatric concepts.

We carry them with us. The animals have not been left behind in a different kingdom separated from us by a wide chasm. That old story may not be true: it says that once we and they were all together in a peaceable kingdom, until slowly a rift appeared in the earth, and gradually the animals were all on one side, the humans on the other of an ever-widening gap. At the very last moment the dog leapt the chasm to be on the side of the humans.

What is not true is that we are far from them, but what may indeed be true is the special place of the dog at our side, perhaps as their representative and ambassador with a particular mission. From what country? With what mission? Let us pursue further.

ANCESTORS

DID THAT PRIMORDIAL DOG LEAP THE CHASM to escape its own shadow? To leave its ancestral wolf behind? Can it leave the wolf behind? Is a dog still not susceptible to the call of the wild?

One of the indelible terrors left from childhood is the curled lip and bared teeth of the sudden dog jumping at you or throwing itself against a chain-link fence. The pack of running dogs in an empty lot, the collie nipping at the sheep's trotters, the baying of dogs in the neighborhood setting off one another with their cries and howls, the chasing Doberman, the ferocity of bull terriers, pit bulls, rottweilers, even a yapping Jack Russell . . .

Did that primordial dog leap the chasm to escape its own shadow? To leave its ancestral wolf behind? Can it leave the wolf behind? Is a dog still not susceptible to the call of the wild?

Our fondness for dogs' endearing sweetness may not deny the fear they can also evoke. Like all things under the sun they too are shadowed.

An important alchemical tract (*The Book of Lambspring*) depicts a dog and wolf fighting. The scene is by a river, but in this image the chasm is bridged, possibly because there is a recognition, as the text says, that they both "are descended from the same stock . . . and full of jealousy, fury, rage and madness."[1]

Full of misery too. Again we find traits of Dame Melancholy in the ancestral wolf. The Norse saga of Snorri describes the mythic figure who gave birth to the wolf as the "Queen of a far-flung land of weeping and wailing; her courts are exceedingly vast and her portal wide as death. Her palace is called Sleetcold; her platter is Hunger; her knife and fork Famine; Senility her house-slave and Dotage her bondmaid; at the entering-in her doorstep is Pitfall; Bedridden is her pallet and Woeful Wan its curtains."[2]

That wolf, her son, had a voracious appetite. Hungry as a wolf, we say. Watch even a small dog rip into its meat; hear a big dog gulp its food, slurp its bowl of water. They wolf-down their food.

If the matted hair of the mythical wolf still lies under the dog's silky sheen, then terrible traits still lurk, at least archetypally potentially. Does the family pet take well to the new baby? Protective or jealous? How far will it go when inciting its fury with a tugging game? Watch the hair stand up on the back of its neck, the snarl and growl. Why has training a dog and daily living with it so much to do with submission and mastery? Is it not possible that somewhere in the dog's subliminal habits, the family is reducible to a wolf pack with hierarchy of power? The study of dogs should also include wolves and jackals and the feral dogs who have been betrayed by their human keepers.

CYNICISM

OUR DOG HAS EVEN WHELPED A PHILOSOPHICAL SCHOOL. The hangdog look, banishment from polite society to the doghouse, and a nose-to-the-ground way of living appear in cynicism (from *kuon*, "dog" in Greek), an asocial, amoral, and anti-intellectual lifestyle stripped of civilized defenses against death.

The Cynics flourished from the early fourth century BC right through to Rome and the mainly anecdotal accounts of them emphasize canine qualities. In propounding primitive nature over and against civilized custom, they justified eating the flesh of any animal, even human, professed laziness as a virtue, and identified themselves with their physical bodies and their needs. In a dialogue with a Cynic the interlocutor says, "Your food is what you pick up, as a dog's is; your bed is no better than a dog's."[3] Another says, "My costume consists of a rough hairy skin, long hair a threadbare cloak, and bare feet"[4]

These bare feet are declared sturdy enough to take the Cynic everywhere freely through city and town, like a vagrant dog in the hurly-burly of the streets and alleys which were the preferable "home" of the Cynic—not the cloistered academic school of the traditional philosopher or the remote cave of the ascetic.

He could boast of being unconstrained by law, by marriage, by care of children, by military service—no leashes of any sort, fully autonomous and performing every act unashamedly in public, "both the works of Demeter and those of Aphrodite," (digestive, whether vomit or defecation, and sexual promiscuity). Xenophon has a Cynic say, "If my body ever has sexual needs, I am satisfied with whatever is at hand."[5] Another text, commenting on Oedipus, reports that the Cynic claims there is nothing wrong with incest

since it is natural to roosters, asses, and dogs.[6] Cynicism today still refers to the dog for its attitude, as when tough guys supposedly say, "If you can't eat it and can't f . . . it, then piss on it."

The dog becomes the exemplar of direct, practical, unrepressed natural life, without artificiality, quite literally the "raw" preferred to the "cooked." Nonetheless, the ancient Cynic considered himself "watchdog of mankind to bark at illusion" on the side of humans who are poor, weak, and oppressed.[7] His calling was to this world and this life, not to another world and an afterlife.

UNCLEAN

THE DEEPEST QUESTION STILL LIES CURLED ASLEEP, starved for an answer. Why unclean? Is it only the daily evidence of dogs copulating at length in public, the pack following a bitch in heat, humping the leg of a visitor, and snuffling under women's skirts? Is it only their slobbering jowls and rank odor when wet with rain, the fleas they give home to, their excrements tracked on your shoe?

Or is the dog considered unclean merely in contrast with the cat's fastidiousness, or because a dog imports into domesticity the wolf's wildness. Or maybe unclean because the Bible so often says so. After all, the dog and the raven violated Noah's law of continence on the ark, says Jewish legend.

For a clue, look to the bone. Of course every dog loves a bone and every "good dog" will run and fetch anything bonelike, and gnaw a bone happily all day long. The dog's desire for the bone has commanded an entire industry to produce bone-shaped fakes of pighide, cowhide, plastic, rubber—and we forget the corpse from which all true bones come. From bone to corpse to graveyard. Raven taught dog the art of burial, but dog knows the art of retrieval, digging up what is hidden and buried away and laying the truth at your feet—if only what is concealed in your carry-on at the arrival terminal.

The one with the finest nose for the dead is the ancestral jackal. "In ancient Egypt, where this animal nightly prowled among the tombs, the god of the dead was Anubis, the jackal, and, this deity . . . is closely associated with decay and decomposition."[8]

Imagine! A close relative of Anubis asleep at the foot of your bed. The dog's delectation with the bones ranges far wider than Egypt. In the Aztec calendar the sign of the tenth day was named *dog* . . . "and regent of this sign is . . . the god of the dead."[9] This god fed on the hands and feet of human corpses. In Siberia on the Chukchee Peninsula the inhabitants "give their dead to be eaten by dogs and picture the 'Lord of the Underworld' wearing a dog-skin and riding a sled drawn by strong dogs."[10] Sven Hedin reported from Lhasa (Tibet) "special dogs are kept, and they destroy the dead bodies with astounding appetite. In many temples the corpse-eating dogs are regarded as holy, and a man acquires merit by allowing his dead body to be eaten by them."[11] From Mongolia, this report: "At the burial place . . . the corpses are thrown directly to the dogs . . . Such a place makes a horrifying impression; it is covered with heaps of bones among which packs of dogs, living entirely on human flesh, wander like shadows . . . The dogs of Urga are so accustomed to this food that they always follow the relatives of the dead as they carry a corpse through the streets of the town."[12]

Perhaps, however, these habits are simply manifestations of the dog's angelic essence, necessary to its calling, a display of its archetypal nature. Dare we speak of a dirty angel?

A DIRTY ANGEL

IT IS THIS ASSOCIATION WITH DEATH, dog as death demon, ravening on death, muzzle deep in the virulent flesh, that I suggest lies at the root of our fear of dogs, our condemnation of them as unclean, and their moping companionship of our loneliness. The death demon may approach via depression (Churchill called his bouts of melancholy the "black dog"), via our fear of their growl and sudden spring, or via our disgust at the dog's nose for filth.

The dog becomes familiaris *(the old word for "household soul carrier")*
because owner and animal are familiar in soul, angel to angel, each knowing how deep
the soul can delve, how dark the passage.

The dog's association with the Underworld and death occurs widely in folklore, in stories of revenants, hauntings, and uncanny intuitions, and in the myths of many cultures. Most well known for our tradition is the twelfth labor of Hercules, his most arduous of all, it was said: the retrieval of the Hound of Hell, Hades' guardian dog Cerberus. To wrestle this terrifying creature into daylight means more than overcoming death and hell as in the Christian example of Jesus's descent which aimed to do away with the Underworld and overcome death.[13] Hercules' struggle is also about the dog.

The Greek myth repeats the motif of the dog crossing over a chasm. This one between death and life, the dog furiously resisting leaving his hellish aspect. Cerberus is also, of course, Hercules' "own" dog, the death-dealing propensity in even "the greatest of all humans" and in every human. Hence bringing the dog to heel was the last major task, if Hercules was to be the founder of so many Greek cults and cities, as well as culture hero, healer, and personal savior.

The ghost of Cerberus in every dog provides its archetypal urge to guard and protect. A Jewish legend says that the dog barks when the angel of death approaches, and a dog barked, warning blind old Isaac that the food his son, Esau, had prepared for him was unclean dog meat. The animal who brings death knows when death is near and can save from it.

This two-fold potential shows in Anubis, who, as jackal, desecrated the body and as embalmer preserved it. Likewise the dog, sacred to Asklepios, the healer who worked the line between life and death. In his temples of healing, to see or be touched in a dream by a dog was to be healed. The dog was the god in animal form.

The distinction so decisive in our culture between life and death, this world and another world, between clean and unclean is supervened by Anubis and Asklepios. If the dog is necessary to healing and preservation of the soul, the unclean belongs with the clean, rot and despair are necessary to preserving the soul. Yes, the angel is dirty. Hence "dog" in some Arabic alchemy is a code word for the spirit hidden in matter.[14] The way down is the way up. That persistence, nose to the ground, relishing the offal of decay, the fever and fret of the rutting male, the bitch in heat, the unwavering melancholy stare, constellate the healers. The dog's obsessive scratching opens the door. Uncleanliness is next to godliness.

So, finally, when we walk our dog for our health or for its, when we make sure it gets its shots on schedule, wears its flea collar, when we groom it for "Best in Show," travels with us on family outings, or rides mascot in the pickup, we are engaged in apotropaic defenses against the death demon. Its companionship holds off our madness; our faithfulness, his. For it is the owner's commitment to staying alive—that Herculean task in all things human—that develops in the dog its latent virtues, and also may account for why that primordial dog leapt the chasm. Those virtues—loyalty, bravery, command—and a certain sweet affection that radiates from your dog are as much potentials in the owner's character as in the dog's. A mutuality of natures. The dog becomes *familiaris* (the old word for "household soul carrier") because owner and animal are familiar in soul, angel to angel, each knowing how deep the soul can delve, how dark the passage.

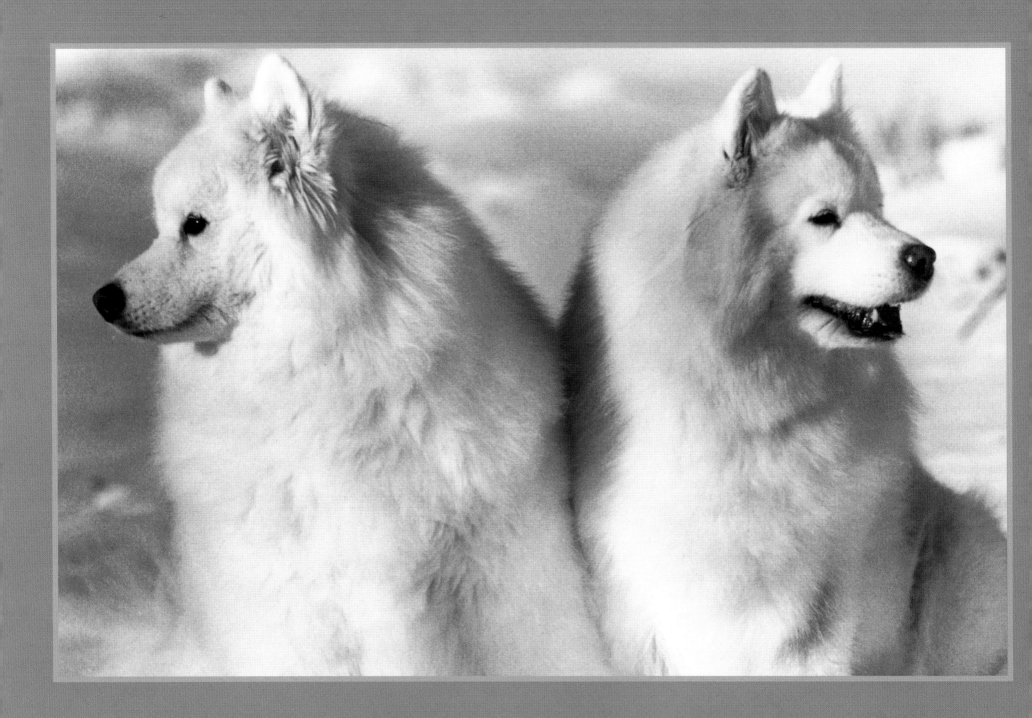

fellow worker
faithful guardian

SAMOYED

He is the right hand of his master, and without them a nomadic race like the Samoyedes could not exist at all.
—A. CROXTON SMITH, *EVERYMAN'S BOOK OF THE DOG* (1909)

THE SAMOYED WAS THE CHERISHED DOG OF THE SAMOYEDES, a seminomadic people who lived along an immense stretch of tundra that extended from the White Sea to the Yenisei River in what is now Siberia. The Samoyedes were one of the earliest tribes of central Asia, and may have lived as far back as 1,000 BC. They depended on their dogs for survival and carefully bred them to serve as herders, hunters, guardians, and companions.

The Samoyed's makeup is well-suited to freezing temperatures. Its double-layered coat is more pronounced than in any other Nordic breed. The wooly, dense undercoat offers warmth while the long outer coat repels soil and water. Dark brown eyes set behind black eyelids reduce glare from the snow. The extra wide spread of the toes operates like a built-in snowshoe and provides traction on glacial terrain. The Samoyed covers its nose with its tail while sleeping, using it as a filter to warm and humidify the frosty air.

The Samoyed's "smiling" face, cheerful eyes, and dazzling silver-tipped coat further endeared it to its people. It slept with the children to keep them warm at night and protected the tent from polar bears. Most importantly, Samoyeds kept the reindeer herds, which provided food, clothing, shelter, and transportation to the Samoyedes, safe from predators. By no means pampered, the Samoyed were highly valued in the home and treated as part of the family.

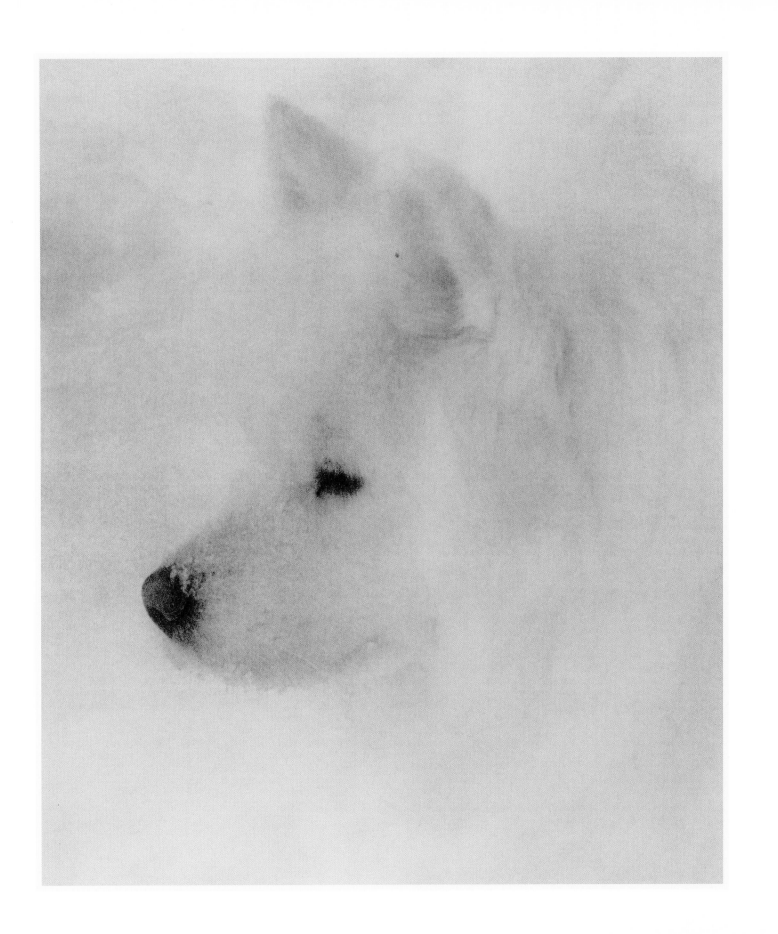

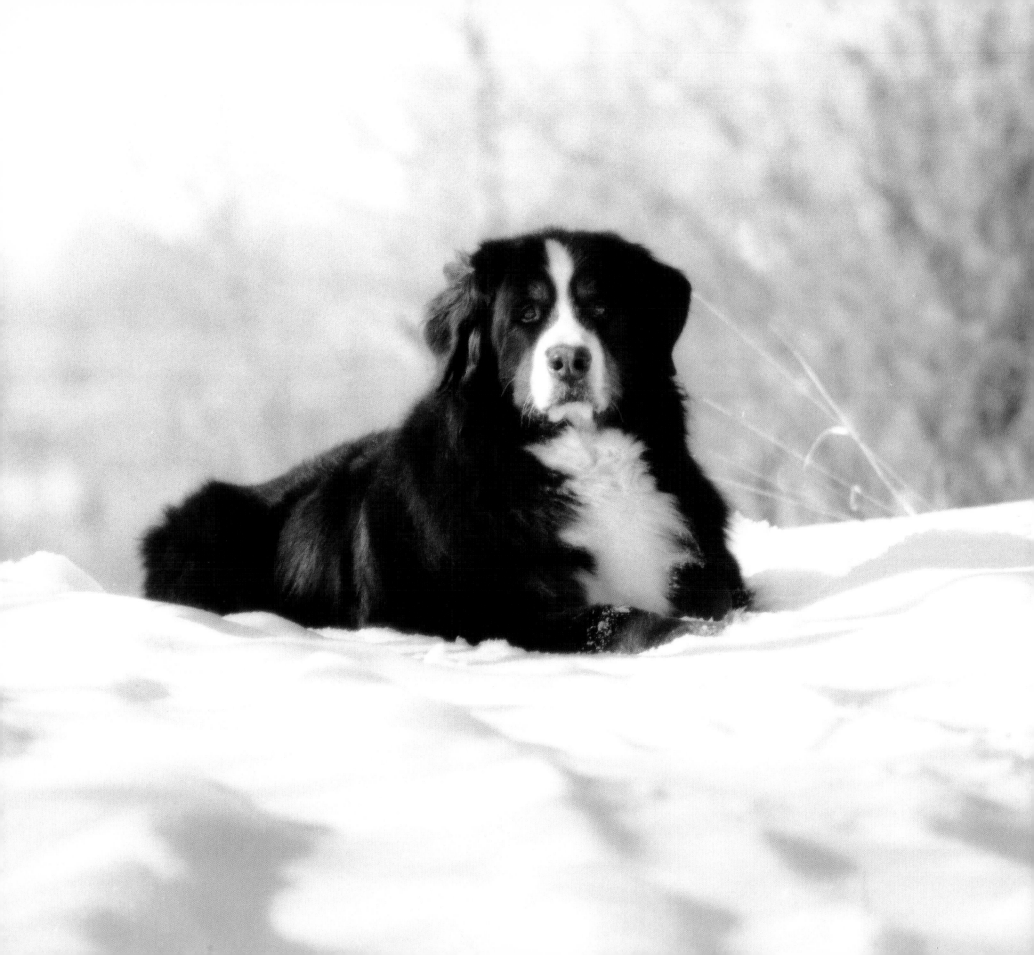

THIS HEARTY SWISS WORKHORSE OF A DOG IS BELIEVED TO HAVE ROMAN ORIGINS; a descendant of the mastiffs brought to Helvetia (Switzerland) by Roman invaders some two thousand years ago. Crosses with Alpine flock-guarding dogs most likely gave the Bernese its cold weather stamina and milder temperament. □ Large and sturdily built, Bernese were primarily used as farm dogs, companions, and watchdogs—although not necessarily as protectors—alerting their owners to approaching visitors or predators. This even-tempered breed is extremely loyal and needs human companionship. □ Named for the canton, or district, of Berne, these gentle dogs were also used to pull carts from farm to market and guard cattle. Some of their early names reflected these tasks, such as Gelbbackler (Yellow Cheeks), Vierauger (Four Eyes), and Cheese Factory Dogs. □ Known as Berner Sennenhund in Switzerland, the Bernese is one of four varieties of Swiss mountain dogs. Its tricolor coat, black with symmetrical markings of rust and white, is similar to the others, but the longhaired, silky texture sets it apart. □ Like many breeds, the Bernese fell out of favor and its numbers dwindled in the early nineteenth century as the popularity of other breeds, including the St. Bernard, rose. Swiss cynologist Franz Schertenleib, aided by other dog fanciers, began searching the countryside around Berne for good quality breed specimens in the 1890s, and his efforts are credited with bringing the dog back from near extinction. A 1910 exhibition attracted 107 Bernese entrants. While most were without pedigree, three quarters were accepted on the basis of type, firmly establishing the breed once again.

Three years a young dog, three years a good dog, three years an old dog, . . . all else, a gift from God.
—SWISS SAYING ON THE LIFESPAN OF THE BERNESE MOUNTAIN DOG

DOBERMAN PINSCHER

THE DOBERMAN PINSCHER BEGAN as the taxman's best friend. Karl Friedrich Louis Doberman was a tax collector in the German city of Apolda in the late nineteenth century. He realized that he needed a trustworthy companion who would offer protection from thieves and encourage reluctant taxpayers to pay their dues. Coincidentally, Doberman also ran the Apolda dog pound.

Through a potential recipe of Rottweiler, German Pinscher, and German Shepherd Dog (with traces of Manchester Terrier, black English Greyhound, and Weimaraner), Doberman began to create a breed with a short, smooth, easy-to-groom coat—a dog that was not too large to manage, yet big enough to be imposing. Upon Doberman's death in 1894, his protégé, Otto Goeller, continued to fine tune what we now know as the Doberman Pinscher. The only working dog bred to be a human companion, it was named in Herr Doberman's honor.

In its early evolution, the Doberman Pinscher was bred to distrust strangers and to aggressively attack, earning its reputation as a vicious animal. The Doberman Pinscher is still portrayed as ferocious although its temperament has mellowed significantly. Affectionate with its human family, it continues to serve as a guard dog, offering determined, alert protection.

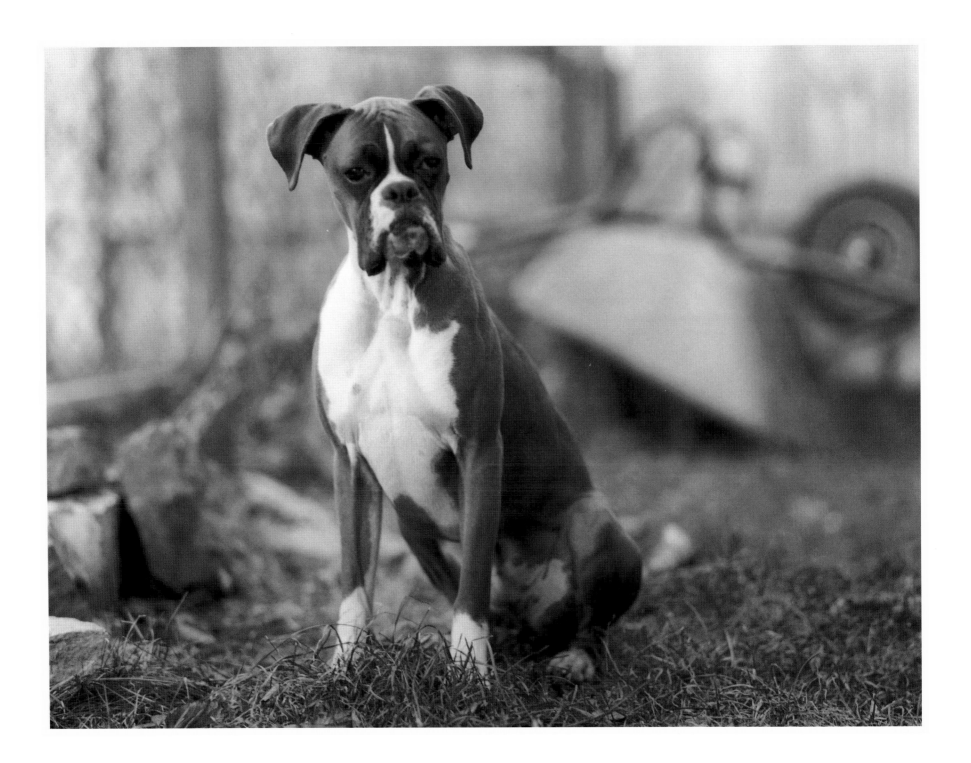

THE BOXER'S GENTLENESS TOWARD CHILDREN belies its origins as a fierce hunting dog. The Boxer's primary lineage comes from an old breed called the Bullenbeisser, a dog of Mastiff descent, whose name translates literally as "Bull-biter." ☐ The fierce Bullenbeisser originated in sixteenth-century Germany and Brabant as a hunting companion for the nobility, used to pursue bear, deer, and wild boar. It seized with its undershot jaw, a trait

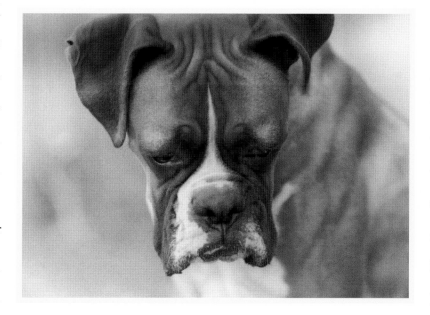

and held the hunted animals still in evidence in today's Boxer. With the breakup of the estates after the Napoleonic Wars in the nineteenth century, the Bullenbeisser was developed into the Boxer and bred to retain all the qualities of its ancestors while significantly softening its temperament and streamlining its appearance. It gained its attractive fawn color from the English Bulldog, its other chief relation. The origins of its name are uncertain, but it may be a bastardization of the word *beisser*, or derived from the original Bullenbeisser dog, known as Boxl. ☐ The Boxer has been employed in a surprising number of tasks throughout the centuries. A hunter foremost, its sensory precision has been called upon by police departments and during World War I it served as a courier dog. Today, the Boxer has been reinvented as a family dog. It shows an affinity for children and its imposing presence makes it a natural watchdog.

NEWFOUNDLAND

They are remarkably docile and obedient to their masters, serviceable in all the fishing countries,
and yoked in pairs to draw the winter's fuel home. They are faithful, good-natured, and ever friendly to man.
—WILLIAM YOUATT, *THE DOG* (1852)

THIS MILD-MANNERED DOG HAILS FROM THE EASTERN CANADIAN ISLANDS OF NEWFOUNDLAND and Labrador, which are subject to some of the highest tides in the world. The "Newf's" physiology adapted accordingly. A superb swimmer, it is large enough to carry a drowning man ashore and there are many stories of the Newf's heroic rescues. ☐ A stiff, oily outer coat repels water, and a fleecy undercoat protects it from icy, harsh climates. Instead of dog-paddling, the Newfoundland breast-strokes through the water; its powerful hindquarters, fully webbed feet, and considerable lung capacity allow it to go great distances on both water and land. A Newf's eyes shut tight to keep out water and infection. Its pendulous flews (droopy upper lips) allow it to breathe while carrying something as it swims. ☐ Black is the most common coat color, although the black-and-white Newfoundland, known as the "Landseer," was depicted in many of Sir Edwin Landseer's famous dog paintings. ☐ In addition to its skill in water, this gentle giant's bulk, strength, and sweet personality make it suited to draft work. Newfs were—and continue to be—used for myriad tasks, including pulling carts, fishing, and rescue work. Known for being exceptionally good with children, their protective instincts earned the Newfoundland the nickname "Nature's Babysitter."

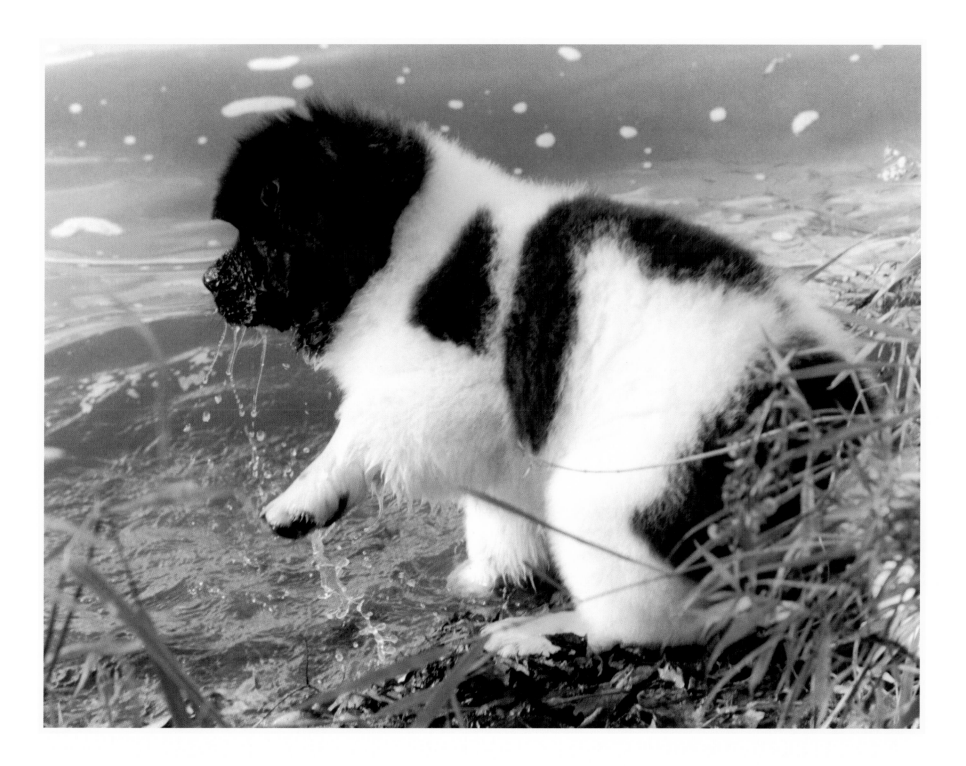

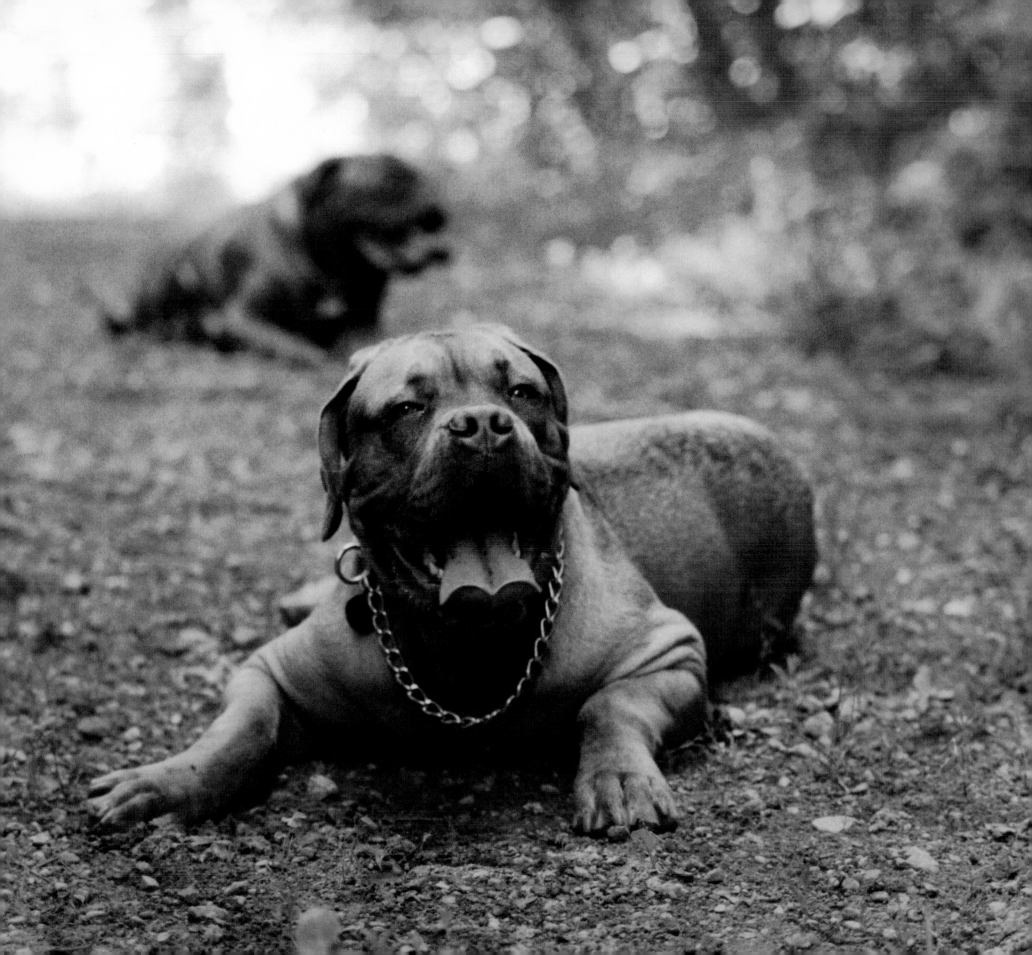

DOGUE DE BORDEAUX

THE DOGUE DE BORDEAUX'S FRENCH ROOTS CAN BE TRACED TO THE FALL OF THE ROMAN EMPIRE. In the intervening centuries, Dogues have served as war dogs, flock guardians, and beloved watchdogs. However, their years as loyal servants were preceded by years of combat. The Dogue de Bordeaux was used in gladiator sports, pitted against bulls and bears, and later in battles of Dogue against Dogue. French dogfights were considered equal to Spanish bullfights in entertainment.

Near the end of the Middle Ages, the Dogue de Bordeaux was more practically used to drive cattle. When the need for cattle drovers declined, the majestic Dogue served as a loyal guardian, providing personal protection to estates. Many perished during the French Revolution protecting their masters and property.

Traced back to the Asian Mastiff and Greek and Roman Molossus, the Dogue's physique echoes the lion; the breed boasts the biggest head of all dog breeds, accompanied by a powerful, muscular body with a strong neck and broad chest. In spite of its menacing appearance, the Dogue de Bordeaux is gentle and calm—until called upon to fearlessly defend its master's home.

There is no doubt about it that he is a most formidable-looking creature,
of enormous strength, and for this reason he should make an ideal guard for a gamekeeper.
—A. CROXTON SMITH, *EVERYMAN'S BOOK OF THE DOG* (1909)

GREAT PYRENEES

THE DYNAMIC LANDSCAPE THAT SEPARATES THE IBERIAN PENINSULA from France has been under the careful watch of *le Grande Chien des Montagnes* (the Big Dog of the Mountains) for millennia. Bred to guard livestock, it does not act like a herding dog but, instead, blends into the flock as it monitors the horizon for predatory threats. Nocturnal

by nature, the Great Pyrenees has an extraordinary ability to recognize unwelcome intruders, including the bears, wolves, and feral dogs that stalk in the darkness. □ One of the most curious qualities of this breed is its dichotomy of fierceness and gentleness. The Great Protector nurtures young animals and looks after the weak and sick within the herd. It accepts and valiantly defends the herding dogs that it works with, as well as other diminutive dogs. □ Isolated in the Great Pyrenees Mountains, the breed's light-colored, wooly, dense coat enables the dog to camouflage itself among the flock. White, or predominantly white, with markings of badger, gray, reddish brown, or varying shades of tan, this working dog is not without elegance and beauty. Its inherent devotion to the peasant mountain shepherd, family, and flock led to its endearment as *Pastou* (pronounced *patou*), which means "shepherd" in old French.

PORTUGUESE WATER DOG

EMPLOYED FOR CENTURIES ALONG PORTUGAL'S COAST, the Cao de Agua (literally, "Dog of Water"), or Portuguese Water Dog, was valued by fishermen for its seafaring abilities. Tireless swimmers, they herded schools of fish, retrieved broken nets, and carried messages between boats and the shore. Many villagers depended on these intelligent dogs for their livelihoods. "Porties" also served as a sort of foghorn, barking continuously to warn others of a boat's presence. □ The Portie's coat is one of its

most striking features. It is waterproof and brown and white hair that can be wavy or wavy coat falls gently on the body and clip or working-retriever clip. In the lion hindquarters, the muzzle, and the base of warm while allowing the hind legs freer offered a handhold for the occasional about an inch long evenly over the body. die out in Portugal at the beginning technology, war, and obsolescence, there living Porties. In the 1930s, a wealthy

resembles a Poodle's, with black, white, or have compact, cylindrical curls. □ The exhibits a slight sheen; it is worn in a lion clip, worn by the original fishing dogs, the the tail are shaved. This kept the body movement. The unshaven tip of the tail man overboard. The retriever cut is left □ The Portuguese Water Dog began to of the twentieth century. A casualty of were at one point as few as twenty-five Portuguese shipping magnate set out to

save the breed; other rare breed fanciers also contributed to the breed's revival. There are currently thousands of Porties throughout the world, many of which can be found channeling their ancient skills in modern athletic pursuits—both on land and in water.

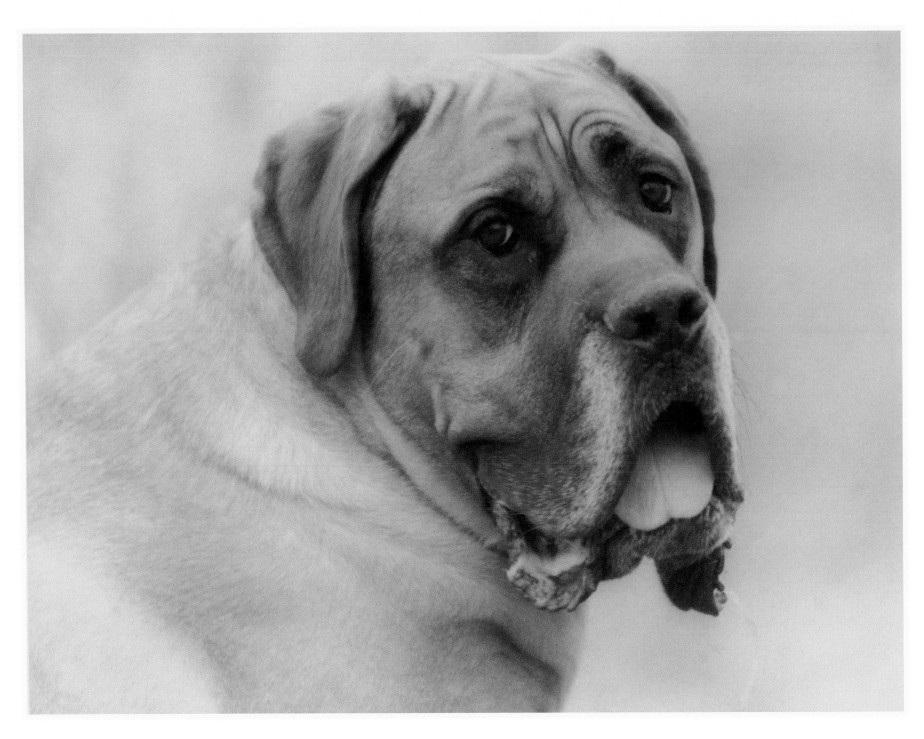

Where oft the mastiff skulks with half shut eye, And rouses at the stranger passing by . . .

—M. B. WYNN, *THE HISTORY OF THE MASTIFF* (1886)

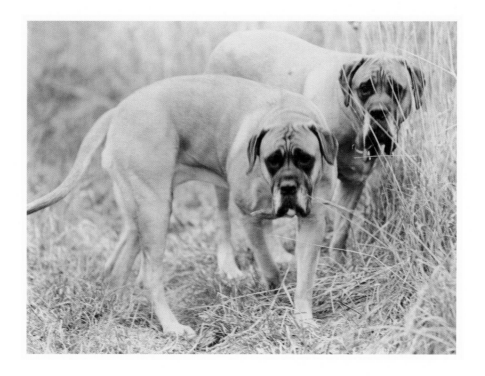

IT IS NO SURPRISE THAT THE WORD *MASTIFF* SHARES THE SAME LATIN ROOT AS THE WORD *MASSIVE*. Though most often recognized for its formidable size, the Mastiff also deserves to be acknowledged as the rootstock for many hound, setter, and Bulldog breeds today. □ Quite possibly the first dog bred by humans to serve a specific purpose, the Mastiff was developed during the Roman Empire to guard and protect the mountain passes in what is now France. Mastiffs were fierce guardians against the large predators roaming the mountains and plains of central Asia and the Middle East. The early Assyrians depicted the dogs battling lions. □ The breed was also used for bullbaiting and dogfighting during the Middle Ages, and for aiding in bear and wolf hunting in Saxon times. Each change in function encouraged breeders to make slight physical changes that enabled the dog to better perform in its new role. These minor changes shaped the familiar form of the Mastiff today—a grand, symmetrical frame with a short fawn- or apricot-colored coat, accompanied by dark muzzle, ears, nose, and eyes.

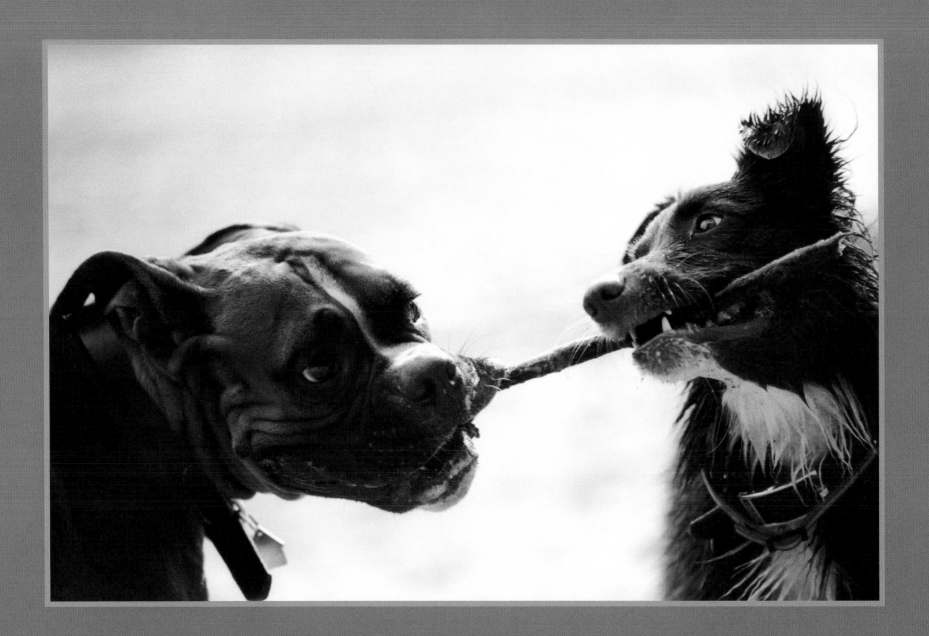

Cat-Dog Marriage
MARY GAITSKILL AND PETER TRACHTENBERG

In an instance of unprecedented interspecies cooperation, Skip, a reporter for *Hydrant Times*, and Suki, of *Litter Magazine,* have teamed up to interview cat-dog couple Mary Gaitskill and Peter Trachtenberg on the way their frankly outlandish marriage works. Here's what they found out:

Part One

Dog to Dog: Skip speaks to Peter Trachtenberg on the unusual arrangement he has chosen.

SKIP: So, when you first met, what stopped you from, you know . . . chasing her?

PETER TRACHTENBERG (PT): Well, I did bolt at her a couple of times, but she hissed and gave me a swipe across the nose.

SKIP (disappointed): And that stopped you?

PT: I realized I'd have to proceed more slowly. Part of me just wanted to grab her by the neck and—

SKIP: Yeah! Yeah!

PT: —shake her. But I was . . . I was curious. She was so different from us. Part of it was the way she just stared into space. She wasn't waiting for something good to come along, you know, something to eat, or someone to pet her. I wanted to know what she was staring at, and what enabled her to just be so still.

SKIP: Hmm.

PT: Plus, I did get the feeling she was signaling me.

SKIP: She wagged her tail? She pawed the ground?

PT: She blinked. Slowly. It was kind of beautiful.

SKIP: Hmmph.

PT: And when I stayed still myself and blinked back—eventually, she came and brushed against me. She was very soft.

SKIP: But I'm still not really understanding. What's the good part here?

PT: For one thing—she usually doesn't like to eat the same thing. That means more for me!

SKIP: I hear that! But what about playing? Chasing, barking—

PT: We can play—though I'd say she's not really interested in sticks.

SKIP: What about balls?

PT: She knows about balls—she likes to paw them, but she doesn't know the first thing about fetching. She won't bring it back. No matter how many times—

SKIP: Dumb.

PT: No, that's not it. It's something else. The thing about a cat is, they're not going out of their way to please you. Or rather, they don't do it automatically. So when she does do something like, bring me a mouse or . . . sometimes start licking on me . . . it's special.

SKIP: I'd rather have a Snausage myself, but . . .

PT: That's because you don't understand. It's something special, the thing you can have with a cat. Look, we're hierarchical. We've evolved so that we're always looking up—for another dog, or a person to please. Cats come from another

place, a world before, where they're alone, basically, and there aren't other creatures to please.

SKIP: So it's true—they're selfish.

PT: No, Skip. They're very dedicated and devoted. But not to a person or even a cat. It's to something bigger and more mysterious than that. Something deep inside that they're listening to: maybe it's their nature. We listen for another dog to bark or a person to say sit or here. A cat is listening to something that speaks from inside them. And its not about sitting or rolling over. It's asking them: Do you understand? And when they blink, it means yes.

SKIP: Heavy. (Starts licking his butt.) So how do you know who's alpha?

PT: It's actually more fun than with a dog. With another dog, it's all straight up and clear pretty fast. With a cat, you let her think she's alpha—but really, you are.

SKIP: That sounds sneaky—like something they would do.

PT: That's the exciting part—beating them at their own game! It's like, you know, a trick!

SKIP (getting excited): Go dog! But here's another really bad thing everybody says about them: if our person is in trouble, you or me, we're gonna get into it. We're gonna fight for our person no matter what—or at least we'll bark our flippin' brains out, y'know? Whereas, I've heard a cat will just sit there and do nothing, not even squeak while—

PT: What would you expect them to do? They're little.

SKIP: But even a little dog—

PT: Well, true. They aren't as brave as us, that way. Also, and I know this will sound like the stereotype and in a way it is—it's their curiosity. Even if it's something terrible, they want to stare and see what happens.

SKIP: But that's creepy.

PT: You could look at it like that. But the detachment is courageous too, in a way. It's, like, accepting the void.

SKIP: I still think it's flippin' creepy.

PT: Well, it's who they are. You've gotta take the gristle with the tenderloin.

SKIP: Hey, gristle's not bad—I'll eat it!

Part Two

Cat to Cat: Suki talks to Mary Gaitskill about her daring and unconventional marriage.

SUKI: So all of catdom wants to know—what are you doing with it?

MARY GAITSKILL (MG): At first, I didn't know myself. But it's true what people say about them—they really are loveable and loyal.

SUKI: When they're not trying to chase you up a tree or worse—I mean, didn't he ever try to tree you?

MG (blinking luxuriantly): Of course he tried.

SUKI: You put him in his place?

MG: I did have to smack him once. But mostly I just cleaned my paws while he watched with the most curious and longing expression. That's what got to me—he had such deep, expressive eyes.

SUKI (tapping her tail): The better to eat you with.

MG (pointedly ignoring her): I never thought a dog could be as deep as we are. But in his own way he is. His eyes show everything, and all in such broad, deep tones. We're all about subtlety

I once asked him a variation on the Zen riddle: if a dog doesn't bark in the forest, is the dog there? You should've seen the panicked look on his face! I had to sit next to him and purr for hours.

and nuance—they're all one big thing at a time. It's kind of amazing—and sometimes it's hilarious. He once took me for a nice trip on my birthday, and as we were leaving the hotel to get some fish, he stopped dead in his tracks and stared at a truck that was turning into the driveway. If he'd just been cool, I wouldn't have thought anything of it—I mean, they're very reactive to trucks—but he started looking from the truck to me and back, all the while licking his lips, which were starting to quiver—well, it was pretty obvious, it was a flower truck and they were for me! It was so cute!

SUKI: I'll admit, that is sweet. But level with me: Aren't there problems?

MG: Of course—starting, I would say, with a general lack of elegance. Just consider the absurd grunting noises they make in their sleep. Then there's the water thing; he can't use the bathroom or the kitchen without shaking water all over everything, I mean everything, and of course I have to walk through it and it gets all over my paws. And it's true what they say, dogs really will eat anything—you wouldn't believe some of the things he brings to the table.

SUKI: What about barking?

MG: He does go off on barking jags. I used to get startled and vigilant every time, but now I just let him wear himself out.

SUKI: I've always wondered—what are they barking at?

MG: That's the thing. Sometimes he's barking at something, sometimes at nothing, sometimes at everything. That's a difference between us and them: they just want you to know they're there. I once asked him a variation on the Zen riddle: if a dog doesn't bark in the forest, is the dog there? You should've seen the panicked look on his face! I had to sit next to him and purr for hours.

SUKI: Are there any advantages, and if so, what are they?

MG: You can say it in one word: Joy. Dogs are really into joy. All that running and leaping and barking—yes, its undignified and idiotic, but its fun, the kind we had when we were kittens.

SUKI: (Looks away and yawns.)

MG: And on a practical level, dogs are great to have at a party, or any situation where you're surrounded by people. They'll go ahead and scout, they'll run interference. They'll go around wagging their tails, sniffing, putting their paws on everybody—while you just quietly size everything up, decide who you want to be near and who you don't. If you want, you can even go find a nice place to lie down, he'll be out there keeping everybody at bay.

SUKI (ears coming forward intently): Kind of like protection?

MG: Yes. There's nothing like lying down with one—they're so muscular and dense.

SUKI: What is it they say? Lie down with dogs, get up with—

MG: Face it, Suki—we're going to get up with fleas anyway.

155

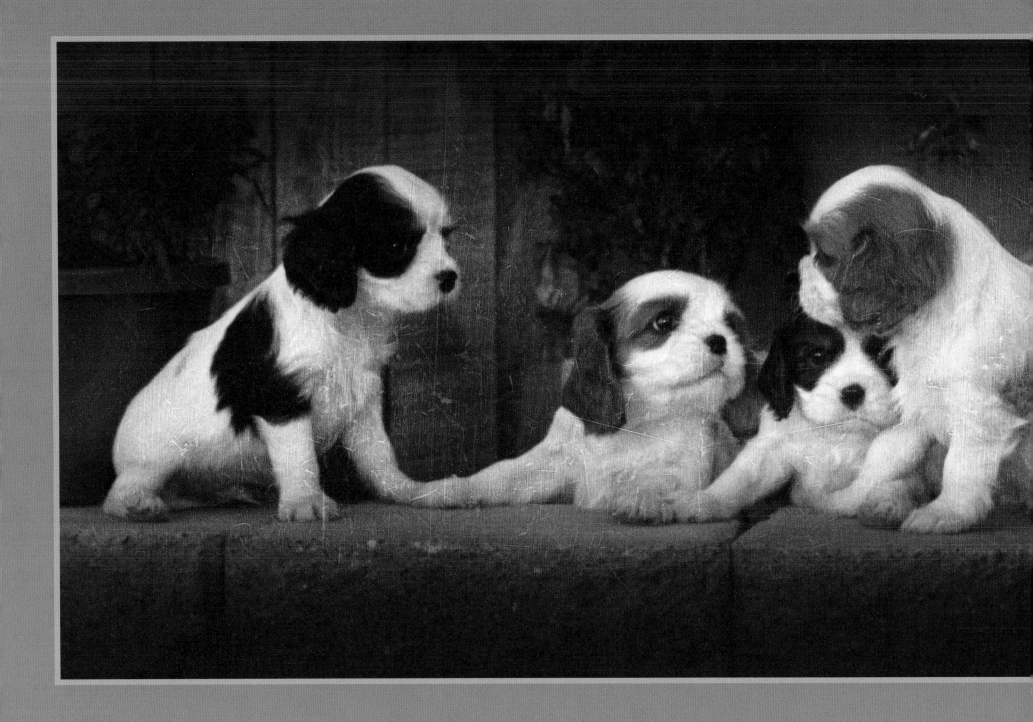

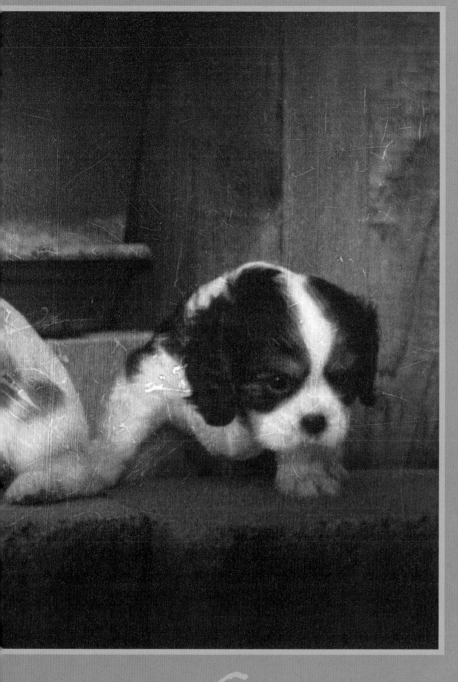

TOYS

comfort and companionship

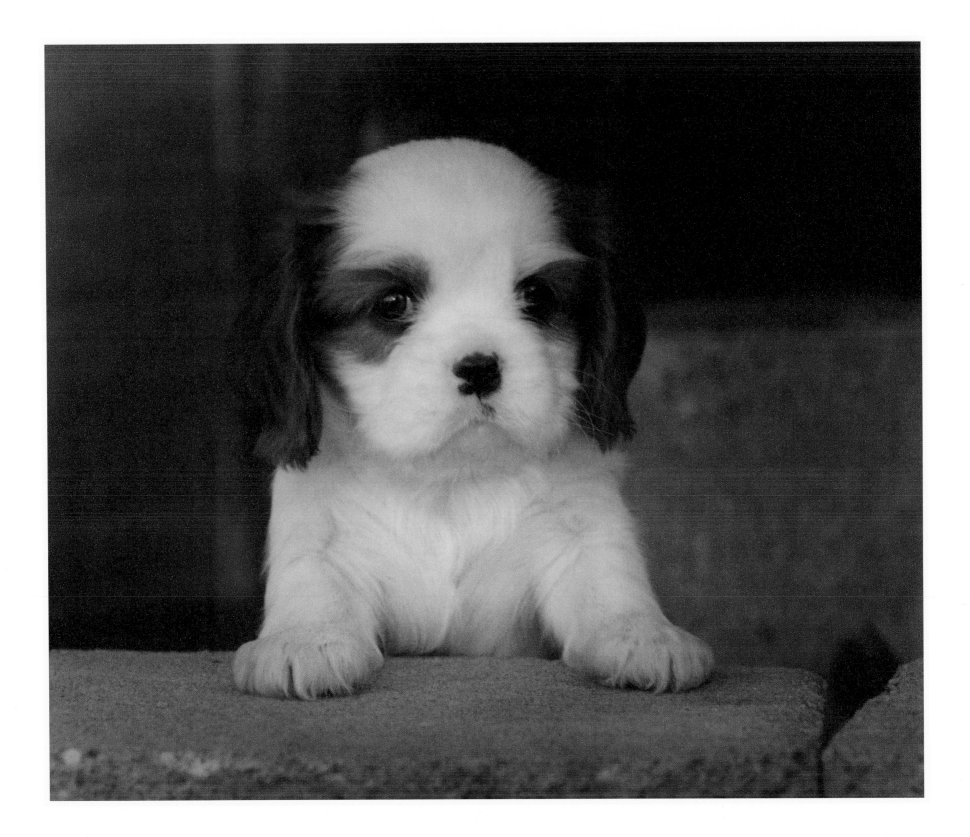

The Merry Monarch did many more foolish things
than take under his Royal care and favour, and thereby raising to Court,
the beautiful toy spaniel which still bears his name.

—HUGH DALZIEL, *BRITISH DOGS* (1881)

LIKE MANY OTHER DOGS, THIS SPANIEL FELL VICTIM to the politics of its owners. A favorite of Britain's King Charles I, the Cavalier King Charles Spaniel's royal popularity continued into the rule of King Charles II. But with the fall of the House of Stuart, power shifted to William and Mary, who preferred the Pug. Suddenly, ownership of a King Charles Spaniel could be viewed as a sign of treason. The population of these small spaniels diminished and soon they could only be seen in oil paintings and tapestries.

In the early 1920s, a well-to-do American named Roswell Eldridge searched for a pair of spaniels similar to the variety depicted in paintings of that era, including Landseer's *The Cavalier's Pets*. Since his efforts came to naught, Eldridge announced at the 1926 Cruft's Dog Show that he would award a prize of twenty-five pounds each for the male and female bred to closest resemble the original King Charles Spaniels. The offer continued for the next five years, and this breeder competition is credited with reviving the toy spaniel breed we know today.

PUG

THE PUG'S DISTINCTIVE FOREHEAD WRINKLES RESEMBLE THE CHINESE CHARACTER FOR PRINCE, three horizontal strokes cut through by a vertical line. This seeming accident evokes the dog's royal origins. The Pug most likely descended from the ancient Chinese Lo-sze dog, which also carried the "prince" mark and is similar to the Pekingese. ☐ Pugs were bred as lap dogs for the Chinese emperors. They lived lavishly, sometimes guarded by soldiers. Appreciation for the dog extended to Tibet, where it was kept as a pet by Buddhist monks, and it kept company with members of the royal courts. As with many breeds with royal origins, Pugs were originally much larger dogs. Aesthetic preferences dictated its decreasing size, until it eventually became the small dog it is today. ☐ Historical record shows a fascinating evolution of the usage and application of the term *pug*. It first appears in written English in 1566 and was widely used as a term of affection. It accumulated a variety of connotations throughout the seventeenth century, including courtesan, demon, imp, and others. By the middle of the eighteenth century, the *Oxford English Dictionary* catalogued the word as "a dwarf breed of dog resembling a bull-dog in miniature." It is unknown exactly why the dog acquired the name; it derives from the Latin *pugnus*, meaning "fist," perhaps a nod to the closed-fist appearance of the Pug's face.

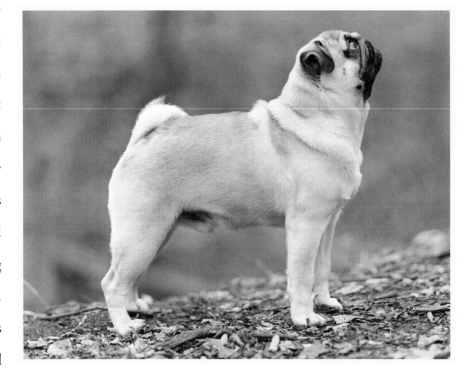

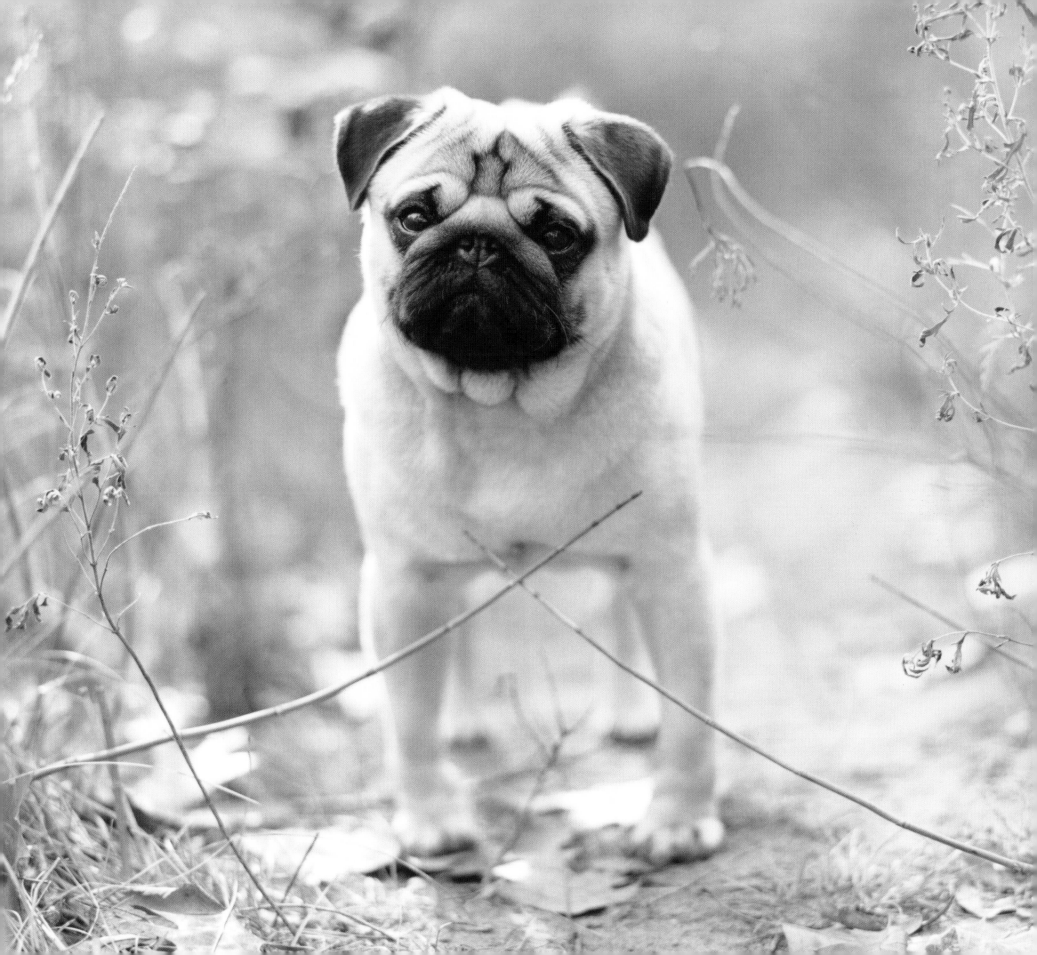

CHIHUAHUA

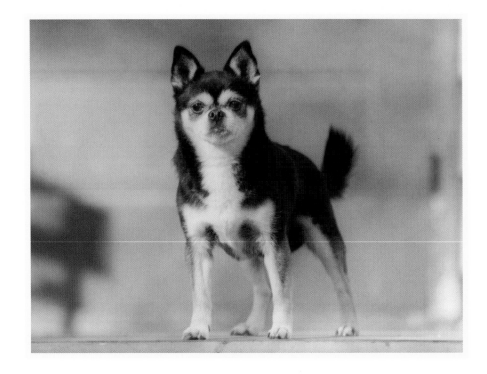

THE ANCESTORS OF TODAY'S CHIHUAHUA ARE SURROUNDED by pre-Columbian history and legend. By the beginning of the twelfth century, the ancient Toltecs had conquered most of central and southern Mexico. They kept a small, heavy-boned, long-coated dog called the Techichi. These dogs are thought to have been bred with the slight, hairless Chinese Crested brought from Asia to Alaska via the Bering Straight, creating the tiny Chihuahua. Another theory points to a crossing of the Techichi with a small black-and-tan terrier brought to Mexico by Spanish invaders. ☐ Archeologists have unearthed the remains of these petite dogs in human graves throughout Mexico. The Toltec, and later the Aztecs, believed that the Techichi and the Chihuahua guided and protected the human soul from evil spirits in the afterlife, and served as guardians of boundaries between this world and the next. Alert and confident yet compact, the Chihuahua gracefully carried this grand responsibility on its diminutive shoulders.

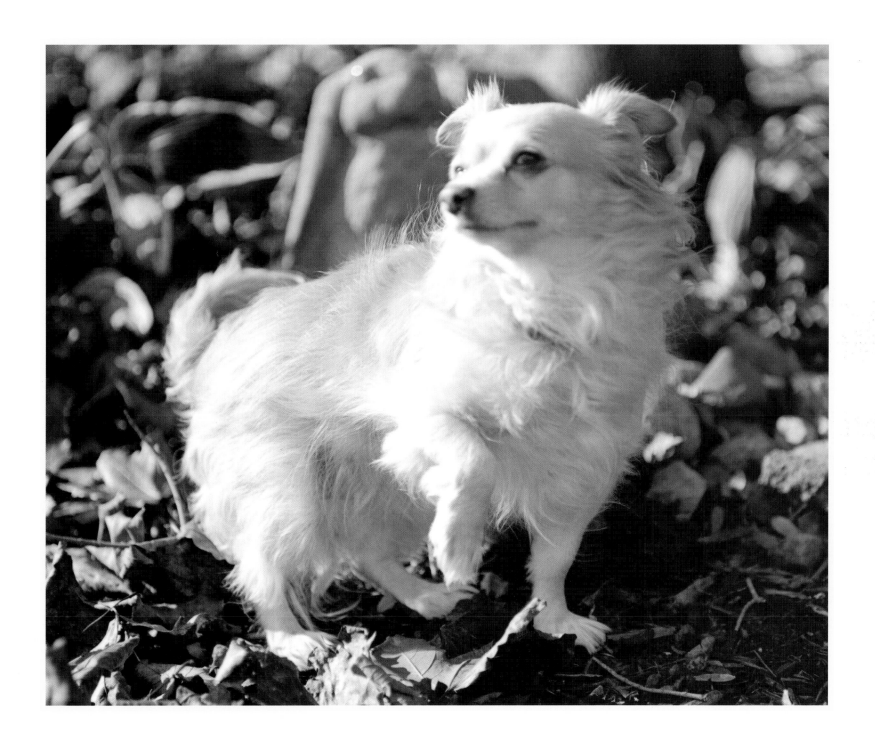

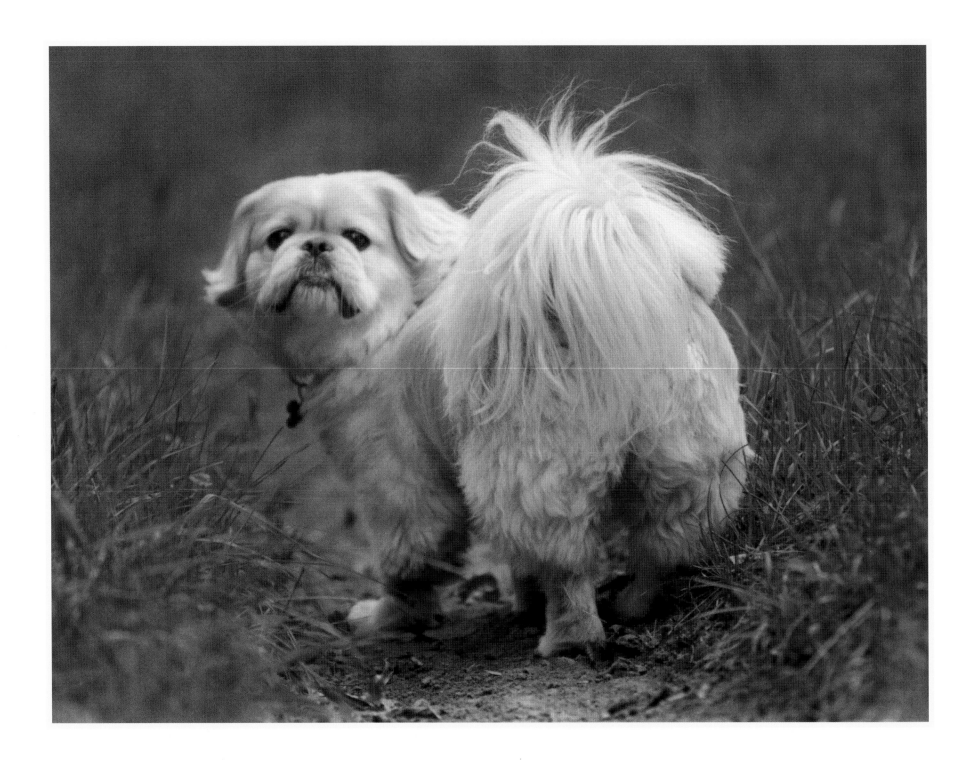

THE GREAT LION, IN HIS DESIRE TO WED THE SMALL MARMOSET, asked Buddha to shrink his size. The result of their union is the Lion Dog of China. Considered a living embodiment of Buddha, the Pekingese was revered in ancient China for its mythical lineage and its manifestation of ancient Chinese standards of beauty. □ The Pekingese is literally a work of art, a product

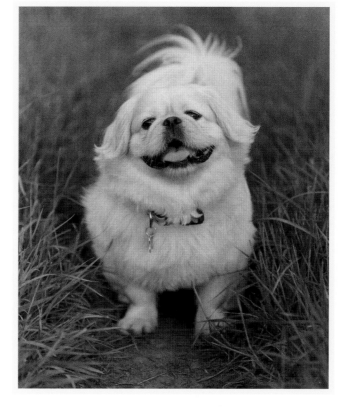

of the ancient Chinese preoccupation a "child substitute." A truly royal dog, companion to the emperor and his breed's history remains the stuff of in paintings and royal breeding dynasty in the eighth century. Pregnant and poetry depicting perfect dogs. It be unable to wander or leave the palace. it in a small wire cage stunted the dog's hand to hand so it touched the ground its nose to discourage its taking on costumes, it slept in its own tapestry- dishes, and was attended by servants

with aesthetics and the desire to create it was bred in ancient China as a entourage. Although much of the legend, its lavish lifestyle was recorded catalogues beginning in the T'ang mother dogs were surrounded with art was bred bowlegged to insure it would Diminutive stature was prized; housing growth and slaves would pass it from only upon maturity. Slaves massaged length or shape. Outfitted in colorful adorned apartment, ate from porcelain who slept at its bedside each night.

Even today, its temperament—independent, direct, and dignified—can be attributed to its royal lineage. □ The Pekingese developed into the dog we recognize today during the Manchu dynasty, beginning in the seventeenth century. Although the Pekingese found its way to England during a British invasion of China in the 1850s, its characteristics have remained largely unchanged for more than two thousand years.

ITALIAN GREYHOUND

THE ITALIANS PROBABLY DID NOT BREED THE ITALIAN GREYHOUND, but they did immortalize them. Ancient Mediterranean decorative artifacts, including mummified miniature Greyhounds excavated from Egyptian tombs, depict the breed more than two thousand years ago. This supports the near-universal theory that the Italian Greyhound originated in Turkey and Greece and then migrated to other countries as the pets of Egyptian, Greek, and Roman aristocrats. □ The Italian Greyhound was most likely bred for hunting small game and vermin, but also as a companion. The smallest of the sighthounds, the Italian Greyhound was bred down to an even smaller version of the Greyhound, but still bears the typical sleek lines and slender proportions. Its fine head and brilliantly communicative eyes round out the physical expression of elegance and grace. This petite breed served as a companion to royalty who favored their high-stepping gait, evocative of the majestic royal horses. □ By the sixteenth century, these tiny gazehounds were available in southern Europe, and had become particularly popular in the royal courts of Spain and Italy. The Italian Greyhound rapidly gained popularity and its rendering in Italian Renaissance art points to how the breed acquired its name. □ Although it is a toy breed, it is a sighthound first, and it cannot deny its instinct to hunt and chase game. Sharing the Greyhound's temperament, it enjoys spurts of running and surveying the environment from all angles—especially high perches, like the back of a sofa or chair. Almost catlike, it enjoys sunbathing and window views.

The Italian Greyhound should be a dainty replica in miniature of the larger coursing variety. In habits he is very pleasing, graceful in movements, and much devoted to his mistress. He is particularly suited to the drawing-room, his close, fine coat being kept clean with a minimum of trouble. A lined basket suffices for his habitation, and he is nothing like so delicate as one might imagine from his slender appearance.

—A. CROXTON SMITH, *EVERYMAN'S BOOK OF THE DOG* (1909)

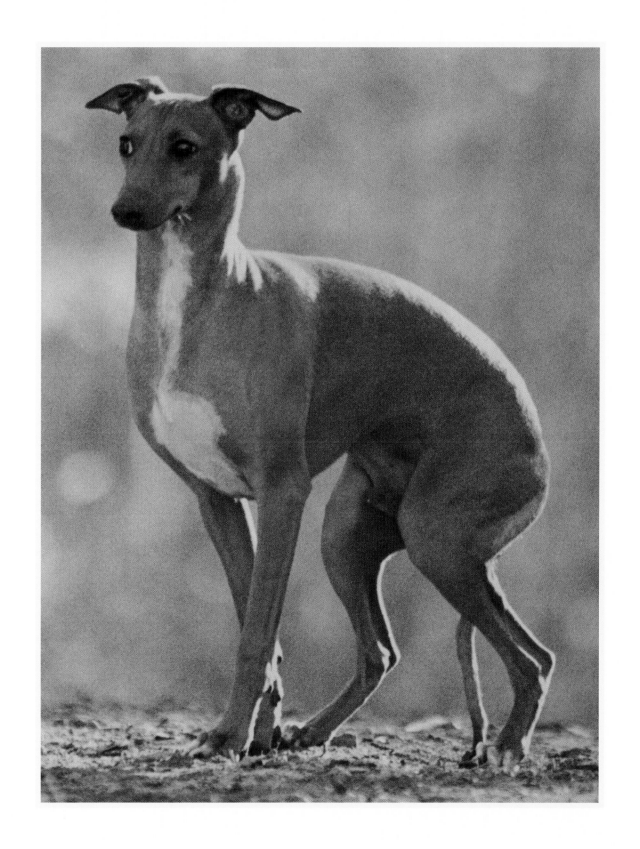

YORKSHIRE TERRIER

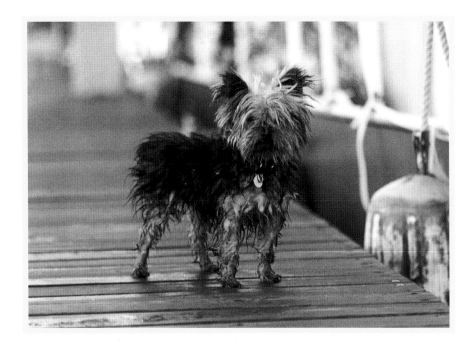

THE YORKSHIRE TERRIER ROSE FROM THE SOOT-BLACKENED, hardscrabble streets of mid-nineteenth-century industrial Britain. Introduced in England by Scottish weavers, it was bred to catch and kill rats that infested the mills and mines. The "Yorkie" was crossed with local terriers, perhaps the now-extinct Clydesdale and Paisley terriers, both of which had silky blue coats. □ Because so many Scottish immigrants worked as coal miners, the Yorkie's partly golden coat may have been developed to make the dog easier to see in the mines, where it was used to exterminate vermin. □ Originally known as the broken-haired Scotch Terrier, Angus Sutherland bestowed the dog with its current name in 1870, stating in a magazine interview: "They ought no longer be called Scotch Terriers, but Yorkshire Terriers, for having been so improved there." The original Yorkie was much larger than today's breed, but eventually evolved into a fashion accessory for women who carried them in their handbags or under their arms—a tradition which has often reemerged in subsequent eras, despite the dog's spirited temperament so reminiscent of its working past.

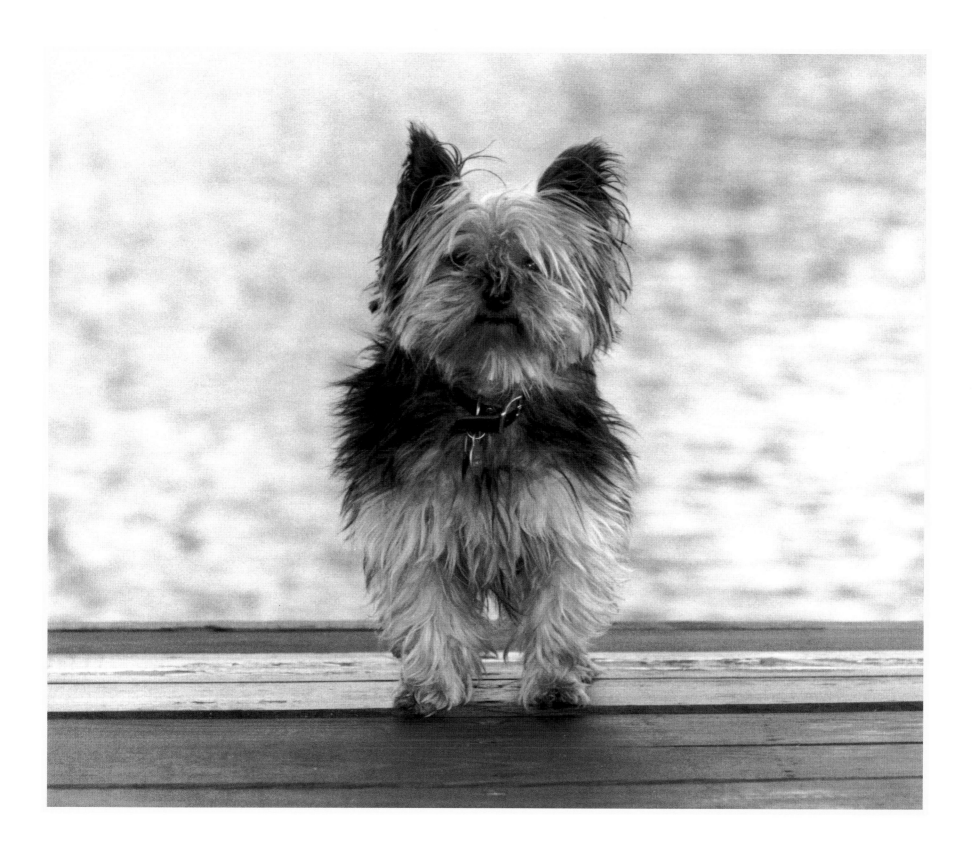

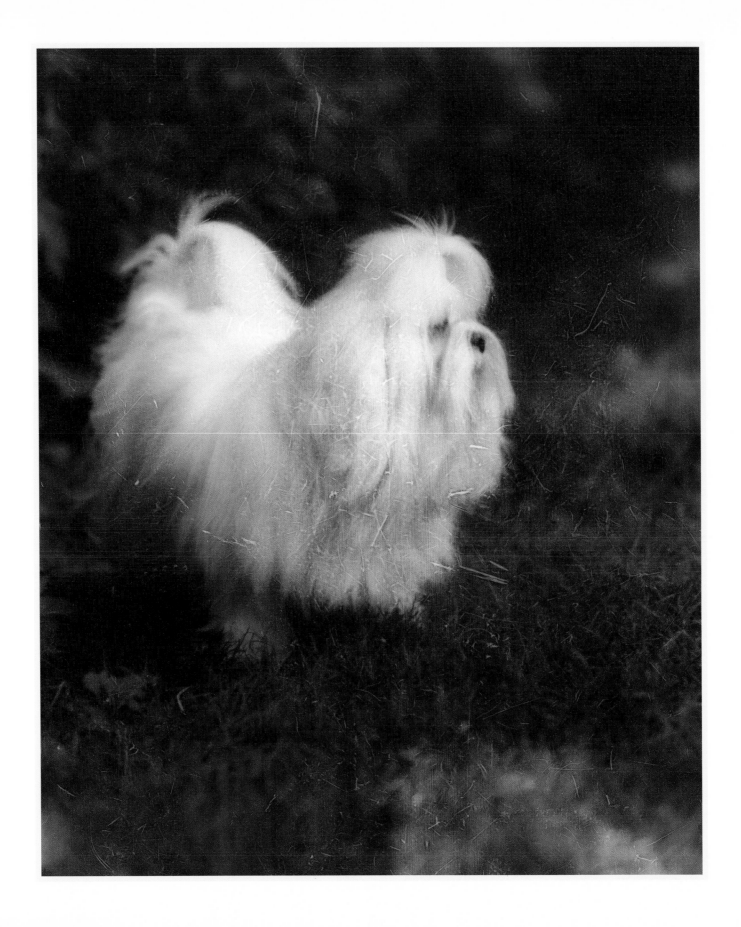

A lion head, bear torso, camel hoof, feather-duster tail,
palm-leaf ear, rice teeth, pearly petal tongue, and movement like a goldfish.
—PEKING KENNEL CLUB BREED STANDARD (1938)

THE SHIH TZU'S ORIGINS ARE MYSTERIOUS. Its roots are in Tibet, but these silky-haired dogs have shown up in Chinese paintings and objets d'art dating as far back as 624 AD. The Shih Tzu became a house pet of the Ming dynasty, which ruled China from 1368 to 1644. The dogs were considered holy and raised in the Forbidden City of Peking. □ *Shih Tzu* means "Lion Dog," and the lion is a potent Buddhist symbol associated with regal bearing, strength, and power. Buddha's teachings are sometimes referred to as the "Lion's Roar." □ Lions were not indigenous to China, however, so Tibetan lamas and the Chinese bred their toy dogs— including the Tibetan Spaniel and the Lhasa Apso—to resemble them. These "lion dogs" were raised in the lap of luxury, which may account for the Shih Tzus' self-importance and aristocratic comportment. □ Often called the "Chrysanthemum-Face Dog" for the way its hair grows haphazardly around its face, the Shih Tzu also features a colored spot on its forehead where the Buddha is said to have bent down and placed a kiss, and a flash of white where Buddha laid his finger in blessing. The Shih Tzu's heavily plumed tail arches over its back like an umbrella, symbolizing the Buddha's ability to protect it from worldly imperfections.

HAVANESE

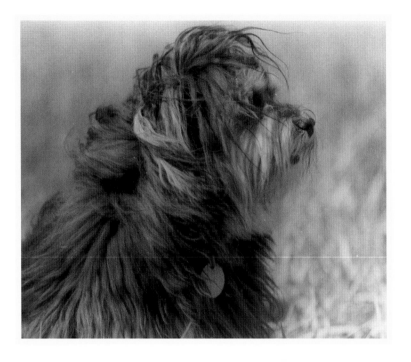

WHEN MEDITERRANEAN MERCHANTS NEGOTIATED FOR OPEN TRADE WITH CUBA, they presented the wives of local businessmen with these sprightly and elegant dogs. Truly a symbol of affluence, the Havanese was never bred to be sold but given exclusively as a gift. Cuban peasants were forbidden from owning the elite breed. ☐ Believed to be a descendant of the Bichon Frise, the Havanese acclimated to the tropical climate, developing a coat with a light, soft, wavy texture that emulates raw silk floss and provides insulation against the extreme heat. Profuse but not woolly, its protective coat was never clipped as intricate grooming would expose it to the elements. Neither was the full hair atop its head tied into a topknot since it served as a barrier for the eyes against the harsh rays of the sun, much like a visor. ☐ Less nervous and fragile than other toy dogs, the sturdy Havanese possesses a clever, playful temperament that thrives on human companionship. A cheerful, energetic playmate, it will patiently tolerate the precocious, clumsy nature of those just learning to walk.

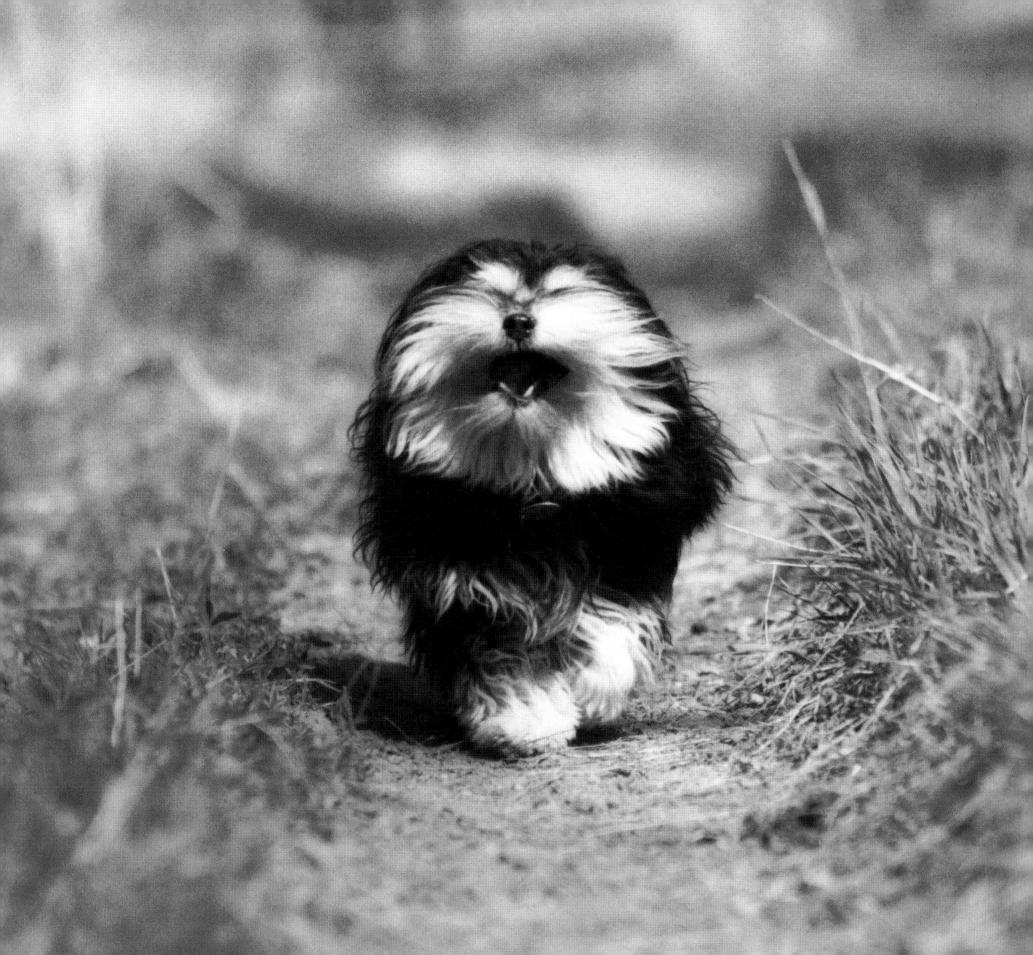

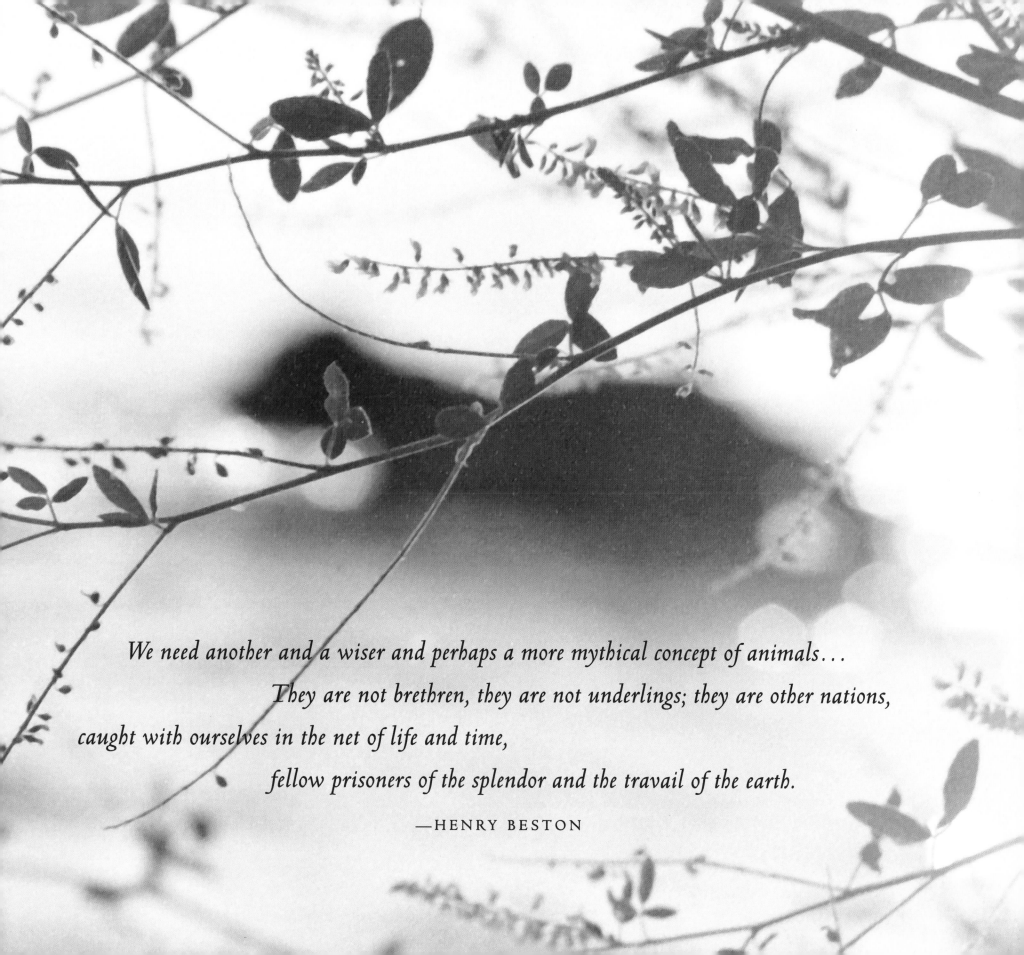

We need another and a wiser and perhaps a more mythical concept of animals...
They are not brethren, they are not underlings; they are other nations,
caught with ourselves in the net of life and time,
fellow prisoners of the splendor and the travail of the earth.

—HENRY BESTON

ACKNOWLEDGMENTS

The work on this project has been ongoing for the better part of ten years. First and foremost, I offer my deepest gratitude to all of the dogs and owners who worked with me. I wish that I could name especially all of the dog friends, breeders, trainers, and fellow enthusiasts who have shared their passion, knowledge, and experience. To all who revel in giving their dogs the best lives they can have, you have my deepest admiration.

A special thanks to Jack and Carol Anderson, Karen Casanova, Barbara Cohen, Lyn Cowan, Michael Dixon, Kevin Fenton, Nan Fulle, Kathy Graves, Kari Finkler, Lisa Havelin, Lyle Jackson, Kathie Johnston, Stacy Lewis, Sarah Liotta, Mary Ludington Sr., Ann Marsden, Leeandra Mizzi, Kira Obolensky, Keri Pickett, Lisa Ringer, Gary Chassman at Verve Editions, and Sydny Miner at Simon & Schuster.

To the essayists who contributed their insight, wit, and scholarly work: the breadth and depth of your writing have brought me to an ever more profound understanding of the importance of the dogs in our lives. I am grateful to have the opportunity to share your wisdom with others.

I have received enormous help from the writers who sifted through the wealth of information about these breeds: you found the essence in each of them. My heartfelt gratitude to Emily August, Richard Hawkins and Barbara Heidenreich, Jaime Kleiman, Camille McArdle, Sarah Peirce and Sarah Sawyer. Wendy Lewis provided insight and invaluable comments on the manuscript, Eliza Shanley's copyediting was precise and relentless, and J. T. Lowen is every author's dream of an editor.

Finally, to my partner Kevin Kling, whose shared love for our animals and gift for finding the extraordinary in the ordinary has been my greatest inspiration. Without you, this book would not have been begun nor completed. And to our dogs, Fafnir, Olive, and Dan, you have tracked love over every page.

—*MARY LUDINGTON*

NOTES TO PAGES 127–131

1. Nicholas Barnaud Delphinas, "The Book of Lambspring," in *The Hermetic Museum*, vol. 1 (London: John M. Watkins, 1953).

2. Brian Branston, *Gods of the North* (London: Thames and Hudson, 1955), 170.

3. Arthur O. Lovejoy and George Boas, *Primitivism and Related Ideas in Antiquity* (New York: Octagon Books, 1965), 142.

4. Ibid., 145.

5. Xenophon *The Banquet* 4.40.

6. Lovejoy and Boas, *Primitivism and Related Ideas in Antiquity*, 135.

7. I. G. Kidd, "Cynics," in *The Encyclopedia of Philosophy*, ed. Paul Edwards (New York: MacMillan, 1967), 285a.

8. Patricia Dale-Green, *Dog* (London: Rupert Hart-Davis, 1966), 85.

9. Edgar Herzog, *Psyche and Death: Death-Demons in Folklore, Myths, and Modern Dreams*, trans. David Cox and Eugene Rolfe (Woodstock, CT: Spring Publications, 1983), 47.

10. Ibid., 44.

11. Ibid.

12. Ibid.

13. 1 Cor. 15:55.

14. Muhammad ibn Umail al-Tamimi, *Book of the explanation of the symbols: Kitab Hall ar-Rumuz*, ed. Theodor Abt, Wilferd Madelung and Thomas Hofmeier, trans. Salwa Fuad and Theodor Abt (Zurich: Living Human Heritage Publications, 2003), 149–50.

SELECTED BIBLIOGRAPHY James Hillman

Clark, R. T. Rundle. *Myth and Symbol in Ancient Egypt*. London: Thames and Hudson, 1959.

Ginzberg, Luis. *The Legends of the Jews*. 7 vols. Philadelphia: Jewish Publication Society, 1954.

Hillman, James. *The Dream and the Underworld*. New York: Harper & Row, 1979.

Höistad, Ragnar. "Cynicism." In *Dictionary of the History of Ideas*. Edited by Philip Wiener. New York: Scribner, 1968.

Klibansky, Raymond, Erwin Panofsky, and Fritz Saxl. "Durer." In *Saturn and Melancholy*. London: Thomas Nelson, 1965.

Toynbee, J. M. C. *Animals in Roman Life and Art*. London: Thames and Hudson, 1973.

SELECTED BIBLIOGRAPHY Mary Ludington

American Kennel Club. *The Complete Dog Book*. 20th ed. New York: Ballantine Books, 2006.

Barber, Richard, ed. *Bestiary: Being an English version of the Bodleian Library, Oxford M. S. Bodley 764*. Woodbridge, UK: Boydell Press, 1993.

Caius, John, and Abraham Fleming. *Of Englishe dogges the diuersities, the names, the natures, and the properties. A short treatise written in latine by Iohannes Caius . . . Newly Drawne into Englishe by Abraham Fleming* London: Rychard Iohnes, 1576.

Clark, Anne Rogers. *Annie on . . . Dogs!* Santa Barbara, CA: Dogs in Review, 2002.

Clark, Anne Rogers, and Andrew H. Brace, eds. *The International Encyclopedia of Dogs*. New York: Howell Book House, 1995.

Clark, Ross D., and Joan R. Stainer, eds. *Medical & Genetic Aspects of Purebred Dogs*. St. Simons, GA: Forum Publications, 1994.

Cole, Robert W. *An Eye for a Dog: Illustrated Guide to Judging Purebred Dogs*. Wenatchee, WA: Dogwise Publishing, 2004.

Edward, second duke of York. *The master of game: the oldest English book on hunting*. Edited by Wm. A. and F. Baillie-Grohman; with foreword by Theodore Roosevelt. New York: Duffield, 1909.

Leighton, Robert. *Dogs and All About Them*. London: Cassell, 1910.

Ritchie, Carson I. A. *The British Dog: Its History from Earliest Times*. London: Robert Hale, 1981.

Shaw, Vero. *The Illustrated Book of the Dog*. London: Cassell, Petter, Galpin, 1880.

Topsell, E. *The History of Four-Footed Beasts and Serpents and Insects*. 1607. A facsimile of the first edition. New York: Da Capo Press, 1967.

Turberville, George. *Turbervile's Booke of Hunting*. Oxford: Clarendon Press, 1908.